Looking for
Clark Gable
and other
20th-Century
Pursuits

T0307947

By the Same Author

BIOGRAPHY
Hugo Black: The Alabama Years
Lister Hill: Statesman from the South
Hugo Black and the Bill of Rights (editor)

STATE HISTORY
Alabama: A Bicentennial History
Seeing Historic Alabama: Fifteen Guided Tours,
2nd Edition (with Jacqueline A. Matte)

TEXTBOOKS
Your Alabama
The Story of Alabama

VIRGINIA
VAN DER VEER
HAMILTON

Looking for Clark Gable

AND OTHER

20th-Century Pursuits

COLLECTED
WRITINGS

With a foreword by Wayne Flynt

The University of Alabama Press
TUSCALOOSA AND LONDON

Copyright © 1996
The University of Alabama Press
Tuscaloosa, Alabama 35487-0380
All rights reserved
Manufactured in
the United States of America

∞

The paper on which this book is printed
meets the minimum requirements of
American National Standard
for Information Science-Permanence of Paper
for Printed Library Materials,
ANSI z39.48-1984.

Library of Congress Cataloging-in-Publication Data

Hamilton, Virginia Van der Veer.
Looking for Clark Gable and other 20th-century pursuits :
collected writings / Virginia Van der Veer Hamilton, with a foreword
by Wayne Flynt.
p. cm.
Includes index.
ISBN 0–8173–0834–2 (alk. paper)
1. Southern States—Social life and customs—1865— 2. United
States—Social life and customs—20th century. 3. Hamilton,
Virginia Van der Veer. 4. Journalists—Southern States—Biography.
5. Women journalists—Southern States—Biography. I. Title.
F215.H2 1996
975′.04—dc20 95–44926

British Library
Cataloguing-in-Publication
Data available

For my wartime companions—

Marguerite Johnston of the Birmingham News

Jane Culbreth, Lillian Keener, and Mary Eleanor Bell of the "Alabama Embassy"

Kay Stokey and Jane Albaugh of the Associated Press

and in memory of

Professor John Ramsey of The University of Alabama

Contents

Foreword

Wayne Flynt

A life may be depicted in many ways. One option is to view it as a series of photographs, each capturing a moment in time. Taken separately, each reveals the exact event portrayed. Taken together, the sum of the parts provides understanding of a much larger process of events.

So it is with Virginia Van der Veer Hamilton's retrospective. Each element captures a precise moment in the history of the South and the nation during the twentieth century. For example:

An evocative memory of family vacations up U.S. Highway 11 through Chattanooga, Knoxville, and the Shenandoah Valley, her father in coat and tie, older women passengers in dresses, hats and gloves, the unairconditioned car packed with six frugal passengers who paused to eat picnic lunches at roadside tables.

The initial reaction to the American South by one hundred Free French aviation cadets stationed at a pilot training base near Tuscaloosa. Her account of their first visit to town in search of wine and women is a wonderful reminder of how World War II altered everyone's life by bringing strangers to the United States and transporting Americans to strange places.

Her three-day journalistic visit to a wartime Women's Army Corps platoon, newly assembled in northern Georgia. Hamilton's interview reveals the ambitions and heartaches of schoolteachers who yearned to be Army officers and of one jilted woman, out to prove her personal worth.

A newly retired history professor celebrated her seventieth

birthday by buying a red sports car with a back seat just large enough to hold her sack of prescription drugs.

Separately these essays, speeches, journalistic accounts, and articles entertain. Combined, they educate. Few books have so thoroughly traced the odyssey of a New Deal liberal woman in the South. None that I know of has laid bare the mean, deliberate sexism that wounded so many women. Nor was all the damage done in predictable places like the "bull pen" at the *Birmingham News,* where male reporters and editors reigned supreme. University history departments also played their role in demeaning women who aspired to the professoriate.

In Birmingham, Alabama, a city with a worldwide reputation for industrial strife and racial bigotry, Hamilton came of age in the iconoclastic community of Roebuck Springs in the company of writers, journalists, musicians, and a sophisticated Russian bookseller. Her father, a journalist by profession, was a bibliophile by avocation, amassing a vast library of neo-orthodox theology and the novels and plays that dominated the literary scene in the early decades of the twentieth century.

Virginia Van der Veer Hamilton has given us more than a personal memoir. Her retrospective treats us to brief, enchanting glimpses of another time and place. Furthermore, she reminds us that strong-willed women do not fit neatly into any compartment but emerged in the South, as well as in other regions of this nation, long before the organized women's movements of the late twentieth century.

Preface

I was born in 1921, the start of a decade during which the young twentieth century shed many of its nineteenth-century attitudes and began to shape its own identity. Unlike the life spans of my children, my active lifetime will not straddle two disparate centuries. I identify with only one century. As I type these words onto a small screen, the twentieth century is winding down; a new century is poised in the wings.

I witnessed much of the twentieth century, and, over a span of almost fifty years, I recorded and commented on it in one form or another: as a member of my campus literati, as a journalist in the heyday of the American daily newspaper, as a historian over a period of twenty-five years, and, on occasion, as an essayist.

This book contains a sampling of my writings on twentieth-century topics, arranged in chronological sequence from the Bank Holiday of 1933—the earliest historic event I remember—to ruminations composed in retirement (a stage of life invented in the twentieth century).

Many of the pieces in this book were written at the moment they occurred; for example, as Franklin Roosevelt's funeral cortege passed my vantage point outside the United States Capitol in 1945, I dictated a description of that scene from a sidewalk telephone booth. Resurrecting these stories from old clipping files and microfilm, I discovered that they contained a quality that my memory could never replicate: *immediacy*.

I had forgotten so many things. I had forgotten my idealistic isolationism, as I expressed it in a letter to Lillian Smith early in 1941. I had forgotten a young French aviator who spoke emotionally in 1942 of his desire to rescue his homeland from its German occupi-

ers. I had forgotten the excitement and sense of adventure bubbling from the first young women to serve in the armed forces of the United States. I had forgotten Hosea Williams's eloquent description of "Bloody Sunday"—March 7, 1965—on Selma's Pettus Bridge.

Memory being a fallible tool, I could never have called back Henry Wallace's pathetic attempt to communicate in 1948 with the rural people of Alabama. Or the atmosphere in a Birmingham police court when a United States senator was tried for defying one of that city's segregation ordinances. Or the jeers that rang out during a raucous assemblage in Birmingham's Municipal Auditorium, later dignified as the 1948 presidential "convention" of the States' Rights Party.

But although useful in preserving words and detail, journalistic writing has its limitations. Only by looking back over a period of years can one detect patterns and relationships. For writers like myself—reluctant to engage in the pitiless self-appraisal and total confessional demanded by a memoir—some aspects of order and form may be captured in brief essays. As opposed to the memoir, the essay allows a writer the luxury of selectivity. Without delving deeply into personal matters, I am able, in essay form, to recall my father's passionate attachment to books. In the tranquillity of my seventies, I recollect the humorous details of touring America before the advent of freeways or air-conditioned cars. The short essay allows me ample room to reminisce about train travel in wartime or to touch lightly on our family's custom—considered heretical in the 1960s—of fleeing home and hearth at Christmas.

But to deal with the latter aspect of this retrospective—the pursuit of history—one must have the luxury of almost unlimited time and space; thus that particular section of this book deals primarily with the methods, experiences, prejudices, and hitherto unpublished findings of a somewhat iconoclastic historian. Any reader curious as to the findings of my academic research will find such in other volumes.

Viewed as a whole, this collection illustrates, as one would logically expect, the theme of change, particularly in the Deep South:

In the waning years of the twentieth century, the spirit of

liberalism that flowered among large numbers of white south-erners during the 1930s is all but extinct.

Numerous grandchildren of sharecroppers—blacks and whites—have made it into the lower ranks of an ever-growing, urban middle class.

The solidly Democratic South of my youth has become, at first in presidential contests and then increasingly in state and national elections, a Republican bastion.

Legal segregation and disfranchisement have ended, to be succeeded by political and—after 5 PM—social separation of the races.

I perceive other signs of change, not confined to the American South:

Although more books are being published than ever before, the serious lay reader, such as my father, is a virtual anachronism.

Although more and more Americans cruise the seas or zip by air to other continents, they see less of their own country than the depression-era automobile tourists of my youth.

Although world events hammer on our consciousness via television, younger Americans know less about the origins and nature of their own nation's complex society than students who came of age when only newspapers and radio transmitted the news.

But the change that has affected the largest number of Americans in the twentieth century has taken place in the status of women.

Could only fifty years have passed since I considered marriage to be my main purpose in life? . . . since newspaper city rooms and the podiums of college classrooms were male citadels? . . . since high school teaching and clerical work were virtually the only careers open to middle-class American women? . . . since "Silent Hattie" Caraway was the sole woman member of the U.S. Senate? . . . since

First Ladies occupied their time giving teas or, if like Bess Truman inclined to a serious pursuit, taking lessons in Spanish?

A preface, by definition, states an author's intention. If this book has any purpose other than to occupy the abundant leisure of my retirement, that purpose is to give those who will live in the twenty-first century a glimpse of the peculiar praxes—to trot out a word I learned in a public high school Latin class—of those who occupied this planet in the twentieth century.

I hope this retrospective will so inform readers, males as well as females. I also hope it will provide them with an occasional, indulgent chuckle at my expense.

ACKNOWLEDGMENTS

For permission to reproduce material included in this book, the author expresses appreciation to the following:

American Heritage
Associated Press
Birmingham News
Birmingham Post-Herald
Mildred Hearn
New York Times
The Register of the Kentucky Historical Society
Helen White and Redding S. Sugg, Jr.
UAB Magazine

Looking for
Clark Gable
and other
20th-Century
Pursuits

A Childhood
in the Great Depression

ONE
─────────────

Way of Life

In my mind's eye, I see my grandfather, five adults and one child gathered round him, handing out dollar bills—five to this person, six to this one, four to this one—until his hands are empty. Since I am unable to recall any other family tableau of my early years, this one must have stuck in my memory on account of all that money. At the age of eleven, I had no idea what caused my grandfather to exhibit such apparent largesse.

This uncharacteristic behavior, I now realize, had been brought on by the Bank Holiday of 1933, ordered by the new president, Franklin D. Roosevelt, to forestall further panic over the collapse of the American banking system. My grandfather, having anticipated this dire event, had withdrawn a sum he deemed ample enough to see his family, plus that of an indispensable employee, Bert Hendrix, through this emergency.

I would never have known the amount of money he parceled out that day had not my aunt, Elizabeth, an "old maid" who turned thirty-two that March, recorded it in her journal. After Elizabeth died at the age of ninety-two, I discovered that, despite the passage of sixty years and six moves, she had retained a fragment of that journal on which she had noted "Family History, February and March, 1933!!"

Therein I learned that, after Bert got his share, our family of seven faced the unknown with a total in cash of twenty-nine dollars.

To me, the whole experience seemed a grand adventure. My family and all other Americans—or so it appeared—being virtually penniless, we had been suddenly, mercifully, delivered by that comforting voice on the radio from our constant preoccupation with money or, in our case, the lack thereof.

3

My extended family—grandparents, aunt, uncle—had moved to Birmingham, Alabama, in 1923, seeking a climate more temperate than those of their previous homes in Frankfort, Kentucky; Kansas City, Missouri; and New Orleans, and hoping to prosper in a city that had sprung to life only fifty years earlier as if, people said, by magic. Two years later, my parents had joined them, bringing a four-year-old girl destined to be their only child.

Our family did, as we had hoped, find the north Alabama climate moderate, but, as to prosperity, the choice of Birmingham could not have been worse. My elders had started an advertising business specializing in a relatively new approach—since grown to landslide proportions—direct mail. When my father arrived in Birmingham, he joined The Van der Veer Company. What could have been more nonessential, in the aftermath of the Great Crash of 1929, than advertising?

I included part of my aunt's first-hand account in an article I wrote marking the virtually overlooked sixtieth anniversary of Franklin Roosevelt's inauguration. How quaint Elizabeth seems, hoarding her nickels and worrying about repaying her total debt of thirty dollars.

"THE BOTTOM REALLY DROPPED OUT":
ELIZABETH VAN DER VEER'S JOURNAL

February is a week old now and we have done $25 worth of business to date. For a week now we have all sat around. . . . I read a few books but in those straight chairs and being worried, it's not much pleasure. I told Bert [an employee] I was going to bring down a radio, my crocheting and a rocking chair for it looks like we're in for a long spell. . . .

March 4, 1933: Inauguration Day

Without par, the dullest month of Van der Veer history. . . . total business for month about $160. More than a week went by without an order. Four days ago, March 7, was the most exciting day I've spent in ages. . . . About two o'clock, an extra [special edition of the newspaper] told of Governor [B. M.] Miller's closing the banks for a ten-day holiday. . . . Dad had seen it coming and drawn out $35. This we divided between the 4 of us and Bert, so now everybody

Birmingham News, February 28, 1993. Reprinted by permission.

4

has the clothes on his or her back, a few dollars, a little gas and that's all. . . .

I had $4 of the spoils—gave $2 to Mama and still (4 days later) have $1.80 which shows how one nurses the nickels. I spend a nickel or dime on lunch. I was wondering where I was going to get the $25 or $30 I owe when, lo and behold, there now is a moratorium on all debts and that problem is wiped out to give way to others, mainly the ones of food and shelter.

For almost ten years after the crash of 1929, our middle-class family endured penury so extreme that we were never thereafter able to spend money extravagantly for fear that our income might, as before, suddenly vanish. However, being young and naturally resilient, we found pleasure in innocent pastimes like Parcheesi, softball, croquet, tennis, diving into a muddy-bottomed swimming hole known as Shadow Lake, walking in the woods, or just sitting on the porch recalling old times in Kentucky and New Orleans.

In 1989, my turn came to recall old times in the rural area where I spent my childhood. To the suburbanites who have filled these wooded hills and valleys with brick ranch houses, I tried to convey a sense of what their neighborhood was like half a century earlier. But my audience heard me out with polite incredulity. What wild tales, they appeared to be thinking, this Ancient Mariner tells.

'POSSUMS AND PARCHEESI

One summer afternoon in 1925, a *Birmingham News* columnist and author, James Saxon Childers, was writing a book in a back room of Wilson Chapel. A tall man on a big black horse followed by a hound rode up to the window and asked if he might come in. "I just rode over from my home," the visitor told Childers, "to welcome you to Roebuck and ask if there is anything I can do for you—such as lending you a horse." He and his brother—the rider explained—were feeding three horses and would be happy to have Childers ride with them.

A few days later, Childers, on a little mare named Dixie, joined

Remarks at a ceremony unveiling a historical marker at Wilson Chapel, Roebuck Springs, April 2, 1989; published in Mildred Hearn, ed., *Recollections, Reminiscences . . . and More Legacies from the Crossroads: A History of the Development of Northeast Jefferson County in Alabama* (Birmingham: Roebuck Springs Garden Club, 1993). Reprinted by permission.

his new acquaintances for a horseback ride through the woods and trails of Roebuck Springs. Childers's visitor was my father, McClellan Van der Veer—known to his friends as "Ted." He had just moved to Birmingham from New York City, and he was to make his home in Roebuck until his death forty years later.

My own early memories are of the Roebuck Springs of the twenties and thirties. At first my mother, father, and I lived in a two-story house that contained four bedrooms for our extended family, sometimes numbering ten people, but only one bathroom. Later my grandparents, aunt, and uncle moved to a larger house that offered the luxury of two bathrooms. My aunt, Elizabeth, was the champion of our Sunday afternoon ping-pong contests on the wide porch of that house.

Eventually my parents built a small frame house heated only by small fireplaces and a large coal stove in the living room. My father loved that property with its view of the hills and valleys: having served in the navy in the First World War, he named his home "Topside." At first we had no close neighbors except for trees.

Those who lived here in that long ago time considered that we lived "in the country." The opportunity to keep horses and hounds, to ride horseback around this sparsely populated, almost rural, area, to 'possum hunt in the woods, had attracted my uncle, Stewart, and he persuaded my grandparents to settle in Roebuck rather than in the fashionable newer suburbs "over the mountain."

If we went horseback riding or for a Sunday afternoon stroll in the hills back of our house, it would not be unusual for a couple of rough-looking characters to cross our path and look us over. These moonshiners checked every intruder to be sure that revenuers were not on the trail of their bootleg stills hidden back among the trees.

These hills also produced iron ore; when we passed open mine-heads, I would ask to look inside. But I was never allowed to step inside the mine opening; if a female, even a very young one, should enter a mine, the miners would not reenter that mine, believing that disaster would ensue.

Our family had not been the first to be attracted by the rustic charm of Roebuck Springs. The Ross Smiths—who owned Wilson Chapel—lived in a rambling one-story white brick house just across Fourth Avenue, in a beautiful natural setting of plants and flowers.

Ross and Jessie Smith were an imposing couple—he handsome and courtly, she presiding graciously over a silver tea service; to me, they epitomized the expression, "to the manner born."

On Fourth Avenue, on a rise above the lake, lived the Frye family; Mr. [John] Frye was a banker and a frugal Scotsman; he believed in the motto "a penny saved" and often saved the nickel carfare on the yellow streetcars #38 or #25 by walking from his home in Roebuck to his office in downtown Birmingham, seven miles each way.

Mr. Frye was the first person I ever knew who was rumored to be a millionaire. He and his wife had two sons, John and Roland. To protect Roland from the perils of public school, Mrs. Frye started a small private school in a building in her backyard. Along with around twelve other neighborhood children, I attended that school. The only thing I didn't like about it was the name; it did not seem fair to me that my report card should bear the name of a fellow student, the Roland Frye School.

We had just one teacher—Mrs. Tarrant—and if there was no one else ready to go into the fourth grade, for example, Mrs. Tarrant would just move that child up with the fifth graders. I doubt if we were an accredited school; people didn't bother with things like that in those days, and besides, no one would dare question Mrs. Tarrant's system of promotion, one result of which was that I entered Woodlawn High School at the age of twelve.

My main recollections are of Roebuck Springs in the 1930s as a kind of artist colony. I say artist, meaning writers, musicians, and booklovers, most of them attracted to Roebuck by my father's enthusiasm. Just up the road from Wilson Chapel lived Dorsey Whittington, the first conductor of the Birmingham Symphony Orchestra, and his pianist wife, Frances Whittington. Their living room was large enough to hold two grand pianos so they could practice at home for their duo-piano concerts.

John Temple Graves II, whose column appeared each morning on the front page of the *Birmingham Age-Herald*, married Rose Smith, daughter of Ross and Jessie Smith, and lived for a time with her parents across Fourth Avenue from Wilson Chapel.

At that time, Hudson Strode, the author and creative writing teacher at the University of Alabama, was courting his future wife,

7

Teresa, whose family, the Corys, had a country place out beyond the Jemison Farm near Shadow Lake.

Douglas Hunt, who taught English at Birmingham-Southern College before he joined Father's editorial staff on the *Birmingham News,* and his wife, Mary, built a house on Ridgetop Circle overlooking the city. Here they raised champion boxers and Mary wrote novels. Another writer, Bill Hays, and his wife, Mable, lived next door to us. Bill wrote short stories for the pulp magazines [*Railroad Magazine* in particular] about adventures on the railroad. When he sold a story, Bill was elated; when his stories were rejected, as they often were, Bill was desolate.

Also on Ridge Road near our house, the owner of The Studio Bookshop, one of Birmingham's earliest bookstores, M. B. V. Gottlieb, an immigrant from Russia, built a large wooden house, a replica of a Russian dacha, and filled it with furniture, paintings, icons, and other memorabilia of his homeland.

Retired people also built on our hill; Harry Austin, who had survived the San Francisco earthquake of 1906, and his imposing wife, whom he and everybody else called "Dodo," had a black servant whom everyone called Walker. Walker lived, as we used to say, "on the place," but once a week, he had a day off. We knew it was Thursday when the scent of Walker's shaving lotion wafted all the way from the road to our front porch.

Will and Clare Thomas, who had come from Ohio to retire in a warmer climate, built a house on the bluff next door to us. Will Thomas was a cautious builder; my father predicted that his stucco house would never succumb to earthquake or fire and would stand for eternity. So far, this house is still standing.

The Thomases brought with them a friend who helped me pass many a quiet day on a hilltop where no other children lived. I played spirited games of Parcheesi with Clare Thomas's mother, "Miss Mame," who was confined to a wheelchair. The Thomases were the first Christian Scientists my family had ever known; even though we were Presbyterians, we all got along famously.

One Sunday afternoon in December 1941, when I was living at home, the telephone rang. Even that ring sounded urgent. It was my father's assistant on the editorial page of the *News.* "He's gone for a walk," I explained. "Well, go find him," the assistant ordered. "The

Japanese have bombed Pearl Harbor!" I had no idea where Pearl Harbor was—or why the Japanese had bombed this particular target—but sensing the momentousness of this unexpected event, I ran through the woods, calling out, until I located my parents.

Although we had no way of knowing it at the moment, the bombing of Pearl Harbor and the consequent entrance of our country into World War II spelled the end of an innocent age in the woods of Roebuck. Bootleggers, ore miners, 'possum hunters, horseback riders, duo-pianists, novelists, short-story writers, streetcars, nickel carfare, Parcheesi games, houses heated by coal stoves, and having one bathroom, all were to vanish from Roebuck Springs after the war, living only in the memory of a few old-timers.

In that talk, I spared those born in the age of television and video an account of our major form of entertainment: reading. We did not read (as many now do) as a form of private voyeurism into the sexual proclivities of the fin de siècle. My father read in search of knowledge, wisdom, insight, an explanation for human existence. Attempting to explain the importance of reading in our lives, I wrote in 1992 the following remembrance.

DUSTING THE BOOKS

Two calamities in a single week—the fire that decimated an historic church and the crack that rent my living room ceiling—forced me to revisit, amid ashes and dust, my father's books.

The repair of my ceiling put me to the task of moving out of harm's way hundreds of novels read by my father during the 1920s, 1930s, and 1940s. The fire that destroyed a large section of the Independent Presbyterian Church of Birmingham, Alabama, in 1992 consumed, among other valuables, some 250 volumes that comprised Father's long search for the meaning of human existence.

After my father's sudden death in 1961, my mother and I ordered a special bookplate and placed his philosophical books in the library of the church he attended irregularly for more than forty years. Within this stone and half-timbered structure, built during the prosperous twenties when cost was no object, Father's collection, we assumed,

Personal essay, 1992.

would be permanently housed, a small cairn to his memory. On the day of that spectacular fire, I watched on live television as the blazing roof of the church annex crashed down upon the library.

Those flames, I knew, fed not only on beams and plaster but on the words and ideas of Reinhold Niebuhr, Paul Tillich, Thomas Merton, Albert Schweitzer, Rabindranath Tagore, Thomas à Kempis, Rudolph Karl Bultmann, Thomas Kepler, Evelyn Underhill, C. S. Lewis, Søren Aabye Kierkegaard, Marcus Aurelius, C. P. Snow, Arnold Toynbee, and numerous other philosophers, mystics, and theologians whose works once lined my father's shelves.

Our longtime plumber, after a day spent repairing our pipes and listening to my father hold forth on esoteric topics, had reported wonderingly to his wife: "Mr. Van der Veer is readin' and studyin' about a world we don't know nothin' of."

During the twenties and thirties, most residents of our rural Alabama neighborhood possessed little in the way of reading matter except a copy of the Bible and perhaps a current edition of *The Old Farmer's Almanac*. Upon entering our living room, they appeared awestruck at the sight of Father's shelves. Hoisting his small daughter to his shoulders, one visitor commanded, as if indicating a wonder on the scale of the Grand Canyon: "Just look at all these *books!*"

Having been an only child, I inherited my father's novels. Before a Sheetrock expert arrived to repair my living room ceiling, I lugged grocery sacks filled with books to safe haven in closets. Some, such as the small edition of Joseph Conrad's *Lord Jim* bound in red leather and a two-volume first edition of H. G. Wells's *The Outline of History* that sold a record two million copies after its publication in 1920, had been presences on our shelves—almost members of the family—since before I was born.

While a student at Tulane University before the First World War, my father had become acquainted not only with the outcast known as Lord Jim but with the tortured protagonists of Edith Wharton's *Ethan Frome* and Somerset Maugham's *Of Human Bondage*, thereby displaying early on what was to become a lifelong proclivity for accounts of inner turmoil, moral dilemma, spiritualism, mysticism, and the occult, topics he explored with a fellow student, Stringfellow Barr. "Winkie" Barr, as Father knew him, was to complete his education at the University of Virginia and become in 1936 president of

St. John's College in Annapolis, Maryland, where he implanted a classical curriculum, still in effect, grounded in the "great books" of Western Civilization.

When my parents married in 1920—my mother less than a year after her graduation from Wellesley and my father just released from his duties as a navy ensign assigned to protect the unlikely target of Galveston, Texas—the bridegroom's fellow editors and reporters on the *New Orleans Item* presented them with a twenty-five volume set of the Author's National Edition of the writings of Mark Twain. In their typeset message, his colleagues expressed high hopes for my father, then a crusading reporter bent on the never-ending task of "cleaning up" the French Quarter.

These small green books, along with other early acquisitions such as a leather-bound set of the *Collected Works of Robert Louis Stevenson,* Tolstoy's *War and Peace,* and *The Great Hunger* by the Norwegian novelist Johan Bojar, must have been packed and repacked many times as Father pursued his wandering newspaper career.

To Enid, Oklahoma, where he briefly experimented with owning his own newspaper. To Kansas City, Missouri, where, as a reporter for the *Kansas City Post,* he crusaded—unsuccessfully—against the Pendergast machine. To New York City where he achieved his dream of becoming a reporter for the *New York Post* but, after three years, fell victim to stress, being stricken at the age of twenty-eight by what was then spoken of, if at all, in whispers as a "nervous breakdown."

As a consequence, my parents and their small daughter sought refuge with my grandparents who had been attracted in the early twenties to the New South venture that boosters called "The Magic City." Birmingham must have been a terrible shock to my mother, who had spent many hours in Boston's art museums, and to my father, a devotee of New Orleans's storied French Opera House before it burned in 1919.

In raw, sooty Birmingham, its streets laid out barely fifty years earlier, what possibility could there be for a life of the mind? What chance for intellectual companionship in a city known for rampant anti-Catholicism, violent labor disputes, religious fundamentalism, fervent prohibitionism, and as home to the South's largest klavern of the Ku Klux Klan?

To his surprise, Father quickly discovered in the person of M. B. V.

Gottlieb, a Russian emigré and proprietor of one of Birmingham's three bookstores, an urbane and knowledgeable bibliophile. Thereafter almost every book we acquired bore an inconspicuous label: The Studio Book Shop, Birmingham, Alabama, 409 N. 20th Street, Main 7903.

On the inside covers, Gottie, as friends called him, carefully penciled the price: for example, $1.75 in 1920 for F. Scott Fitzgerald's best-selling first novel, *This Side of Paradise;* a surprising $3.50 in 1922 for *A Book About Myself,* Theodore Dreiser's autobiographical account of his newspaper days; and, after the great crash of 1929, $1.00 for Charles Morgan's *Portrait in a Mirror,* $1.50 for Sinclair Lewis's *Dodsworth.*

On Christmas, birthdays and other occasions, Gottie could be counted upon to add his personal contributions to the stacks of books we always received. For Christmas 1926, he gave my parents a boxed three-volume set of *The Diary of Samuel Pepys,* bearing, in his tiny handwriting, the message: "My good friends Ted (my father's nickname) and Dorothy. 'I come to you by Pepys!' "

I, too, benefitted from Gottie's literary taste and generosity. Like my father, who had read these worn editions in his childhood, I grew up on romanticized depictions of post–Civil War Kentucky (Annie Fellows-Johnston's *The Little Colonel*) and of our family's ancestral homeland (Mary Mapes Dodge's *Hans Brinker or the Silver Skates: A Story of Life in Holland*).

Gottie set in to elevate my literary taste. No more doings of Peter and Wendy, exploits of Miss Minerva, or adventures of Tarzan. Gottie steered my relatives firmly in the direction of chronicles that widened my world, such as A. Conan Doyle's *The White Company,* Charles Kingsley's *Westward Ho!,* Charles Dickens's *Oliver Twist,* and Sir Walter Scott's *Ivanhoe.*

When I finished the first year of high school, Gottie himself presented me with a leather-bound copy of James M. Barrie's *The Little Minister* and this gentle reminder: "To my great friend Virginia—Because you and I remember the first book you read, I am sending you this one J. Barrie at the end of your first journey so-to-speak through bookland and knowledge-land. Luck speed you on! And may you never lose that first asset, your love of reading."

At Father's instigation, Gottie, then a bachelor, built a dacha near us. One cold winter night, a fire on our remote hilltop reduced that wooden house to rubble, destroying not only valuable icons and paintings brought from what he called the Old Country but also Gottie's cherished collection of rare first editions.

My father's early purchases at Gottie's bookstore obviously had been inspired by his own brief experience in the First World War. Romanticizing his stint in the navy, Father was attracted to the works of writers who, like H. M. Tomlinson, simply loved the sea. However he much preferred authors who had worked at sea but whose writings dealt with moral exploration and tests of character as, for example, the works of Knut Hamsun, the Norwegian one-time fisherman whose *Growth of the Soil* won the 1920 Nobel Prize, and Conrad, whose *Victory* joined *Lord Jim* on our shelves.

Father also evinced an early partiality for the work of women writers such as the English novelist May Sinclair, with her taste for Freudian psychology; Matthew Arnold's niece, Mary Augustus Arnold, who apparently felt obliged to sign her novels by her married name, Mrs. Humphry Ward; Vera Brittain, who wisely chose a pen name rather than that of Mrs. George Edward Gordon Catlin; and Ellen Glasgow, whose *Barren Ground*, an unflinching account of poor-white southerners, must have been a bracing tonic for my father, reared on *The Little Colonel* and John Fox Jr.'s *The Little Shepherd of Kingdom Come* and *The Trail of the Lonesome Pine*.

Alerted by Gottie, Father knew when authors came to town by train to promote their books. Long before the advent of talk shows, writers who bothered to include Alabama on their tours had few duties other than to meet the book editor of the local newspaper and sign a few autographs at The Studio Book Shop.

With little warning to my mother, Father would chug up the hill in his Locomobile, proud to show our modest home to some stranger from afar—usually England. On October 19, 1926, one visitor wrote in Father's copy of *Fortitude*: "To McClellan Van der Veer with the best wishes of A. Hugh Walpole who has been happy this evening." In 1930, another dinner guest inscribed *The Meaning of Culture* "To Ted Van der Veer. John Cowper Powys."

Touring Brits being few and far between, Father usually had to

content himself with the companionship of local writers. As a child, I assumed that, like ours, every family contained writers. After a day's work at the family advertising agency, Father relived his bout with depression by writing a novel that was never published. My uncle and aunt hid in separate closets, heated by electric toasters, and pecked away under green eyeshades, attempting to master formulas that promised short stories sales to the "pulps." My uncle, having lived six months in Oklahoma, wrote Westerns; my unmarried aunt wrote love stories.

As an ambulance driver in Italy during the First World War, Uncle once conveyed a wounded fellow driver to the hospital. Both these young men aspired to become famous writers, but only one of them, Ernest Hemingway, put his wartime experiences on the Italian front into the form of a novel.

In our neighborhood, writing was virtually a cottage industry. James Saxon Childers, a Rhodes scholar who taught English at Birmingham-Southern College, had his studio in a small private chapel near our house. In 1925 Childers edited a limited edition of the tales of *Mother Goose,* published in London with hand-colored illustrations and Chinese cover paper. He wrote travel books and unsuccessful novels, the most venturesome being *A Novel About a White Man and a Black Man in the Deep South.* This depiction of the barriers to friendship between male southerners of different races sank almost without a trace, probably because in 1936 this was a topic ahead of its time and because Childers only hinted at the then-ultimate taboo, sexual attraction between a black man and a white woman.

Teresa Cory, a striking brunette who lived with her parents across the road from my grandparents, became engaged to Hudson Strode, who had made quite a reputation by bringing the work of his writing students at the University of Alabama in Tuscaloosa to the attention of New York publishers. A few days before their marriage, fire destroyed the Corys' house, filled with wedding gifts; nonetheless the ceremony went off as scheduled.

Thereafter, we struggled valiantly to forget Teresa's plain Alabama name and call her—as her new husband insisted—"Thérèse", pronounced "Tuh-" (with our tongues to the roofs of our mouths) "-rez" (with a little lilt on the "z"). For this and other reasons, Father considered his friend Hudson somewhat of a poseur.

Strode wrote several well-received travel books before taking on his biggest challenge, a three-volume biography of Confederate President Jefferson Davis, at the behest of "Tuh-rez's" mother, Marielou, a hostess at the White House of the Confederacy in Montgomery. Reviewing this work, T. Harry Williams, perhaps tongue in cheek, commented: "There is value in having Davis presented as his own people saw him."

Another young woman in our neighborhood married the syndicated columnist John Temple Graves II, who was later to observe in print: "The Southern male is a totalitarian about the female of the species. . . . nearly always he is her master or her slave, rarely her comrade." Graves made that perceptive comment as an aside in *The Fighting South,* a paean to the South's martial spirit and to Old South concepts of honor and chivalry. Graves's 1943 book bore a further message: blacks should move slowly, if at all, in their drive for civil rights because the South had its hands full fighting a foreign war. By the time *The Fighting South* appeared, Graves had shifted from ardent admirer to truculent critic of President Franklin Roosevelt, thereby cooling the hitherto warm relationship between him and my father.

If his writer friends became caught up in their own projects, my father pressed more conventional friends, like a banker, a stockbroker, an insurance actuary and their wives, to spend long evenings at our house, reading aloud. Through my bedroom walls, I would be lulled by the murmur of Father's voice reading William Alexander Percy's ode to white southern planters, *Lanterns on the Levee.* In 1934, our thin walls vibrated with expressions of shock and injured pride when the group read *Stars Fell on Alabama,* a forthright representation of Alabama in the thirties by a Yankee observer, Carl Carmer.

Other than these and the books of Thomas Wolfe, Father evinced little interest in the contemporary southern novel. Works by William Faulkner, T. S. Stribling, and James Agee are conspicuously absent from his collection. Maybe—living in Birmingham—my father had his fill of the burdens and peculiarities of his poor-white neighbors. Furthermore, he did not read Margaret Mitchell's *Gone With The Wind,* his ancestors having fought for the Union and his ideal of womanhood being my genteel mother, not feisty Scarlett.

Perhaps due to the lingering influence of Prohibition, Father conceived the notion that to read a play aloud would be a law-abiding

and elevating way to observe New Year's Eve. Everyone must have a part, thereby insuring that all celebrants stayed awake. Father's group rang in 1935 by reading the French playwright Jacques Deval's comedy *Tovaritch;* in later years, he mandated more serious fare like *Hamlet* and T. S. Eliot's *The Cocktail Party.* On the eve of 1959, Father's group read Archibald MacLeish's *J.B.,* a fitting precursor, so it turned out, to the tumult and anguish of the sixties.

Racial segregation in the social scene having been profound in Birmingham in 1937, news of a forthcoming public appearance by James Weldon Johnson was relegated by the *Birmingham News* to a weekly column, "What Negroes are Doing." Johnson, the author of novels such as *The Autobiography of An Ex-Colored Man,* volumes of poetry and free verse including the highly acclaimed *God's Trombones,* and an autobiography, *Along the Way,* was at that time professor of creative literature at Nashville's Fisk University. The NAACP had awarded him its Spingarn Medal as the outstanding American black of 1925.

An elite organization of black women, the Periclean Club, sponsored Johnson's appearance. Despite sparse publicity, 1,200 turned out to hear the poet read from his works and extol "The Creative Genius of the Negro." According to the custom of that time, the sponsors politely ushered my parents and perhaps fifty other whites to front pews. Few Alabama whites had heard of Johnson although, in the South and nationwide, thousands of readers had chuckled over the misadventures of Florian Slappey of Birmingham, a fictional "sepia" character invented by the city's most prolific and best-selling novelist, my uncle's friend Octavus Roy Cohen.

My diary shows that I, an ardent moviegoer, spent that evening at the Ritz Theatre watching Merle Oberon and Brian Aherne in *Beloved Enemy.* Probably my parents never considered bringing their fifteen-year-old daughter to Johnson's reading. But I would have been accorded every courtesy, in contrast to the terrible fate of four young black girls who died in 1963 after a bomb exploded in the Sixteenth Street Baptist Church where Johnson had read his poetry on that peaceful night a quarter of a century earlier.

Although few white southerners in the thirties challenged the concept of racial segregation, a number of open-minded men and

women proudly regarded themselves as liberals. Within this intimate yet influential circle, my parents found friends and kindred spirits. John Beecher, a great-great-nephew of the abolitionists Henry Ward Beecher and Harriet Beecher Stowe, worked a brief stint under my father who had returned to journalism as editorial page editor of the *Birmingham Age-Herald;* later Beecher administered various New Deal programs.

Stifled by the prevailing racial, political and intellectual climate, Beecher left Alabama just before Pearl Harbor. Upon departing, he gave my parents a copy of his first book of poems, *Here I Stand,* inscribed: "For Dorothy and Ted, on going away but not from you." Eventually Beecher grew a white, Whitmanesque beard and attracted a following as a poet who, like his famous ancestors, championed the cause of racial justice.

Around that same time, Father brought home for dinner two intense and striking women from Georgia. Back then, relatively few people had ever heard of Lillian Smith and Paula Snelling. *Strange Fruit,* Smith's vivid tale of love between a white man and a black woman, had yet to become a national sensation. Father knew of Smith and Snelling because he read their small quarterly, *The North Georgia Review.* I made a brief contribution to that periodical in my senior year at Birmingham-Southern College; consequently—or perhaps out of regard for my father—Smith and Snelling offered me a job on their little magazine, soon to become more widely known as *South Today.* Being set on a career in daily journalism, as glamorized in Ben Hecht and Charles MacArthur's play *The Front Page,* I turned that offer down.

Before American entrance into World War II brought book tours to a halt, another of Father's favorite British novelists accepted an invitation to dinner. That author's inscription in a worn copy of *The Fountain* describes the evening: "The writer, having found in McClellan Van der Veer's shelves some eight or nine hundred thousand words of his writing, adds these few in recollection of many good things pleasant to a wandering Englishman—namely Van der Veer's community of thought, his wife's hospitality, and their daughter's charm and generosity from one good journalist to another, this Guy Fawkes Day, 1941, Charles Morgan."

During that premonitory fall, Thomas Mann, exiled from Germany for his outspoken criticism of Hitler, included Birmingham on his nationwide lecture tour. In a long editorial, Father recorded his impressions of Mann: modest, self-effacing, "ever the seeker of truth . . . convinced that he can learn as much as he can teach." As proof, he quoted Mann's remark to one inquirer (undoubtedly my father himself): "Your questions were better than my answers."

After the war ended, the adventurous and the merely curious reappeared in Birmingham. At their dinner table, my parents entertained Ilya Ehrenburg, Brooks Atkinson, Paul de Kruif, and Alfred Knopf, the latter hoping to discover and publish other southern writers of the caliber of Shirley Ann Grau and W. J. Cash.

But Father's interest in visitors from the outside world began to pale. Retreating to what he called his "book room," he spent hours rereading the novels of Aldous Huxley and George Santayana and intensifying his lifelong study of philosophy and theology.

Dusting, weeding, and reshelving books is a task best performed in solitude; almost a life review. One needs time to marvel at low prices; repair torn jackets; gather bits of worn leather from the floor; retrieve yellowed letters; discard 1960s travel guides and three little paperbacks on how to speak tourist Greek; muse on roads not travelled, like wartime romances or a job with Lillian Smith; and ponder the recurrence of destructive fires in our lives—the French Opera House in New Orleans, Gottie's dacha, the home of Thérèse Strode's parents, and the church annex.

Putting Father's books back in place, I was surprised to come upon a slim volume that my mother and I evidently overlooked when we gave that collection to the church: Nicolas Corte's *Pierre Teilhard de Chardin: His Life and Spirit*. Father had written his name on two separate pages to insure, I guess, that this book would be returned if he mislaid it while he and my mother sailed home on the *Liberte*. Below his name, he wrote: "London, May, 1961." On the evening after the *Liberte* berthed, my father died of a heart attack in New York, the city from which his illness had driven us forty years before.

This, then, was the last book he read.

TWO

Way of Travel

During the Great Depression, our chief indulgence—indeed, my Father's passion and one that he passed down to me—was to take trips in the car. All year Father looked forward to his two-week vacation, plotting our itinerary mile by mile and setting aside money to pay for this, our sole extravagance.

In the following essay, I tried to convey to the sophisticated travelers who read the New York Times Travel Section what it was like to tour around America before the advent of freeways, motels, McDonalds, shorts, T-shirts, blue jeans (except in the guise of overalls), Reeboks, nylons, plastic, polyester, state rest stops, and—miracle of all miracles—air conditioning.

BEFORE THE FREEWAY, THERE WAS U.S. 11

"Bring me a bedspread if you see a pretty one," my aunt called after me as I departed on a recent automobile trip. At first I was puzzled. What possessed her to make such a mundane request? Then I remembered—as she must have—our family odysseys during the Great Depression, when a common sight along the highways had been little roadside stands piled high with gaudy chenille bedspreads, the proprietor displaying her prize creations on a clothesline—perhaps a sky-blue spread with pink roses as big as cabbages or, for the unreconstructed, a double-bed version of the Stars and Bars of the Confederacy.

On our summer vacation trips—our family's sole luxury during the 1930s—we ventured out of the Deep South on three major highways. If headed toward Chicago, we drove U.S. 31, officially named the Beeline but more ominously known as Bloody 31 for its heavy

New York Times, Travel Section, November 23, 1986. Copyright © 1986 by The New York Times Company. Reprinted by permission.

19

toll of accidents. On a trip to California, we picked up U.S. 66, joining the hegira of "Okies" fleeing the Dust Bowl for that fabled land of milk and honey. But most summers found us setting forth on U.S. 11 (the Lee Highway in Tennessee and Virginia), headed south toward New Orleans or north toward the Great Smoky Mountains, the historic shrines of the Old Dominion and Washington, or the 1939 New York World's Fair. On recent travels, I tend to forget almost instantly the designations of modern freeways—had that been I-24, I-40 or I-81?—but, half a century after the trips of my childhood, the numbers 31, 66 and 11 remain firmly fixed in my memory.

U.S. 11 bore us from Birmingham directly along the main streets of small Southern towns and cities. On both sides of this intimate road, a stream of entrepreneurs importuned us to buy not only bedspreads but a host of other adornments as well. To enhance the front lawn, why not a little black groom, hand extended to grasp the reins of an imaginary horse, or a fountain shaped like a small boy, water trickling from a part of the male anatomy normally hidden from my view? To adorn the mantel, would we like an original oil painting in our choice of subjects—lion, snowcapped mountain, or the self-taught artist's conception of Jesus?

Other temptations soon beset us. Dozens of red birdhouses advertised "See Seven States From Rock City." Barn roofs bore larger messages: "Discover the Lost Sea" and "Explore Sequoyah Caverns, Finest Cave or Your Money Back." As we crossed a corner of Georgia, someone offered "Blood Test for Marriage: No Waiting"—a message over which I puzzled in silence—and the proprietor of a "game park" urged us to see a half-buffalo-half-cow, a horse with ski feet, and an old-fashioned Texas electric chair.

After U.S. 11 rounded the Moccasin Bend of the Tennessee River at Chattanooga, we began a maddeningly slow passage through small east Tennessee towns swarming with Saturday shoppers. Tent revivals, Bible colleges and other manifestations of Southern fundamentalism lined this portion of the highway. White letters on rocks proclaimed, "Jesus is Soon Coming. Are You Ready?" or warned, "Get Right With God."

Around noon, I began to pay particular attention to those merchants proffering catfish, barbecue, pecan candy, Grapette, cherry cider, R.C. Cola, Coca-Cola and a variety of other delights to south-

ern taste buds. But of necessity we resisted these roadside sirens as determinedly as we had the purveyors of bedspreads, fountains and oil paintings. At some roadside table, close by exhaust fumes from passing traffic, my grandmother unveiled waxed-paper parcels of stuffed eggs and ham sandwiches. My mother produced collapsible aluminum cups and a big silver thermos of coffee or tea. Another ritual inevitably followed this repast: my grandmother's arch announcement that she wished to wash her hands. This necessitated a stop at a filling station carefully selected for its promise of a clean ladies' room. Born and reared in the South, we took it for granted that all such doors bore the warning "whites only."

To afford this annual extravagance, we adhered to a daily budget: $1 for food and $1 for lodging apiece. One dollar sufficed to buy three plain but ample meals in small-town cafes or big-city cafeterias. (We packed lunch only on the first day.) Housewives in frame Victorians along U.S. 11 supplemented their family incomes by hanging out the handmade sign "Tourist Home" and renting clean but sometimes lumpy beds in spare rooms for $1 a person. But my own preference in lodging ran to the newest thing: a row of tiny wooden structures lighted at night by the red neon sign "Tourist Cabins."

For a 15-day vacation (not requiring overnight accommodations on the last night), each person's basic expenses came to $29, with perhaps $2 or $3 extra squirreled away for souvenirs, admissions or special treats. Our trips having taken place long before the advent of the credit card, adults entrusted this precious hoard to a carefully guarded purse or billfold. My father provided the car, oil and gas; at 20 cents a gallon, 20 miles to the gallon, the automobile expenses of a 2,000-mile trip must have come to around $25.

To my father's way of thinking, it was a mortal sin to leave a seat vacant in a car headed for interesting places. Thus he never traveled without five (preferably six) passengers crammed shoulder to shoulder, hip to hip, in his black Ford or Chevrolet, each with one small suitcase in the trunk. How did we stand the hot, humid air that assaulted us through the open windows of a car moving at 50 miles an hour—clad as we were in dresses, various undergarments, silk stockings, hats and, often in my grandmother's case, a veil and gloves; my father in long-sleeved shirt, tie, seersucker suit and straw boater, its inner band stained with sweat?

For the most part, we female family members had been conditioned to endure hardships without complaint. Lacking enough of these pliable travelers, my father once offered the sixth seat to a professor of philosophy whom we called "Cousin George" [Dr. George Lang, the University of Alabama] and who held forth on esoteric topics from the back seat. Usually these outsiders, riding free, gamely adapted to our Spartan style of travel. If the leader of our caravan decreed a 450-mile day along main streets and two-lane highways in the era before air-conditioned cars, so be it.

Had he lived to travel by freeway, my father would have been dismayed. These roads seldom go to the heart of things as did U.S. 11, which passed right by Andrew Johnson's tailor shop in Greeneville, Tenn., and Abingdon's Barter Theater, where destitute Broadway actors offered entertainment in exchange for milk, vegetables, or hams; directly over Virginia's Natural Bridge; down the main street of Lexington, Va., one block from the cold recumbent statue of Robert E. Lee and from my chief interest, Stonewall Jackson's stuffed horse—had not the great Stonewall, in his Valley campaign of 1862, galloped Little Sorrell up and down this very road?—and within sight of the birthplace in Staunton of my grandmother's hero, Woodrow Wilson. If we stuck with U.S. 11 long enough, it crossed the Mason-Dixon Line from Maryland to Pennsylvania and took us to the vicinity of what was for white southerners a darker memory. After Gettysburg, like Lee and thousands of his followers, we turned back toward home.

One Sunday morning during a recent trip over efficient but colorless freeways toward Vermont, my husband and I pulled off I-81 in Scranton, Pa., in search of something other than fast food. We discovered the Castle Restaurant, filled with noisy churchgoers, Catholics already finishing their eggs and home fries, Protestants just filing in for veal cutlet, calf's liver, or spaghetti, all greeting one another and their waitresses with friendly camaraderie. The Castle, with its fragrant aromas, cheerful customers, and Art Deco interior, struck a chord in my memory. Sure enough, as we departed I noticed a familiar white shield on the streetpost: U.S. 11.

In 1937 I observed my sixteenth birthday, graduated from high school, and started to college. Over my father's strenuous objec-

tions, I joined a sorority, began to wear lipstick, and had my first five dates.

My father's strictures—I now realize—stemmed from concern for the safety and morals of his only child. Practically all of my high school classmates belonged to typically large Alabama families, but most of the intellectual couples who comprised my parents' friends had only one child, another reflection—so my mother told me much later—of the impact of the Great Depression.

One such couple, the parents of my friend Ellen, had a much more unusual distinction: Ellen's father had asked her mother for a divorce so that he could marry his childhood sweetheart. Of all my acquaintances, only Ellen had parents who were divorced. Divorce was totally alien to our mores, an exotic and shocking event, a romantic tragedy rivaling that of Gone With the Wind.

GWTW burst upon the literary scene in the summer of 1937. Ellen and I, impatient to learn the fates of Scarlett and Rhett, stayed up all night long, scanning its pages, hastening to its finale. Within a few weeks, I inveigled my mother into buying me what was billed as a "Gone With the Wind" dress, with ruffles, puffed sleeves, and a skirt made entirely of pleats. To avoid ironing all those pleats after a washing, we wrapped that dress to dry around a broomstick.

I also saw a movie almost every week, my favorites being Camille with Robert Taylor and Greta Garbo and The Plainsman, starring Jean Arthur and Gary Cooper. I heard Lawrence Tibbett sing, watched Blackstone perform magic tricks, saw Edwin Strawbridge and Lisa Parnova dance, and suffered through a lecture by Roy Chapman Andrews about the Gobi Desert.

With my father, I attended a lot of Birmingham Barons baseball games. When he was only 17, Father had been such a promising college pitcher that Connie Mack himself had tried to sign him with the Philadelphia Athletics. But my grandmother, horrified at the very thought of a professional ballplayer in the family, refused to allow her son to accept that offer; at the conclusion of that 1913 season, the "A's" won the World Series.

My parents took me to concerts by the Birmingham Civic Symphony, to a performance of Aida, and to vaudeville shows at the Pantages Theater, including a risqué review billed as "Parlez Vous Paree."

(All this took place in Birmingham, Alabama, the heartland of what H. L. Mencken had derided as "the Sahara of the Bozart.")

I could never have stored all these events in mere memory—certainly not the subject of Roy Chapman Andrews's lecture. I recorded what I considered the major events of my life in the four lines allotted for each day in my diary, a small, red book, bound in real leather embossed with gold curlicues.

To get to department stores, to the thirty-nine movies I saw during 1937, and to Joy Young Restaurant, where two customers could split a thirty-five cent Mandarin lunch and have chop suey and noodles to spare, I rode streetcar number 25 or number 38, either of which conveyed me to downtown over slightly different routes.

Sitting up front with other white passengers, I was to travel thousands of miles aboard those yellow streetcars on my way to and from high school, college, and the sybaritic treats of downtown. I never pondered the fact that number 25 and number 38 had "white" and "colored" sections; to one with my limited knowledge of the world, that was simply the way things were on streetcars.

However, my experiences in 1937 were not confined to Birmingham. My father took me to Chickamauga battlefield near Chattanooga where I first realized—to my then shock and dismay—that my ancestors had not fought for what I had been taught in high school history class (and by simply breathing the Alabama air) was the "glorious Lost Cause" of the Confederacy but had worn blue uniforms and wielded bayonets to help Union General George H. Thomas earn the sobriquet "Rock of Chickamauga."

My parents also took me with them on a visit they made to Calhoun Colored School that had been established in Lowndes County, Alabama, after the Civil War ("War Between the States," said my high school history teacher) by some Northern missionaries ("do-gooders," my teacher would have called them). We went to see a contemporary "do-gooder," Mary Chappell, the daughter of James E. Chappell, my father's boss at the Birmingham News. *Mary had just joined the faculty of that remote little school, deep in the Black Belt.*

There, for the first time, I rode in the same seat of an automobile and ate at the same table with black people who were not servants but teachers. I confided this to my diary ("a novel experience") but

never dared mention either of these trips to my high school class-mates who, had they learned one of these secrets, would doubtless had surmised the other.

I also noted in my diary that I saw Eleanor Roosevelt in person when the First Lady visited Birmingham, but I didn't waste any of my precious space on the details. Perhaps Mrs. Roosevelt (so many Alabamians thought at the time) was "meddling in our affairs" by going down in a coal mine to stir up miners to demand more money or safer working conditions. Or (so many white southerners believed) she had been "consorting with our good colored people and giving them ideas."

My father knew Alabama Senator Hugo Black personally, but, like everybody else, he was surprised that August when President Roosevelt nominated Black for the U.S. Supreme Court. I may have been among the thirty million Americans who gathered around their radios on the evening of October 1, 1937, to hear Justice Black admit that he had once been a member of the Ku Klux Klan. But I made no mention of Black's dilemma in my diary, the four lines being taken with my own painful prospect, a "blind date" for the Pi Beta Phi steak fry.

My sole reference to the possibility of American involvement in the Second World War appeared November 11 as a laconic aside following matters of more immediate concern to me: "We all had a big discussion about my going out. It grew out of the dance the pledges are giving for the actives on Sat. night to which I am not going. Armistice Day. Probably the last one."

Being an editorial writer, my father surely realized that another great war threatened to change all our lives. But I, in my self-absorption, could never have imagined that, in the aftermath of that war, so many components of my girlhood would vanish altogether or be relegated to the company of other endangered species: street-cars, the Philadelphia "A's," downtowns as focal points for shopping and entertainment, thirty-five cent lunches for two, thrift, vaudeville, "colored schools," segregated public transportation, life-long marriages, Victorian fathers, sixteen-year-old virgins, diaries.

Funny thing: GWTW endures.

Campus Liberal

With money still scarce in 1937, most graduates of Birmingham's high schools grabbed the first job they could find. Wealthy citizens managed to send their sons, as usual, to Sewanee, Virginia, or Princeton. But for many offspring of parents in the middle and lower economic ranks, higher education was possible only if we lived at home and attended a local college.

Young men who might have yearned to be at Vanderbilt or Chapel Hill, and young women who dreamed of Wellesley or Smith, probably did not realize at the time that Birmingham-Southern College, although small and obscure, provided us with an education that—if not top drawer—turned out to be solid, disciplined, and remarkably open to ideas and debate.

Although growing up in the region branded by President Franklin Roosevelt as "the nation's economic problem number one," young men who sat beside me in college classrooms viewed the future with typical American optimism: they could become a member of the United States Senate (one did), a member of the House of Representatives (one did), a Rhodes scholar (one did), a Princeton professor (one did), a secret agent (two did), or swell the ranks of physicians, ministers, lawyers, airline pilots, and entrepreneurs.

But for the great majority of women students, life after college offered severely limited options. Practically every one of us expected—indeed, hoped—to fill the role of wife and mother. Those who failed to attract a husband could aspire to become schoolteachers, librarians, secretaries. That was about the sum of it.

At Birmingham-Southern, I took up with the campus liberals. We liberals constituted a minority in a student body composed largely of upwardly mobile southerners. However, in the tolerant

climate of the late 1930s, our classmates regarded liberals as harmless eccentrics.

In the South, where a few Socialists and Communists preached radical solutions, largely in vain, defenders of the status quo wasted no time worrying about liberals. As the Birmingham News *had put it, in explaining its switch from opposition to support of Democratic presidential candidate Franklin Roosevelt in 1932, "What appeared to be radicalism early in Roosevelt's campaign seemed now to be* merely a kind of liberalism" *(Emphasis mine).*

During the decade of the Great Depression, liberalism enjoyed widespread acceptance among Alabama journalists, college students, and the state's small cadre of intelligentsia.

John Temple Graves II flirted with liberalism in his widely read column on the front page of the Birmingham Age-Herald. *Prominent Alabamians formed the Alabama Scottsboro Fair Trial Committee, which included editors Grover Hall of the* Montgomery Advertiser *and James E. Chappell of the* Birmingham News; *Dr. Henry M. Edmonds, pastor of the wealthy congregation of the Independent Presbyterian Church; and Forney Johnston, one of Birmingham's most prominent corporate attorneys, and sought to win pardons for the nine young black men hastily convicted of raping two white women.*

The majority of Alabama's sparsely educated whites would have been unlikely to describe their philosophy of governance by any such esoteric term as liberal. But their votes spoke for them. Eighty-five percent of Alabama voters, in the 1936 referendum, indicated their approval of the New Deal's program of progress and reform.

In 1938, the year in which Eugene Talmadge's fiefdom, Georgia, reelected Senator Walter George, despite FDR's all-out effort to purge this New Deal opponent, and at a time when Senator Theodore G. Bilbo, a racist demagogue albeit a New Dealer, represented Mississippi in the eyes of the nation, Alabama voters chose the liberal New Dealer Lister Hill over the old demagogue, J. Thomas Heflin, to succeed Hugo Black in the Senate—and thereby helped assure passage of a federal wage and hours law.

By applying to ourselves the label of "liberal," we students

meant to flaunt our support for Franklin Roosevelt and most of the measures that made up his New Deal, including Social Security, the Tennessee Valley Authority, rural electrification, and the general concept of using the central government as a positive force to create a better life for workers, farmers, and other average citizens. But, like FDR, few of us actively involved ourselves in fighting the injustices suffered by blacks.

Our interests focused on domestic reform until war became a distinct possibility. At that point, campus liberals split into opposing groups: those who believed that America should come to the aid of forces opposing fascism, especially the brand practiced in Spain by Francisco Franco, and those like me who feared that internal democracy would be threatened if the United States took part in another world war.

We liberals were convinced that we constituted the wave of the future; had someone told us that, as the twentieth century neared its end, white southern liberals would have dwindled to an ineffective few and that the label we flaunted so proudly would become a pejoration, we would have hooted in disbelief.

Being a liberal influenced my choice of a topic for a senior thesis: The Southern Tenant Farmers' Union, founded only eight years earlier. In the course of my research, I interviewed H. L. Mitchell, the young sharecropper who cofounded that union; he impressed me as a handsome, albeit rustic, visionary. I sent him a copy of my paper.

At meetings of historians four decades later, I often ran into "Mitch," by then a virtual icon of native radicalism; he never failed to recall and praise my student paper; rank amateur that I was, I had written one of the earliest histories of his movement at a time when sharecroppers and their cabins were a common sight in the rural South.

Excerpt from
"VOICE OF THE SHARECROPPERS:
THE STORY OF THE SOUTHERN TENANT FARMERS' UNION"

Stop your car on a highway of the South—almost any highway. See that cabin—it could not possibly be called a house—sitting in

Senior thesis, Birmingham-Southern College, 1941.

28

the middle of the cotton field with the sun beating down on its patched roof? A sharecropper lives there.

It is summertime now and the cabin is hot, especially when the iron stove is going. But this is much better than January, when the wind and the rain come through the cracks and down the roof, and one stove, burning precious sticks of wood, can't warm a man and his wife and their ten children.

The sharecropper's year begins, not in this cold January, but in March when the fields are ready to be plowed. In the Spring of every year, the tenant signs a contract with his landlord, providing usually to halve or third the proceeds of the crop. In return for his half, the landlord contributes the soil and the seed, sometimes a mule or a plow. For his half or third, the cropper gives the daily labor of himself, his wife, and as large a family as they can possibly afford to feed.

From March until September, these people spend six long days a week in the fields, plowing or chopping or picking. When the crop comes in, they may have raised on twenty-five acres one bale an acre. In terms of cash, this much cotton would be worth somewhere around $450, of which the cropper's half would be $225. This is a good yearly income in the cropper class. Often they do not make more than $180, the total return for seven months of intensive physical labor.

Out of a cotton season's income must come food, clothing, fuel, a little patent medicine, tobacco and one or two other luxuries. Usually these goods are bought at the plantation commissary, where the account books are kept by the agent of the landlord. Most croppers, barely able to write their own names, have no way of checking the arithmetic of the commissary keeper. If the cropper is a Negro, he dares not challenge the store's record.

Less than $200 a year limits a man's food severely. The diet for a sharecropper and his family consists mainly of fatback, corn meal, molasses, and turnip greens. This cheap and vitamin-less combination is breakfast, lunch and dinner with little variation month in and month out. In the five months of winter, when $100 cash must feed the family until another crop time, the monotony is broken only when there is no food at all. The cropper has no back yard vegetable garden, for cotton grows right up

to the door; there is no money to buy the seed and no time to work it.

Daily life, during crop season, is daily work, broken only by the one rest day of Sunday. School and church mean little to the 'cropper. Children are summoned from their often inadequate schoolrooms early in the Spring to help with the plowing. Many of them do not go to school at all, because there is no school bus, no food for lunch, no money for books. Church is an "escape." In evangelism, Holy Rolling and baptisin', the cropper finds his only entertainment and his only hope.

But these people, in their flour sack dresses and dirty overalls, have been caught in a system from which there is, as yet, no real escape. They have no incentive to improve their homes or their soil, for the land is not their own and next year the eviction notice may come around and all the work and sacrifice of improvement go for nothing.

"The only way to stop gullies," according to an old-time plantation owner, "is to fill sharecroppers' stomachs full of food and their souls full of hope."

Tenants have no opportunities off the farm, for the cities of both the North and the South are already crowded with the slums in which live their industrial counterparts. Croppers migrating to the city bring with them lower wages, poorer working conditions, and even worse standards of living. This fact fits in with the Raper-Reid thesis of "sharecroppers all" [Arthur F. Raper and Ira De A. Reid, *Sharecroppers All*, University of North Carolina Press, 1941]: "Sharecroppers are not limited to the plantation system; they realize that their children who left home to escape the plantation system have come upon overseers and commissaries in the cities."

. . . In 1941 there is a new force fighting for the destitute croppers and tenants of the Southern cotton country. It is not another governmental force, it is not the work of philanthropists, it is not pushed by the Democrats, Republicans, Socialists, or Communists. It is the force of the sharecroppers themselves, and it is called The Southern Tenant Farmers' Union. It is a force of white men and black men working together against their common enemies of exploitation, hunger, cold and fear. By necessity it had a slow, tortuous beginning, but today, eight years after this beginning, the Southern

Tenant Farmers' Union has begun to mean rights and progress and hope for its 40,000 members and for the thousands more who will join its ranks.

This is the story of that union. . . .

Being a somewhat timid liberal, I spoke with surprising fervor in a letter in 1941 to a small magazine then called The North Georgia Review. *I had met its publishers, Lillian Smith and Paula Snelling, at my parents' dinner table; evidently an encounter with those outspoken southern liberal women had emboldened me.*

In 1940, I and many of my fellow college liberals feared the domestic effects of American involvement in another European war; we listened to Charles Lindbergh and Joseph Kennedy; we were, in the great debate then raging over American entry, isolationists.

Smith and Snelling worried about the possibility of generational conflict over this issue between older intellectuals and those of draft age. In one of the published symposia by which they hoped to spark interest in their magazine, they invited college students "whose minds do not goose-step comfortably" to express themselves on this matter.

YOUTH ANSWERS BACK

Is it right to forbid the Communist Party a place on the electoral ballot in many states on the basis that it threatens our form of government? Is it wise to develop this high sensitivity to "fifth columnists" and "sabotage," this jittery vigilance which breeds mistrust and fear within ourselves? Is this so-called United Front worth the sacrifice of free thought and free expression, worth the hissing and booing of the little fellow, worth the blind accusations which an ignorant mob flings at Charles Lindbergh, an American citizen? Can we afford to think with our emotions and not with our minds in this world of today?

It is youth which realizes that we must fight dictatorship, not with dictatorship, but with democracy. It is youth which refuses to hide

The North Georgia Review (Winter 1940–41); reprinted in Helen White and Redding S. Sugg, Jr., *From the Mountain: An Anthology of the Magazine Successively Titled* Pseudopodia, The North Georgia Review, *and* South Today (Memphis: Memphis State University Press, 1972), 351–52. Reprinted by permission.

behind the glib sayings of "our traditions will save us," "we did it in the last war," and "look at England."

Traditions are falling fast in 1941. The third term, one of our most "sacred," collapsed in November. Ten years ago we would not have dreamed of forbidding any party the right of representation on a democratic ballot.

Yes, we gave up things in the last war and we got them back. That was over twenty years ago. . . . this is another world . . . another war . . . we must be more careful what we surrender.

And look at England. She did away completely with elections this year. Ambassador [Joseph] Kennedy brings home the news that democracy in England is doomed.

It is youth which says to America:

"A form of government which cannot stand up under the severest test, which is forced to backtrack on its principles in an attempt to preserve them, which blindly adopts the theories of the enemy it is fighting . . . this form of government is not worth preserving."

It is youth which really believes in democracy.

The following essay—narcissistic and jejune as befitting a nineteen-year-old—shows no evidence that I even questioned, much less resented, the narrow expectations attached to being a middle-class southern female prior to World War II. Published in the college literary magazine, my essay also clearly shows that no stigma attached to the label "liberal." Had liberalism been regarded as disgraceful or scandalous, I—a dutiful daughter—would never have thus identified myself so openly and matter-of-factly.

AUTOBIOGRAPHY OF A SENIOR

College? Yes, I went to college. At Birmingham-Southern, on a hilltop down home in Alabama. . . .

Funny, when you think back on it. Those four years probably shape most people's lives. I know I grew up during mine.

I remember we had one of those brilliant Alabama falls my freshman year. The mountain behind our house was a different shade of golden red every afternoon when I came home. I did go home afternoons then because there wasn't much else to do. A freshman in

Quad 1 (Summer 1941):4–5.

college is such a terribly self-conscious little human. You know, that tight feeling you had all day and how ill at ease you felt around all the strange people and how your voice cracked when the professor asked you a question in class.

None of the teachers could pronounce my name those first few weeks, and it was slow torture to listen all the way down the roll call and know that pause was coming and he was going to say, "Miss, er uh," and then get it absolutely wrong. The class always laughed and I would blush and say it for him, very slowly and distinctly, and the next day he would get it wrong again.

The bookstore was only a dark little room with spindly, wire-backed chairs like an old-fashioned drug store. Nobody ever sat there because it wasn't the place to sit. The social center was a front row of cars lined up by the rail and there you went and cut classes and felt very collegiate and daring and a little bit ashamed.

You sat with a few girls usually and talked about the girls in other cars. Or you sat with a boy and that was a triumph. Only persons very high or very low in campus social esteem could afford to be seen sitting by themselves.

I went to get on *The Gold and Black* [the campus newspaper] that first year, and I was so scared I made another freshman climb the steep flight of stairs to the second floor of the Student Ac [Activities] Building with me and ask for a job too, even if dramatics was her line.

Everybody on the campus thought the editor was brilliant, so I did too. But he wasn't very much impressed that I had been city editor of a high school paper and that I now wanted to help him. He asked me my name and said, "Go dig up a feature," and went back to his reading.

I dug one up and he printed it with my byline under it in bold-black type, and the day it came out I was self-conscious again. The story was silly, I thought, and now there it was with my name on it for everybody to read and laugh at. I'm sure now that nobody read it but a few people who knew me, and they said very politely that it was "good," but I didn't write anything else for the paper that year.

When I was a sophomore I was very sure of myself. That is the college year for running in little, exclusive crowds and taking refuge within their protective circles. We sat by each other in classes and

in the library and walked across the quadrangle in groups and ate together in the cafeteria. This made life so much easier.

And nothing was more important than the steak fry Saturday night or the fraternity lead-out next week and whether you would get gardenias or just sweetheart roses. That was my year for getting bored in class and writing notes and becoming a watch-watcher. The ten minutes in-between and the dash to the bookstore—the little gossip and the chance of seeing the latest "him"—all this was so much more exciting than the history of England.

That was the year of spending the night out with some other girl in the crowd and double-dating and giggling over it afterwards and working hard with bobby pins and cold cream. Yes, sophomore is a silly year.

When I was a junior, I followed the pattern and took philosophy and creative writing and became a college liberal. I "thought." I even thought I could think. I lay on the grass in the last warm days of that third fall and read poetry and Plato and mostly just watched the brown leaves, hitch-hiking in the wind.

I sat with other thinkers in the college newspaper office and discussed the poll tax, John Steinbeck, and eternity. The boys all smoked pipes and wore disreputable clothes and rolled their shirt sleeves up, and the girls sat on desks and knitted and made a good audience. There were some coffin pillows and Petty girl drawings and a big sad picture of Hedy Lamarr in that basement office, and we thought it was Plato's Academy.

I was still riding to school on the streetcar, and I watched all the people who rode with me and made them into "characters" and "plots" and got $10 for a short story which the local newspaper printed.

It snowed in January and put off the awful pressure of mid-term exams. My philosophy [exam] was due the day we were to come back, but I stayed outside and puffed up and down the hill with a sled and all the neighbors, and fell in bed dog-tired at 8:30 every night. . . .

The thinkers put on some crusades during spring but they sort of fizzled out. Nobody, it seemed, appreciated us much but we ourselves. Nobody had any liberal ideas but us. That, maybe, was the best year of all. No one should go through college and miss it.

I came to be a senior at last, and I wasn't afraid any more. There wasn't anybody any higher, there wasn't anybody to look up to, except the professors, and they didn't count. This was the top.

My course sounded impressive, and whenever any kindly person asked me what I was taking I sounded off—"principles of economics" and "international relations" and "the South Today". The shreds of the college liberal consolidated and made themselves into a little sound sense. A precious little, but it felt like a lot to a newcomer.

I had begun to learn. It had taken a long time. But learning came so suddenly and quickly, when it finally did come, that I could look back upon myself a month before and be scornful at my ignorance. This was a new experience. . . .

That was 1941, a war year, and I keenly felt my importance as one of the "youth" of the nation. Conscription and draft and Fifth Column were ordinary words, and new uniforms, blue and brown and white, appeared on the campus to be admired every week or so. Familiar faces looked strange under those stiff-beaked caps. The mail brought letters from somebody in the air corps and somebody else in the naval reserve and a draftee in an army camp.

I began to read the newspapers—below the headlines—and to listen to speeches on the radio and the regular 10 o'clock newscast every night, and I argued in class about democracy and how it should be preserved.

That was a good year too, but it wasn't like being a junior. You could see daylight now at the other end of this college. We were halfway out of the shell, almost ready to be citizens of the world. We were like so many biscuits, cooked to a faint brown in the oven and ready to be taken out. We were "done."

I remember it seemed sort of funny to stop then, just when I had begun to learn. I think I decided at the time that you didn't learn so much in college, you just learned how to learn. You got a basis for knowledge and tried out your wings in a sheltered, miniature world. Everything was on a smaller, a safer scale, but it was all there—competition, society, love, hate, fear, peace, and war.

I don't believe I'll ever forget the spring that year. Maybe it was just the contrast with the things men were talking about that made it seem so unreal. The vista to the mountain was crowded with dogwood and redwood and the first fresh green leaves. At school,

the sunshine fell on the grass, shimmering in the wind, and if you got close enough to the ground it looked like a wavy, endless, green ocean.

We put on one final sprint in May and finished up all the odds and ends—term papers, the senior class gift, donations for the gym, most popular, biggest tightwad, most likely to succeed. It was hot in Munger Bowl on graduation day when the climax finally came, and I filed by in the long, black line and heard my name read—this time without a falter—and shook hands and filed out.

I was a freshman in the world the next day.

PART TWO

Journalist

"Girl Reporter"

I got my first job because the U.S. Army drafted the 23-year-old man who had held this position. The "old boy" network also played a role, my father and my employer, Charles G. Dobbins, being acquainted in liberal circles. Just shy of my twentieth birthday, I began my journalism career on the Anniston Times, a struggling biweekly. My title—managing editor—was more imposing than my salary—$15 a week.

Charlie Dobbins had bought this newspaper so he could use its editorial page as a podium to support Eleanor Roosevelt, Hugo Black, the National Youth Administration, and other icons of the liberal agenda. Naive though I was, I must have suspected that Colonel Harry M. Ayers, owner and publisher of the Anniston Star, would never allow a second newspaper to pose a serious challenge to his journalistic fiefdom.

In the fall of 1941, Anniston swarmed with soldiers from nearby Fort McClellan. But when an entire division went away on maneuvers, the local economy came to a virtual halt. Thus with profit as well as patriotism in mind, Anniston put on the largest military celebration in its history to welcome 15,000 soldiers of the Twenty-Seventh Division back from maneuvers in Louisiana and Arkansas. Young women from nearby towns and college campuses came to Anniston to help the war effort by dancing with the soldiers.

Viewed with the mindset of the 1990s, the most remarkable thing about that evening was that thousands of strangers mingled until midnight on a main street in small-town America, the element of fear never entering the picture.

NOBLE STREET CELEBRATES BIG NIGHT
AS HOMECOMING SOLDIERS ATTEND DANCE

A litter of peanut shells and dried corn stalks, a few strings of Christmas lights, and a sagging red sign proclaiming "Welcome Home, 27th Division" greeted early workers on Noble Street Thursday morning.

Everyday business was starting up as usual, and a stranger in town would never have guessed that the night before had been the biggest and most exciting in the street's history.

The night before . . . a smaller but no less riotous edition of New Orleans Mardi Gras as all able-bodied Annistonians, including the kids and grandma, and thousands of soldiers paraded up the street and down again, stopped for a while to listen to a band or watch a jitterbug couple, and then moved on. . . .

The night before . . . when four soldier bands beat out the rhythm of "Green Eyes" and "Oh, Daddy" instead of martial music, and maneuver-weary feet patted the hard pavement and got "in the groove" below the patio of the Alabama Hotel.

The largest stag line in state history lined the street and razzed their luckier comrades who had found dancing partners.

Neighbors met each other walking down the middle of Noble and stopped to talk about the big doin's, and, when nobody was looking, the Smiths from down the street got in the dance right with the soldiers.

The Christmas lights, pride of the city, were strung from above, and every neon sign in town flashed its bright advertising.

And did you see the stout couple dancing on the open porch of the Alabama, and Mickey, wire-haired mascot of the 27th, taking in the sights with his captain master, and even Chamber of Commerce Secretary Charlie Varner having a whirl in the street?

The 165th's band was so good that everybody stood in a circle and just listened, and Tommy Dorsey couldn't have had a more appreciative audience.

And there was no quiet for guests in the hotel, so they gave up and leaned on the sills, wide-eyed and sleepless, and the more con-

Anniston Times, October 10, 1941.

40

servative people of the town went up in their office windows for a grandstand view.

A farm family from out in the county, lured to town by news of the celebration, sat on newspapers on the curbs and marvelled at Anniston's big night. Late in the evening, they were still there, but the little boy in overalls had gone to sleep on his father's shoulder and his pile of peanut shells had fallen into the street.

Well there weren't enough girls to go around, but almost every soldier got one dance, even if it was with his tent mate.

The town clock struck nine, ten, eleven, and twelve—but nobody heard it.

At a little after midnight, soldiers fished for their passes as a big red bus marked "Fort McClellan" came rolling down the street.

The last remaining band, in front of the hotel, gave out a snappy rendition of "Hail Alabama" and wound up for the evening. Straggling soldiers and a few tired townspeople made for home.

The big night was over.

After only a few months, I left the Anniston Times *to replace another draftee abruptly summoned from his job as a reporter for the* Birmingham News.

In 1946, Charlie Dobbins accepted what must have seemed a dream offer: the editorship of the Montgomery Advertiser, *the forum from which Grover Hall had won a Pulitzer Prize in 1928 for editorials opposing the Ku Klux Klan. But Dobbins and the* Advertiser's *owners, Richard F. Hudson and Richard F. Hudson, Jr., soon found themselves at political loggerheads. Dobbins resigned after only a year, to be succeeded by the man who had always considered himself heir apparent to the* Advertiser's *editorship: Grover C. Hall, Jr.*

Dobbins tried to plant some of his liberal ideas in the inhospitable climate of Montgomery through editing another short-lived weekly newspaper, the Montgomery Examiner. *In 1956, he went to Washington, D.C., to become executive secretary of the American Council on Education. Dobbins spent the rest of his life in the nation's capital; in his latter years, he championed a strange cause for one who had always proclaimed himself a liberal: an unsuccess-*

ful crusade to bar women from becoming members of Washington's elite Cosmos Club.

In the thirties, most households that could afford electricity possessed a radio that, except for rare news flashes, served as entertainment. Gathered in the evening around the one radio in our house, my parents and I chuckled at the misadventures of Amos n' Andy and kept up with the fortunes of the Birmingham Barons baseball team, as dramatically narrated by a widely known local announcer, Eugene "Bull" Connor. ("Three and two! Wot's he gonna do?"; then, "He's ow-you-it!")

To stay abreast of events in their community, nation, and world during the first half of the twentieth century, the vast majority of Americans relied on daily newspapers. Those born after 1950— the take-off point of mass television—will never realize the degree to which communities once depended on newspapers. With primitive supplies such as library paste and cheap yellow paper, and slow, noisy machines like typewriters, teletypes, and linotypes, newspaper staffs managed to produce several editions each weekday, plus a fat Sunday edition.

Unlike television's anchors, sportscasters, and weather reporters, those who wrote for newspapers were seldom, if ever, regarded as minor celebrities. We walked around town and bought our groceries in anonymity; few, if any, strangers could recognize us from the tiny mug shot that sometimes accompanied a column or the occasional picture that illustrated a feature. Alabama's largest daily, the Birmingham News, wanted its readers to consider the members of its staff not as public figures but as family.

The following article, which I wrote for the centennial of the News in 1988, gives a glimpse of the era when a newspaper glued a community together, serving as its preeminent source of news and information.

THE WAY WE WERE BACK THEN

Visitors to the city room of the Birmingham News in the late 1930s

Birmingham News, March 13, 1988; republished as "The News Family: The Way We Were," Birmingham News: Our First 100 Years (Birmingham: The Birmingham News Co., 1988). Reprinted by permission.

found themselves in what might easily have been a stage set for that currently popular play *The Front Page.*

Typewriters and teletypes clacked. Telephones shrilled. Bells clanged to draw attention to big news stories on the Associated Press wires. Pneumatic tubes snapped up copy bound for the composing room. On hot days, oscillating fans hummed.

As in *The Front Page,* some editors wore green eyeshades. Cocky young men, hats tilting on their heads and cigarettes dangling from their lips, rattled the keys of their typewriters.

People shouted to make themselves heard over this din. "Copy!" reporters yelled to summon boys who hustled portions of stories from typewriters to editors. "Copy!" editors called to dispatch a boy for coffee and cigarettes or to refill big pots of the library paste used to bind "takes" together.

From their dais, telephone operators loudly proclaimed important callers: "Billy, the mayor wants you!" In stentorian tones, city editor Vincent Townsend summoned reporters to his desk: "Hinds!"

Perpetually under a cloud of smoke, the city room reeked of cigars, paste, and an occasional whiff of bourbon sneaked from a desk drawer. Because a low railing defined its borders, this section was commonly known as the "bull pen." The nickname fit: except for the switchboard operators and Miss Eugenia Self, a wispy, gray-haired woman who delivered the mail, the city room was virtually an exclusive male preserve.

Yet almost miraculously, those who worked amid this apparent chaos produced five or six editions every weekday, plus "extras" when important news broke. Equally remarkable, many devoted their entire working lives to the *News* despite the fact that $12 to $25 a week was normal pay for reporters in the 1930s. . . .

Managing editor Charles A. Fell rated a private office wherein, one memorable day, a female carnival actress, enraged over an account of her troupe in the *News,* swatted the gentlemanly Fell so hard that he fell onto his couch. Perhaps to avoid encounters with other angry readers, Fell preferred to exert his quiet authority as chief of news-gathering operations from a desk in the midst of the city room.

City editor Townsend orchestrated his staff with a vigor that instilled fear in oldtimers as well as neophytes. Unlike a later city edi-

tor who, after a particularly trying day, threw all his clanging telephones into a drawer and slammed it shut, Townsend thrived amid the commotion of the city room.

His strong leadership style produced results. Young reporters never forgot the lessons that they learned from their stern editor. Townsend insisted, for example, that with the help of *News* switchboard operators, they could locate any person by telephone—"even in Hell!"

Maestros of the switchboard . . . memorized thousands of phone numbers, made wake-up calls to staff members on early shifts, and knew the favorite haunts of politicians and reporters. E. M. "Danny" Danenberg, who covered police and general assignments, sneaked away one quiet afternoon to the dark sanctum of the Alabama Theater, only to have his shoulder tapped by an usher who whispered: "Your office is on the phone, Mr. Danenberg."

Those who covered major beats, such as politics, labor and business, took pride in their star status. Business editor Louis Friedman, during a brief illness, was deemed important enough to be assigned the presidential suite at the Tennessee Coal, Iron and Railroad Co. Hospital. Labor editor Robert Kincey, a railroad and circus buff, wrote many a column from the old caboose deposited in his West End backyard as a gift from grateful trainmen. Each year, on his two-week vacation, Kincey went to Sarasota to ride the Ringling Brothers train to New York City for the season's opening show.

From the seedy press room of Birmingham's old city hall on the corner of Fourth Avenue and 19th Street, dressy Jack Earle, whose wealthy family delivered him to the *News* each day in a chauffeured Cadillac, covered city politics.

William "Billy" Hinds specialized in helping police track down perpetrators of major crimes. Hinds also developed the knack of winning an Alabama Theater competition by quickly identifying a rhyme spelled backwards. After Hinds claimed three successive prizes of 30 silver dollars each, the theater discontinued its contest. . . .

Restricted almost entirely to the society page, women writers described garden club meetings and the decor of parties, from the lace on the tablecloth to sweetheart roses, forget-me-nots and lilies of the valley. Others, many of them former debutantes, wrote the "Scribblers" column devoted almost exclusively to the country club set.

Mrs. C. F. Markell, who joined the News as society editor in 1915, often arrived for work in a chauffeured limousine belonging to her sister, Mrs. B. M. Miller, wife of Alabama's 1931–35 governor.

Mrs. Markell spent 27 years applying elaborate adjectives to dresses ("gowned in fawn crepe made along silhouette lines, with flowing skirt in which shades of rose and silver-green predominated" or "made of flesh point d'esprit with matching capelet and ruffled shirt") and brides ("radiant" or "tall and willowy.") Toward the end of her career, Mrs. Markell frequently described the weddings of daughters of women she had "married off" two decades earlier.

Relatively few women wrote "hard news." Edna Kroman, who wore ankle-length dresses during the Flapper era, covered the federal building and state women's clubs. From her vantage point in New York City, Gladys Baker glowingly described celebrities, including the Prince of Wales, who would become Edward VIII.

By far the best-known reporter on the News during the '30s was Lily May Caldwell. Like Kroman, Caldwell displayed little concern with appearances. She wore long dresses and knotted her red hair severely at the back of her head or tucked it under a shapeless felt hat.

Eventually Lily May accumulated so many autographed pictures that she acquired a private office to house them. Assigned in the '40s to movies and musical events, she filled her walls to the ceiling with photographs of her favorites, among them Jeannette McDonald and Alabama-born actresses Tallulah Bankhead and Gale Patrick.

World War II impelled the News, along with other newspapers and the wire services, to hire more female journalists. Townsend set in to acquire what some males joshingly referred to as "his all-girl orchestra."

Upon joining the News, Alyce Billings Walker, formerly society editor of the Post, had insisted upon being assigned to the city staff. When Mrs. Markell retired in 1943, Walker was offered the job of society editor but protested that World War II had vastly changed and expanded women's interests. Eventually she persuaded the News to create the first comprehensive women's department of any southern newspaper.

Observing this rapidly growing staff, Townsend demanded, only

partly in jest: "What do you think you're running back there—a city room?" Walker replied boldly: "Trying!" . . .

After graduating from Birmingham-Southern, Marguerite Johnston and Virginia Van der Veer joined the "city side." Initially ill at ease with these new female reporters, Townsend addressed Johnston as "Miss Johnston"; Edgar Valentine Smith, a courtly member of the copy desk staff, called her "Miss Marguerite." . . .

Before World War II, black writers were rarer than women. Oscar Adams wrote a weekly column, "What Negroes are Doing."

In keeping with the mores of that era, the *News* devoted little further space to routine happenings in the black community. When its editors decided in the early 1940s to permit Adams to refer to black women in his column as "Mrs.," many white readers expressed outrage.

Largely unknown to readers, those who worked around the horseshoe-shaped copy desk made corrections and wrote headlines with fat black pencils and pasted "takes" together with long brushes, their chief seated in "the slot."

Around "the rim" sat, among others, Edgar Valentine Smith, whose short stories had won national prizes, and Jack Lacy, who spoke fluent French and had been a concert pianist. In the '40s, Margaret Putnam, one of the first female copy editors on the *News,* took her seat on the rim.

Unless they happened to witness a major event, readers relied entirely on news photographs for glimpses of famous people and momentous happenings. *News* chief photographer Walter Rosser, lugging his cumbersome Graflex and an aluminum pan in which to light flash powder, became a familiar figure on the sidelines of Legion Field. Audrey House stored photos of important people in what staff members forthrightly referred to as "the morgue."

Eventually, the output of editors, writers, photographers and artists came together amid the clattering linotype machines of the *News'* composing room. The prize for longevity of service in the composing room belonged to Edna Venable, who operated a linotype machine for 61 years.

On Saturday mornings, Cashier Harry W. Dearing, a former paper boy who was to work for the *News* 67 years, greeted each *News*

employee by first name as his long, slender fingers counted out their weekly pay in cash.

Around noon each weekday, Simon "Si" Denaburg, head of street sales for more than 40 years, loaded stacks of papers and delivered them to his salesmen on downtown corners, many of them elderly or handicapped persons.

"Read All About It!" these vendors called to passersby who dug in their pockets and came up with a dime in exchange for a freshly-inked copy of the latest *Birmingham News*.

Before World War II, a reporter was, ipso facto, a man. Although they never spoke of "boy reporters," city room bosses referred to new, young female employees, whom they reluctantly hired in the early forties to replace draftees, as "girl reporters."

The most menial writing assignments fell to girl reporters—accounts of PTA meetings and skimpy outlines of the lives of ordinary citizens who died on our watch. However, once in a while, a girl reporter might be dispatched to write a feature article, usually on a topic that no real reporter (i.e., male) would deign to address. This often entailed the girl reporter pretending to be someone else, thus inspiring a variety of headings like: "Girl Reporter Spends Day As . . . "

I entered eagerly into these charades, even signing some pieces "Hildy" Van der Veer, a reference to Hildy Johnson, the male hero of Ben Hecht and Charles MacArthur's play The Front Page. *In the spring of 1942, "Hildy" Van der Veer wrote a series on women taking over jobs heretofore reserved for men, illustrated by photographs of me driving a bakery truck, delivering telegrams, and parking cars. Males on the copy desk made it clear in their headlines that they considered my efforts a joke. One wrote: "Sob Sister Gets War Job, But Her Feet Just Can't Take It. As a Messenger, She's a Good Reporter, Hildy Opines As Her Dogs Begin to Bark."*

Another composed the following: "Hildy Chagrined As Men Take War Working Girl For Granted: Handsome Fail to Note Her Golden Locks As She Does Trick As Parking Lot Parker."

In those days, the word "trick" did not have one of the connotations it has since acquired.

Had it been possible for me to spend a day making casings for shells, I would undoubtedly have given this a try. Fortunately, wartime regulations barred girl reporters from such activities; thus I was forced to focus on the reactions of women who actually performed this new kind of work.

THIS IS A WOMAN'S WAR, TOO—
SOME ARE BUSY MAKING SHELLS;
HANDS THAT ONCE ROCKED CRADLES AND RAN TYPEWRITERS
TURN OUT MESSENGERS OF DEATH

Somewhere in Alabama—This is woman's war too.

On a quiet side street, a block from children playing in a schoolyard of an Alabama town, I saw women making shells.

The one-story building in which they worked had been a six-man factory to produce cotton tie buckles in early December, 1941.

Now its 132 employees, 50 of them women, work in three shifts —all day and all night—to turn out thousands of bright yellow, heavy tubes of steel, the empty skeletons of shells.

With Christine Adcock, photographer of the *News* and Capt. Roy Hickman, of ordnance district headquarters in Birmingham, I spent a morning watching white-collar women at their war work.

Who are these women who sit at the long table in an assembly line of print dresses? What were they "in civilian life"?

They were the girls who waved your hair, who typed your letters, who taught your children, who stood behind counters in stores, cafes and offices, who swished past you in white uniforms through hospital corridors, and who made the homes of America.

From P.T.A.'s, schoolhouses, beauty shops, shoe stores and idleness, they have come now to make munitions of war.

It was the changing of the shift at 7 a.m., when we arrived at the factory.

Tired women, the lipstick and rouge worn from their shiny faces hours ago, were leaving the stools and machines of a night shift. Up the shady street, in twos and threes, came a fresh group of women, ready to take over the machines without loss of a minute.

Birmingham News, May 24, 1942. Reprinted by permission.

Slogan of the shop, hung on a large red banner across one entrance, warns "Every minute counts."

It's not easy to get into an American war plant. Capt. Hickman showed his pass, explained about the visit, which had been arranged long ahead of time, and vouched for me and Christine.

The three of us signed our names and stated our business on the official visitors' sheet. Past a sign which declared "positively no admission to the plant except on official United States Government business," we entered the shop.

Why women in this work?

"Because they're nimble-fingered and quick witted. They can handle the shells lightly and easily. And—well, they're just better than men for the job," admitted the male superintendent of the shop.

And how do they like this new trade?

I talked to the incoming women as they showed their badges at the door, punched time slips and headed for seats on the assembly line.

"Before I worked here? Well, I was a nurse at Norwood Hospital in Birmingham," answered one.

"I married a doctor," she grinned, "and when he came to work here, I came too. Be a housewife? Not when I can be a little bit of help. And besides, this helps at home as well as in the war."

Lining up her work at a large copper-plating machine, one of the most difficult and exacting jobs in the shop, was an unusually pretty woman in brown slacks and shirt—a woman who looked more fitted to deal a hand of bridge than to handle thousands of hot shells each day.

"My husband works in war industries now, and has to be away from home a lot," she paused to tell me. "He may even have to go into the army soon. I'd never worked before December, but I didn't like staying at home alone. And I wanted to help out, too," she added simply.

This is not "girl's work"—it is woman's work. More than three-fourths of the women employees are married, and their spring cleaning has to wait on the war.

We were taken on a tour of the plant, saw long steel rods sliced

into shells, and watched the processes of welding, plating, shaping, checking and re-checking to make shells which must be perfect.

A few women do actual machine work. They are more highly skilled and better paid.

And what about the salaries?

Average salary of a woman shell maker—on a 40-hour weekly schedule and paid time and a half for overtime—is $25 a week.

Good wages are a large part of the attraction of the job. A monthly salary of $100, and often more because of overtime, is better pay than many schoolteachers, waitresses, secretaries, and other Alabama white collar workers receive for their efforts.

But women's main job is on the inspection line. Here each worker in a long row holds a measuring instrument by which she tests one part of each individual shell.

Any shell with the slightest imperfection is discarded or sent back to the machines for reworking. This is the company checking line.

At the next table sit girls doing the same exact job on the government's re-checking line. This strict "check and double check" has brought imperfect shells down to a minimum of the plant's entire production.

The women glanced up as Christine got her camera into action, but no worker missed a shell as it went down the line.

Monotony is the main drawback of the job, but the girl inspectors swap stools, instruments, places in line and jokes to make the eight hours pass.

A loud clang sounded through the shop at 11. It was midday, 15-minute lunchtime.

Women sit at their tables or on the grass outside and rest their heads and fingers. Each worker brings her brown paper bag of lunch from home.

In one corner of the shop, a motherly looking woman operates the plant's latest enterprise—a sandwich shop. Seeing that some of the other workers often brought no lunch, she began to make extra sandwiches and sell them. Now she has a business to rival the cold drink and candy machines in the plant.

"Well, how do you really like it?" I asked one after another of the women during lunchtime.

Never have I heard more enthusiastic answers. They like the work, the hours, the pay and each other. They like it better than stenography, beauty operating, waiting on tables, teaching school, nursing and keeping house.

And without fail they gave me one other reason:

"We've got to help out, you know, It's a woman's war, too."

I gloried in this type of feature; that's what I thought girl reporters were supposed to do when they were not busy writing "stunt" stories. In a typical example of the latter genre, I spent the day of October 14, 1942, as an "elephant girl" with the Ringling Brothers and Barnum and Bailey Circus. The supposed reason for such a frivolous feature was to give readers an insight into what went on behind-the-scenes at the circus. In hindsight, I realize that this caper, concocted by a circus publicist and a dedicated fan, News labor editor Bob Kincey, was nothing more or less than a free ad.

Bored with PTA and the "obits"—and obedient to almost any directive—I put on a circus costume of white chiffon and silver spangles, topped by a three-crowned hat. An elephant handler hoisted me onto a throne attached to the back of a huge animal.

Holding a scepter in my right hand and clutching my throne for dear life with my left, I rode that swaying, lurching elephant around the tent in the opening parade known to circus people as "the spec." In that nonlitigious era, it did not occur to me that—never having ridden an elephant before—I had put myself at considerable risk of physical injury. In my photograph, I am smiling gamely.

The heading pretty well told the whole story: "Girl Reporter Turns 'Helligan' and Rides Circus Elephant: She Spends Day with Performers, Eats Lunch and Sees What Goes On to Keep Show Running."

In the wartime summer of 1942, I and another girl reporter, Marguerite Johnston, looked forward to our annual vacation-with-pay—"pay" being a more accurate word than "salary" to refer to $25 a week. We spent two weeks in a famous resort city that had been transformed into an armed camp.

Half a century later, that experience surfaced vividly in my memory. The following essay, written from the perspective of 1990,

attests not only to our spirit of adventure but to the then extraordinary value of innocence as a protective shield for unworldly young women.

LOOKING FOR CLARK GABLE

Funny how memory hops from one thing to another like a stone skipped across the smooth surface of a pond. For instance, all the recent hoopla about the fiftieth anniversary of the premier of the film *Gone With the Wind* put me in mind of Clark Gable. Thinking about Clark Gable triggered memories of the vacation trip to Miami Beach that my friend Marguerite and I took in the summer of 1942.

Clark Gable was in Miami Beach that wartime summer, a 41-year-old volunteer struggling to keep up with the 22- to 26-year-olds in the army's Officer Candidate School. Marguerite and I spent a lot of our precious vacation hours trying to spot Corporal Gable, no easy task in a city where, as the saying went back then, "23 out of 20 men" were in uniform. Nonetheless, we scanned thousands in identical sun helmets and sweat-stained khaki uniforms, hoping for a glimpse of the one who, on screen, had seemed the very embodiment of the maddeningly attractive Rhett Butler.

From the window of our room at the Lord Tarleton Hotel, we kept vigil as squadron after squadron drilled on Collins Avenue under the Florida sun. If we heard the approaching marchers singing "I've got six pence, jolly, jolly six pence," we knew they were air force cadets, who, for some obscure reason, had adopted this Royal Air Force ditty: "I've two pence to spend," the American boys chanted. "And two pence to lend. And two pence to send home to my wife."

But when we heard the faraway strains of "Someone's in the Kitchen with Dinah," or "Alouette," or "Hinky Dinky Parlez Vous" (its final line before the last "hinky dinky" always delivered with a good-humored roar: "What the *hell* are we walking for?"), we knew that an O.C.S. squadron was about to pass and leaned out our window as far as we dared.

Our vacation was particularly adventurous because, although we were in our early twenties, this was our very first excursion into the big world free from parental scrutiny. Each of us was an "only child,"

Personal essay, 1990.

probably due to the economic constraints of the Great Depression. Having just one hostage to fate, both sets of parents had been unduly watchful.

We had arrived on one of those new trains known as a "streamliner," crowded with sailors and soldiers, their wives, children, and prospective wives. A few alighted when our train paused at little stucco, Spanish-style railroad stations labeled Cape Canaveral, Cocoa, Melbourne, or West Palm Beach. But most passengers were bound, as were we, for the end of the line—Miami.

Then we had wedged ourselves into one of the many jitneys that had sprung into being in the wake of gas rationing. The six other passengers in this oversized taxi, we observed in awed silence, included a captain, two majors, and a lieutenant colonel.

With Miami obscured by its nightly dimout, our driver made his way cautiously over a causeway and across islands, distinguishing land from water by the pale glow of his parking lights. Eventually he deposited us safely in front of a black and seemingly deserted high-rise hotel on Collins Avenue.

"Please, no light in your room," the desk clerk warned. "If you'll keep the door closed, you may have a light on in the bathroom."

But we had light in our room after all: a real moon over Miami silvering the combers of the Atlantic.

Next morning, having admired our white art deco hotel with its gleaming chromium trim, we set about finding some cheaper mode of transportation: army officers might be affluent enough to afford jitneys on a regular basis but not girl reporters. The crowded buses, with their frequent stops, seemed ill suited to our free-spirited mood. Marguerite had a sudden inspiration: "Let's rent bicycles!"

At night, however—mindful of our worried parents—we made our way by bus to a cafeteria where food prices bore some relation to our budgets. Riding buses with their interior lights off seemed suitably adventuresome. Couples held hands, passengers hummed and whistled, and Marguerite and I, perched safely above the sidewalks of Collins Avenue, peered out at mysterious places where music seeped from behind blackout curtains.

Given the fact that our salaries were in the neighborhood of $25 a week, we indulged in a few wild extravagances. For a mere one week's salary each, we had our portraits sketched in charcoal by

a sidewalk artist. Later, upon being proudly presented with these framed Hollywood versions of their daughters' faces, our mothers blanched but—for a polite interval—gamely hung our portraits in dim corners of their houses.

We signed up for a deep sea fishing trip. Not the economical four-hour trip that Marguerite had urged but, at my insistence, an all-day trip far out to what must surely have been, considering the turbulence of the waters, the Bermuda Triangle.

Our fellow passengers included four army air force navigators, two of them from Brooklyn, one from Wisconsin, and the fourth from Yokum, Texas. They were enjoying the wonders of Miami while awaiting their overseas assignments.

The guy from Yokum and I spent most of that eight-hour fishing trip prone on the same bunk, too overcome by *le mal de mer* even to question our sudden intimacy. From the depths of my misery I could hear Marguerite, well attended by my bunkmate's comrades, chirping gaily on the deck above.

As we had devoutly hoped, Marguerite and I made innocent romantic conquests over the course of our two-week vacation. She captured the admiration of an army lieutenant; I flirted with an airline pilot I met in the hotel elevator.

On the day we caught the streamliner headed back home to Birmingham, Alabama, these new swains came to see us off. We rewarded each with a chaste kiss. When the train paused in the vicinity of a naval air station, my hometown beau, resplendent in his white ensign's uniform, was waiting for me on the platform. To kiss two different men in as many hours was—for someone of my limited experience with the opposite sex—unprecedented. But after all, I assured a scandalized Marguerite, it was more or less my patriotic duty.

Oh yes, about Clark Gable. Hard as we tried, we never even caught a glimpse of him. But we did meet a couple of officer candidates who had actually served in Gable's squadron and been quartered in the same resort hotel with the star himself. They told us an anecdote that, once home, we repeated so often we almost came to believe that we ourselves had witnessed this little performance.

It seems that one day, after hours of drilling in the tropical sun,

Gable pretended to polish an imaginary lieutenant's bar on his shoulder.

"Baby," he said as he caressed the spot where the bar would rest, "I'm sure working plenty to earn you!"

Scarlett would have been proud.

Covering the Homefront

World War II snatched Birmingham out of the Great Depression. As in the twenties, clouds of noxious smoke obscured the sky above its industrial belt. Its plants hastily converted to war materiel: from cotton gins to ship machinery, from awnings to tents, from iron lawn furniture to hospital beds and bomb racks, from cast iron pipes to parts for planes and tanks, from metal lathes to yellow shells.

In 1942, the Tennessee Coal, Iron and Railroad Company set new records in its output of pig iron, ingots, plate, coke, and coal. Ingalls Iron Works transported whole welded sections for Liberty ships to shipyards on the Gulf coast. Bechtel-McCone-Parsons Corporation began clearing 260 acres next to the municipal airport where 15,000 workers could put finishing touches and equipment on four-engine bombers and Liberators.

Birmingham's Chamber of Commerce estimated the city's industrial work force at 90,000 and its total 1942 payroll at $95,000,000. The head of the War Production Board in Alabama stated the obvious: Birmingham ranked first in the Southeast in war industry.

This frantic activity offered a "girl reporter" an opportunity to address a topic more substantive than riding a circus elephant.

STIMULUS OF WAR IS AFFECTING EVERY ANGLE
OF OUR DAILY LIVES

Work, sorrow, loneliness and courage are the fortunes of war for those who fight at home.

War comes and lives with us, works with us, eats with us. It is a powerful magnet, compelling, controlling, pulling onward millions of little humans.

Birmingham News, January 31, 1943. Reprinted by permission.

In a year and two months, the magnet has drawn all men, women and children in this country out of their accustomed, private paths onto one broad, crowded highway.

Where has it taken you and you and you—people of Birmingham?

Five minutes to eight. Nine o'clock. Ten o'clock. Each night these hours are significant to people in Birmingham homes—news!

News broadcasts, two and three a night, have become rituals with American radio listeners. Whether there is news or not, whether they listen or not, whether they have heard it all an hour before, still Raymond Gram Swing or H. V. Kaltenborn or John Daly must be tuned in to fill the house with strange Russian names, campaign reports, Washington rumor.

It is the same during the day with newspaper headlines. Few men or women walk down 20th Street without skewing their heads sideways to read the streamer across the paper's face.

News is our stimulant, stoking our nervous energy for war.

We are eager, too, for reassurance. Ministers in Birmingham pulpits are looking down upon strange faces in the congregation each Sunday. Many of these new churchgoers are mothers and fathers with sons in service, turning to church for comfort and strength. Others are the city's recently acquired citizens. Others are just plain worried. Since Pearl Harbor, Birmingham ministers agree, there has been a general upswing in church attendance.

And something else has happened. Faces now turned up to the pulpits, say the ministers, are not dead-eyed and sleepy, but listening faces, pathetically anxious for a sermon of hope.

To get away from it all is impossible, but we try often to lose ourselves, for a few hours, in the music of a concert or the plot of a movie.

Traviata, presented by the Metropolitan Opera Company here six months after Pearl Harbor, drew the largest crowd ever to attend a presentation of the Birmingham Music Club.

Gas rationing has banned these concerts now to people over Alabama and Mississippi who drove hundreds of miles before the war

to hear Lawrence Tibbett or Lily Pons or Marian Anderson sing in Birmingham.

The audiences who do come are more earnest, less flashily dressed and quieter. Through most concerts, they sit tense, alert, as if listening for something in the music.

Sunday afternoon is the newest popular time for movies. A show is taking the place of the old-time drive in the country. Downtown movies often have only standing room to offer on Sunday and call brief intermissions between shows to let the new audience get settled.

Brief escape from war comes also another way. State liquor stores do a steady business all week, are jammed every Saturday afternoon. Waiting in line are soldiers and civilians, men, and women, Negroes and white, poor and well-to-do.

Even the cycles of human life—births, marriages, divorces, deaths—are war-stimulated.

More babies were born in 1942 than any other year in the history of Jefferson County. There were 7,313 in all—608 more than in 1941.

More people were married than in any other year. Licenses were issued to 7,944 couples, an increase of 720 over 1941.

And there were 231 more divorces than ever before in a year. Since placid 1936, the divorce rate of this county has almost doubled itself, and 1,543 couples were granted decrees in the first year of war.

The toll of war in lives of Birmingham boys from Pearl Harbor to January 1943—while it seemed heavy to families and friends—was comparatively light for a city this size.

Listed as killed in action in the army, air corps, marines and navy were 34 Birmingham men. Twenty-nine more are reported missing.

In the first month of 1943, however, War and Navy Department telegrams have come more often to Birmingham homes, and the toll has risen sharply. . . .

Then there are the little things. Women wearing slacks in a casual, take-it-for-granted manner. Wings of all sizes sprouting from the lapels and shoulders of pretty girls.

Pats of butter engraved "Buy War Bonds." Soldiers strolling city

streets on a quiet Sunday afternoon. Tokens as light as paper. Penny chocolate mints disappearing from cigar counters.

These are the small, almost invisible fingerprints of war touching every day of our lives.

Yet we are rich. Above all other nations, the United States is well-fed, warm-clothed, amply provided for. And the stepchild South is probably her country's most fortunate province.

While northerners shiver, we have moderate weather, plenty of fuel. While easterners walk or bus, our streets are still lined with cars. Butter and egg larders in Alabama are well-stocked today, but far westerners go without.

Industrially, physically, socially—war has not been too hard on Birmingham.

And, "having it easy," we are all the more responsible for our part, dedicated to a job well-done.

My city editor, apprehensive over what might result if a nubile reporter should confront the enemy, had no intention of assigning me to write about the German prisoners of war interned in 1943 in Aliceville, Alabama. That plum fell instead to a tough, middle-aged male.

But this same editor had no qualms about allowing me to interview young French aviators training for combat in Tuscaloosa.

What a welcome relief from obits and ration stamps: a chance to encounter that rare commodity—young men and, rarer still, young Frenchmen!

THAT FRANCE MAY LIVE AGAIN!
FRENCH CADETS FIND 'LE PARADIS'
AS THEY 'CHEEK' IN AT TUSCALOOSA

Vandegraaff Field, Ala.—This small field bakes in the Alabama sun, along a highway, a few miles from Tuscaloosa. On three sides it is hemmed in by green acres of cotton and corn; on the fourth, by concrete highway.

An occasional motorist ambling his 35-mile-an-hour pace along the highway would label it in a casual glance just one more of the

Birmingham News, August 1, 1943. Reprinted by permission.

air corps' mushroom crop of training fields—a hangar, the usual neat lineup of planes, one sentry guarding the gate.

But to some 100 boys inside that gate, Vandegraaff Field and the country it serves are nothing short of "le Paradis"—Paradise.

Enter the gate and listen. These are strange sounds for a U.S. Army air field.

From the open windows of a classroom comes the clear, emphatic voice of an American instructor, explaining the longitudinal, vertical and latitudinal axis of the compact model plane he holds in his hand. He pauses.

Now from the windows pours a rapid volley of French, spoken in the soft, lisping tones of a civilian—unmistakably a French professor—beside the instructor.

On and on the voices go—first the loud bark of English, then its echo, a quick, pattering French.

"Comprenez-vous?" demands the professor suddenly. "Do you understand?" Forty intent heads nod briskly.

Who are these pupils speaking of airplanes in French at a small Alabama airfield?

Inside this classroom, out on the concrete flight line, playing volley ball behind their barracks are the first 100 young men of a new French air force.

This is how they came.

A big, gray liner nosed into an East Coast port not long ago. Down its gangplank, staring big-eyed at their first sight of "le Paradis," came a line of boys, jaunty white caps above their blue uniforms.

This ship came from North Africa. Its French passengers were picked volunteers from the ranks of the French North African Army—the first of hundreds to come to America to train for air war.

The French boys with their blue uniforms and eager faces were spirited to a train and rushed down the long coastline of America, then inland to Craig Field, Selma, Ala.

Here they were "processed"—counted, weighed, tested, questioned. A few days later they boarded two large buses, headed for Tuscaloosa and what they think the most important job of their lives.

A Tuscaloosa girl, visiting the field, was eager to see the new arrivals. She had never, she declared in excitement, seen a French-

man. A line of French cadets marching to mess was pointed out to her.

"Why," she stammered, "why . . . they look just like we do!"

And so they do—until you look more closely. Here is one with an ugly scar slashed across his cheek. Another, tall and dark-eyed, looks 30 or more—his record shows he is 23. Almost all the faces are trouble-lined and strained.

Mostly they are around 22. But between a 22-year-old Frenchman and a 22-year-old American today lies a mighty difference.

For four years now, since they were 18, these boys have known war. All of their lives, except for a long-ago childhood, had been lived in uncertainty of when the next meal would be and what the next day would bring.

Every boy in the group now in America is a veteran. Every one has been in combat, either in France or North Africa. They have seen their fathers taken off to German factories, their brothers to German prison camps, their friends killed.

What they have seen and suffered shows in their eyes and in the earnestness with which they are beginning to learn to fly. For the skill to fly will give them the only chance they want—to help rid France of her German occupiers—"les Boches."

That one aim looms above everything—above their curiosity about America, above their anxiety over their families, above their present eagerness to meet some of Tuscaloosa's "jeune filles." The chance to fight back is what they are flying and living for.

American cadets at Vandegraaff and Americans everywhere are beginning to think now of "after the war," some in terms of building a new postwar world, others simply of building their own postwar lives.

One American boy at Vandegraaff suggested to a French cadet that the war might possibly end this year.

"Mon Dieu!" The French student was horrified. "It cannot be!" It must not end, he protested, before he won his wings and could get back into the fighting.

At Vandegraaff, safe among the cotton fields of Alabama, these boys from France waste no time on idle thoughts of a world without war. They have forgotten such a thing as peace. They think only of today, and its lessons to be learned.

But hear cadet X tell what this war means to him.

He is tall and olive-skinned, with a lean, intelligent face. He is 24, and before the war he was a young lawyer of good family in southern France. He loves classical music and can hum any theme you name. Three days before he left to come to America, his baby was born in North Africa.

He is speaking now through an interpreter, and he pats his foot on the rung of his chair as he talks:

"Say," he begins, "say that there is no life in France today. The Germans take everything—our food, our shops, our art, our sisters, our lives.

"Tell them this is what my family and my friends in France get to eat a month—not a day or a week, but a month! One-fifth of a pound of bread, one-fifth of a pound of meat, one-fourth of a quart of oil, and what little else they can buy or steal from the black market.

"Say that each town lives on what it can hold out of what the Germans take. Say that to get a new suit, one must have written permission from the mayor and must turn in two old suits and when he finally gets the new suit it is of terrible material and it falls apart.

"Tell that I had no new shirts and no new socks for three years after the war began.

"Explain that before the Americans came, the Germans took 80 per cent of everything Frenchmen had in North Africa. Now they cannot get that 80 per cent anymore, so they squeeze it from the starving mouths of France."

The boy is speaking with frightening intensity. His black eyes burn the faces of his American listeners, his foot taps faster. He is asked how he feels toward the Germans.

"Tell her," he instructs the interpreter "that once I lived in a nice French town, about the size of Tuscaloosa. I went away to fight and a long time after it was over in France, I was allowed to go home.

"The first morning I went to church with my family, and there were all the people whom I had always known—and I could not recognize them! They had lost so much weight—many 25 pounds, some 50 pounds, a few 100 pounds—that I did not know them.

"Ask her how she would think of men who had done that to her people."

There was an embarrassed silence as the interpreter finished. But the young Frenchman had one thing more to add:

"Say that we do not think France will survive another winter. We think if our people do not get help before this winter, our families will not be there when we return."

The commander of this first French group is the most insistently modest man a newspaper reporter could ever meet.

Only a little over 30, he looks older, but has the vigor and fire of youth. He, too, has the melting eyes and great intensity of most of these French.

In his uncertain English, he insists that he not be named, that the decorations he has won in air battles over France and North Africa not be described.

"You will not speak of me—you know?" he repeats over and over. He has confused "you know" with "you understand" and ends each slow sentence with a questioning "you know?"

A squadron leader before the fall of France, he has too often watched German planes outnumber his fliers by 15 to one. Miraculously he has escaped to become a leader at this rebirth of the French air corps.

Can the French people gather strength to help out if the Allies invade their land, he is asked. In excitement, he almost tips over the chair, a quick grin floods his expressive face.

"But of course!"—with emphasis and a shrug to indicate this is a question to which the answer is obvious.

"Without your help no," he goes on. "The people of France are tied hand and foot. We have a saying over there—'If you cut your own throat, you cannot breathe.' "

Deeply grateful for their shelter, food and training in this country, these young men of France find only one unsatisfactory side to their American hosts.

We do not realize—we do not have any idea—of what their country and their people have gone through, are enduring and have yet to conquer, these 22-year-old war veterans have found after only a few weeks in "the promised land." When he has talked with them, any American will admit they have discovered the truth.

The first French to go into Tuscaloosa almost created havoc—

even in a town used to RAF cadets who inhabited Vandegraaff until February.

Bold and unabashed by the barriers to language, French cadets confuse store clerks, hotel managers, taxi drivers, and policemen with elaborate sign language and quick French gestures to explain what they want to buy or where they want to go. Nothing—not even a nail file—stumps these French shoppers.

Clothes have been their main purchase so far. When they arrived, each had only the uniform he was wearing. Outfits—regulation khaki with dark blue overseas caps—have been issued them by the U.S. A tricolor with the one word "France" at its top is their sleeve insignia.

Other purchases have been mainly food and clothes to send to friends and families in North Africa. The visitors have expressed no desire to see Tuscaloosa's offerings of Hollywood movies.

Only one thing they have wanted to buy in Tuscaloosa and failed to find—wine. Tuscaloosa County is dry. Except for the bootleggers, about whose customs the French have not yet learned, there is no source of wine, liquor, or beer. This "dry" business, the wine-suckled French simply can't comprehend.

More than wine though, they are looking for "jeune filles." That is Vandegraaff's newest catch phrase among American cadets and officers. The French spoke so much of "jeune filles" when they arrived that Vandegraaff old-timers learned the two words as their first French expression and now toss it about like Ph.D.'s. . . .

Tuscaloosa society is waiting eagerly for the first large-scale visits from French cadets. Sororities at the university plan to have them for dances. The town belles, desolate since the departure of the RAF, are hurriedly reviewing their French lessons.

Proud but ever-courtly, the French are masters of any social situation. Taking his leave after dinner at a Tuscaloosa household, a Frenchman was asked by the proud Southern matron, "Well, how do you like us?"

The rest of the company shuddered. But the guest never hesitated.

Smoothly with a faint smile, he replied. "As a French officer, I claim the privilege of not answering that question. But madame, if that lamp over there should ask you how do you like the light it gives, what would you say?"

With a continental bow, he kissed her hand and left. The Tuscaloosa grande dame is still puzzled. . . .

Soon after meeting the French cadets, I leaped at another chance to play "Girl Reporter Spends Day As . . ." The new Women's Army Corps, currying public favor and seeking recruits, invited female staff members from a number of daily newspapers to spend three days observing how women were adjusting to army life. An editor's note, at the top of my front page story, referred to me in new terminology: newspaper **woman.**

THIS IS THE ARMY, MISS JONES!
FROM REPORTER TO AUXILIARY—AND BACK

and

WRITER FINDS WOMEN LOSE SELF-CONCERN IN ARMY:
WAC STRONGLY WELDED INTO SINGLE CAUSE

Ft. Oglethorpe, Ga.—It is just before dawn on the battlefield of Chickamauga.

This is 1943—80 years later—but the Confederates and Yankees are at it again. You see, there's been a moon tonight, and people in these parts say they come back, armies of ghosts from North and South, to fight out their silent massacre again every moonlight night.

Over the wooded battleground, a single cannon speaks, a 1943 cannon, and the ghost soldiers of '63 shoulder their arms and begin to fade.

From Snodgrass Hill, bloody last stand of the Union troops, they glance down on the barracks of waking Ft. Oglethorpe, just to see how a modern army is behaving itself.

Below them, soldiers are appearing like ants from their hills, swarming about the eternal army duties of cleaning the grounds, the barracks, the mess halls.

There is nothing irregular about this, but the weary, old fighters of Snodgrass Hill rub their eyes in disbelief and stare. For these

Birmingham News, August 8 and 9, 1943. Reprinted by permission.

soldiers at work below them wear housecoats, skirts, short seer-sucker dresses above their knees, curls.

"By crackey," says Yankee to Confederate on Snodgrass Hill, "them's women!"

Yes. 'Them's women'—and soldiers too. I will vouch for it.

I have been an auxiliary in that women's army three days—drilled, about-faced, saluted, scrubbed barracks, and addressed my superiors as "yes, ma'am."

To enter the army for a three-day stint, one must have three things: War Department permission, a waiver and a physical examination.

Permission from the War Department comes in a formal letter and, arriving unexpectedly in the mailbox, has almost the same electrifying effect as orders from the draft board. It instructs that the reporter shall visit the Third Wac Training Center for a period of three specified days for the purpose of "story from standpoint of a recruit."

"It is understood," warns Washington, "that this visit is for this purpose only."

Packing is simple. The army will outfit me. Oglethorpe is reached by train to Chattanooga, where a staff car is waiting to take the newspaper reporter on the nine-mile trek to Oglethorpe—a special consideration since most new recruits take their first army ride packed amidst baggage in the open back of a khaki-colored truck.

Oglethorpe lies just at one corner of historic Chickamauga Park. An old cavalry post, its grounds have been trod since Civil War days by marching soldiers and since the beginning of 1943 by the nation's first women soldiers.

My first assignment is to a brand new platoon, just arrived the night before via troop train from Pennsylvania.

They have set up army housekeeping in the reception center, their wooden barracks stifling in Georgia's mid-afternoon sun. Beneath an army cot goes my suitcase. A pile of bedding—two sheets, two blankets, a pillow—is dumped unceremoniously on the bare cot with orders to "make it up like the others."

The Pennsylvanians, weary, hot and a little frightened, gather

round to gape and question the new recruit whom they christen then and there "that writer."

I begin to struggle helplessly with the bed—its corners must be folded with the neatness of a Christmas package, its wrinkles non-existent, its blankets parallel with those on other cots.

"Here," offers one onlooker, "you'll never get any place that way. Let me."

Miraculously with only one day's practice, she is squaring off the corners at perfect right angles, accomplishing a bed-making job I never managed to equal in three days of army life.

The bed is barely smoothed over before a sharp, commanding whistle sounds outside. The Pennsylvanians scatter like scared rabbits tumbling over one another in their dash to get outside. I am swept out the door with the tide.

Waiting for us, whistle in hand, is a lanky solemn-faced sergeant— female—who watches critically as the inexperienced lines fall into shape.

"Come on girls," she rebukes, "that's the worst falling in you've done yet."

The girls—a motley line-up, some in black dresses and high heels, others in all shades and sizes of cotton—stand silent and crestfallen.

"All right," the sergeant is a cadre member, assigned to the important job of breaking new recruits into army routine. "We're going to learn some drill."

We learn. We stand in the blaze of the sun and practice again and again. Right, face! About, face! Present arms! Parade rest! Order arms! The commands are barked with the assurance and lordliness of the traditional army sergeant. Here is no soft, easygoing femininity.

An hour later, we are still at it when the sergeant suddenly relents. "Attention" she yells. "Fall out."

Back in the shade of the barracks, we practice half-heartedly, discuss the sergeant, mop our streaming faces.

"That'll give you something to write about," the panting fat girl on the floor beside me suggests with feeling.

Another command of the whistle, and the same nervous rush for the door. We are lined up, right faced and set on the course for mess hall. It is 5:30 [P.M.].

Stacks of tin trays, divided like restaurant blue plates, are at the entrance. Take one, a knife, fork, and spoon and pass along. The K. P.s behind the counter dump big spoonsful of beef stew, potatoes, slaw, string beans in the sections of each tray, and we file on, taking our places at the long tables as we come to them.

The mess hall is steaming and there's no reason to take the meal slowly. Within 10 minutes, our table is empty again, each girl has scraped her tray at the side door, stacked her handleless mug and headed back through the dust to barracks.

It is second night in the army for these girls and they are going through the inevitable let-down. Leaving home was exciting, the train trip adventurous, first day new and frightening, but this is the end of the second day and everybody is a little homesick and wondering.

A group has gathered on the barracks' steps to talk it over. One is obviously drooping and the others try to bolster her.

"Well I'm not sorry," says Kate defiantly. Kate is skinny and intense, operator of a drill press back home in Pittsburgh and already a standout personality in the platoon. "I left a good job too—more money than I'll ever make again prob'bly. But I feel good about this —better than I ever felt about anything before in my life. Yessir, I feel good inside, and in my heart, not my stomach."

Kate has made her speech simply and without heroics. It is not put-on. She means it. "Me too" the others chime in. "That's the way I feel. I think this is wonderful—just wait'll we get our uniforms."

They are giving each other pep talks, and everyone feels better. Even the homesick 21-year-old, who joined when her husband was drafted, stops her sniffling on the grass and shows signs of perking up.

Inside, by the glare of unshaded light bulbs, they are getting acquainted. From a bunk in the corner, this story is pouring out:

"Yeah, he wanted me to marry him, and I kept saying wait 'til this is all over and things are settled down some. We had fights about it, but when his furlough was over and I went down to the station with him, everything was all right and he said we'd wait.

"Then it wasn't a week later 'til this telegram came, and he just said he wished me the best of luck and he'd gotten married the night before. I'd already signed up and was waiting to come down

here, and I didn't do nothing but cry for two days—'til this train left, so I guess it's a good thing I had the Wacs to come to."

The voice breaks ever so slightly. "Bet he'd be sorry if he ever saw me in that uniform."

Writing cases are being opened around the room and pictures passed out to be admired.

"This's my boyfriend. He's in the air corps now in Memphis, but he's hoping to get over here before long."

"This's my grandchild. Just 3, and smart as he can be. He's the main thing I hated to leave behind."

"This's my sweetheart, and he's in New Guinea now. Gosh I hope I can get sent over there."

"This's my husband . . . my son . . . my mother . . . my brother." The whole family is on proud display, to be passed from hand to hand and introduced. A homey atmosphere steals over the impersonal barracks, and spirits are perceptibly rising. The danger point is passed.

It is afternoon, and a peak moment in the army. Now we are to get our uniforms, see ourselves for the first time in "Hobby hats" and khaki and brass buttons and Pallas Athene.

That saying about an army marches on its stomach is wrong. An army marches on its feet—all the time, everywhere. Cheered on by our cadre, we start the mile-long trek to the clothing warehouse.

In motley civilian dress, unmilitary and wrinkled, we pass the barracks where live in graduate grandeur the regular Wac training members and officers assigned to Oglethorpe. Startlingly, when we are secretly expecting cheers and clapping, comes a taunting chorus:

"You'll be sor-ry. You'll be sor-ry."

All the way to the warehouse the call echoes and follows us. "You'll be sor-ry" is a Wac tradition. Everybody yells it. Nobody means it. Our group is already planning snapshots to be taken immediately for the family back home.

"That writer" has left the Pennsylvanians amid all the glory and excitement of their new uniforms and, by staff car again, been transferred to a company whose one week in the Wac makes them, to my eyes, seasoned battle veterans.

69

This new group is from Kentucky, Arkansas and Ohio. They have sun-red faces and red Vs on their necks. They are just polishing off the hardest-working week of their lives, and they are fervently enthusiastic about the whole thing.

Only one girl is in the barracks as I join the company. She is huge and solid as an Indian squaw and known affectionately as "Brown." Brown has had too much drilling the day before and she is laid out in the bed.

I tackle my third Army bed with typical amateurishness and Brown, though flat on her back, can't stand it.

"Here," she says, rising gruff and friendly from her lower deck bunk, "lemme do it."

This is something new among women—this eagerness to help out, this going out of their way to do things for other women. All my three-day sojourn in the army, I am constantly being helped—having my bed made, my tie tied, being loaned a towel or an overseas cap—always without the asking coming first.

Civilian women are not like this. What makes the difference? Could it be that these army women are welded strongly enough in a common cause and purpose that they forget self-concern and learn cooperation? I think perhaps that is it.

In the lower next to mine sleeps a former schoolteacher, tall and angular with many classroom years behind her, known to the company as Sims.

Sims has a sense of humor, a quick, dry wit and a half-hidden desire to be an officer. One look at the good-natured but definitely schoolteacher face is good for a grin any time.

I lie on my bunk—after 5 P.M.—and wonder what her former pupils would think if they could see Sims now—flat on her back, her legs stretching straight toward the upper bunk, raucously describing her day on K.P.

Sims is a jewel. She will be an officer someday, and a good one.

Then there is Thomas. Thomas is the cheerleader in our barracks. . . . If a song is started, it is Tommy who has started it, Tommy who is getting up a quartet; Tommy who introduces me to the company; Tommy who is our morale officer, the spirit of Company Six.

Tommy has the honest face and straightforward, gray eyes of a girl

who has always been a tomboy. She marches with a swagger and no signs of feminine slink. She has put her heart into the business of being a Wac, for Tommy this is "the greatest life in the world."

That's why I'm amazed when Tommy, too, brings out a picture for her shelf—a pilot in his plane, a pilot with a moustache—and a daredevil look about him.

"Brother?" I asked Tommy.

"My husband," says Tommy simply. "In Australia. That's where I'm going."

There are the two Wrights—one fresh from a college sorority house, the other from behind a cashier's counter in the drugstore—inseparable because their names happen to be the same. And the dull, little chatterbox from Arkansas who rattles on like a mechanical doll. And the fat girl who is six feet and weighs well over 200 and is the company clown.

And 70 more like them, all personalities and individuals, and yet, somehow, all one—Company Six.

My father, McClellan ("Ted") Van der Veer, happily at home with his books.

"Topside" in the late 1920s.

"Topside" at the end of the Great Depression.

My mother, Dorothy Rainold Van der Veer, with "Inky," one of our cocker spaniels.

Author with Wolf Solent, named for the protagonist of a novel by John Cowper Powys.

Our friend and neighbor, M. B. V. Gottlieb, whom we called "Gottie."

(*Left to right*) My father, grandfather, aunt, and uncle at the family advertising firm, 1928.

Author (*left*) as somewhat disgruntled May Queen at Roland Frye Private School, 1929. Roland, next to queen, is, of course, the king.

Author as the only child in family group at Shadow Lake, 1927.

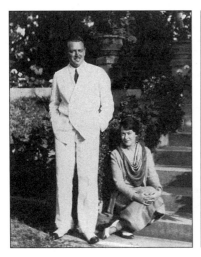

Hudson and Thérèse Strode, attired and posed as they thought fitting. (Courtesy of Special Collections, Hoole Library, University of Alabama.)

James Saxon Childers in his office, his Oxford oar prominently displayed. (Courtesy of Department of Archives and Manuscripts, Birmingham Public Library.)

Dorsey and Frances Whittington. (Courtesy of Betty Whittington Hustis.)

Father insisted on traveling with at least six in the car (note 1930s form of air conditioning); on Huey Long Bridge, New Orleans, 1935. (*Left to right*) Author, Mary Chappell, Corinne Chappell, my father, James E. Chappell, my mother.

(*Left to right*) My grandmother, my aunt, and my parents in proper tourist attire, Mount Vernon, 1937.

My mother and I, New Orleans, 1936.

Author and her parents with their neighbors, Rose and John Temple Graves II.

My aunt and grandmother on our trip to Hollywood,
California, 1935. (Elizabeth has
forgotten her gloves!)

H. L. Mitchell as he looked when I first knew him, 1937.
(Dorothea Lange photograph, courtesy of the Library of Congress.)

Paula Snelling (*left*) and Lillian Smith at Laurel Falls Camp in the 1930s. (Courtesy of the Hargrett Rare Book and Manuscript Library, University of Georgia Libraries, and of the Lillian E. Smith Estate.)

Girl reporter (*left*) spends day as(Copyright *The Birmingham News*.
All rights reserved. Reprinted by permission.)

The literati of Birmingham-Southern College at play in my parents' living room. (*Left
to right*) E. L. Holland, Jr., Shelby Southard, Thomas Childs, Marguerite Johnston,
Robert Lively, unidentified man; (*floor*) Martin Kruskopf, future Rhodes scholar.

Girl reporter spends day as Wac. (Copyright *The Birmingham News.*
All rights reserved. Reprinted by permission.)

Assigned to KP duty. (Copyright *The Birmingham News.* All rights reserved.
Reprinted by permission.)

Visit to monument of Union ancestors at Chickamauga battlefield. (Copyright *The Birmingham News*. All rights reserved. Reprinted by permission.)

Clark Gable (*right*), sans moustache, and two less famous trainees at Officer Candidate School, Miami Beach, 1942. (Courtesy of UPI/Bettmann.)

Wartime Washington

Like a powerful magnet, Washington, D.C.—holding out the lure of government jobs—drew hordes of young women from cities, towns, and farms all over the country. To reach the core of a nation at war, we crowded aboard the only available means of mass transportation. During a long rail trip in 1987, I had ample time to reflect on the contrasts between Amtrak and the trains of wartime.

"When does your flight leave?" my young acquaintance inquired as our Philadelphia convention drew toward a close. For a split second I considered an evasive answer, then decided to brave it out: "I rode the train." My friend's fleeting grimace probably mirrored her inner conclusion: any American in the 1980s who deliberately wastes 48 hours on a train trip to and from a professional meeting must ipso facto be phobic, indigent or verging on senility. Possibly all of the above.

The first two assumptions would be wide of the mark but I must admit that the third would come uncomfortably close to the truth: a quixotic urge to replicate a part of my own youth led me to elect this journey.

In the early 1940s, with gas severely rationed and commercial aviation unequal to the demands of wartime, I and millions of other Americans aged 20 to 40 moved about the country by train. What a pity that Thomas Wolfe, that bard of train travel, did not live to chronicle an entire generation packed into trains: men in khaki, navy or white bound for leaves or new assignments, others in civil-

New York Times, Travel Section, May 31, 1987. Copyright © 1987 by The New York Times Company. Reprinted by permission.

ian clothing being transported from plow to machine; thousands of young women like myself, in demure dresses, shoulder-length hair restrained by snoods, heading for jobs vacated by men; a few adventurous women parading in the drab brown skirts and jackets of Wacs or the spiffier blue outfits of Waves.

At major holidays, all of us at once, or so it seemed, jammed aboard the trains, perched on suitcases in the aisle or stood all night or even rode in the dangerous open space between cars to return briefly to familiar surroundings from which war had wrenched us. In summers, these trains converted their steam into an early form of air conditioning. On occasion, however, this process continued to produce heat, whereupon we forced open the windows to admit blasts of humid air along with fine black cinders.

With the ebullience of youth, we transformed these tests of endurance into high adventure: singing (laments like "I'll Never Smile Again" or a nonsensical ballad like "Mairzy Doats"), joking, flirting, eating the stale sandwiches hawked on station platforms, consuming gallons of Coke. For white passengers accustomed to the highly structured society of the South, the all-coach train between Birmingham and New York proved a democratic experience, albeit temporary. I once spent an entire overnight journey in conversation with the young ensign on the next suitcase, a scion of wealth and privilege in my hometown, who I, an offspring of improvident gentry, would never otherwise have met.

My wartime journeys took place aboard the Southerner. I don't remember ever hearing anyone remark on the name of this train. To travelers from the north, the Southerner seemed to promise exotic sights. To us natives, such a designation seemed entirely suitable although we might have taken umbrage at the invasion of a train christened the Northerner.

Despite the romantic implications of its name, the Southerner followed tracks laid down with profit rather than scenery in mind. J. P. Morgan had created the Southern Railway in the late 19th century to help divest the South of timber, coal, iron ore and minerals, and to deliver the yarns and coarse cotton cloth of the Carolina Piedmont to the finishing houses of the East.

Originating in New Orleans, the Southerner whipped through Mississippi's pine barrens and the western edge of Alabama's Black

Belt, navigated the smoky haze emitted by Birmingham's steel mills, dawdled in Atlanta, then, after nightfall, moaned and hooted its way through the Piedmont of the Carolinas and Virginia, past towns as empty as deserted stage sets; occasionally coming upon what Wolfe described as "the thrilling, haunting, white-glazed incandescence of a cotton mill"; sometimes pulling alongside another train occupied entirely by khaki-clad men. What a torrent of eloquence those troop trains would have evoked from Wolfe!

More than four decades after these journeys, I await another train northbound from Birmingham. The Southerner is no more, but Amtrak operates its longtime companion, the Crescent, its name hinting at the fleshpots of New Orleans. As it approaches, I see that the Crescent is propelled by a workaday diesel instead of one of the smoke-belching Pacific steam engines, green trimmed in gold, that were the pride of the Southern line. On the platform, knots of people are absorbed in the rituals of farewell. But the roles of the 40's seem reversed: now the younger generation is seeing its elders aboard.

As the journey unfolds, I am struck by evidence of further change. Gone are the Jim Crow cars that always headed up the trains of the 40's. No heavy curtain separates blacks from whites in the dining car; now races mingle in club car and diner as if it had never been otherwise. Plastic, in the form of dishes, tablecloths, napkins and yellow roses, has displaced glass, china, cotton and nature. Microwaved steaks and eggs have succeeded the Spanish omelets and corned-beef hash of memory. However Amtrak is not wholly oblivious to tradition: its menu still boasts of "old-fashioned French railroad toast" and coyly suggests that "on certain trains" grits may be substituted for home fries.

But the route through the Piedmont is as drab as ever, cruelly revealing the South's enduring poverty. Kudzu, not yet green, grips expanses of this infertile clay like a gray hairnet. Clearings beside the tracks reveal scruffy pine trees, shacks, trailers and rainbow-hued jumbles of what had once been automobiles. In the era when my choice of a car was limited to a black Ford or a dark green Ford, and in years when no cars rolled off American assembly lines, what might I have sacrificed for an automobile such as one of these rusting models in its prime?

By contrast with sitting all night on a suitcase, I consider my

roomette a marvel. In an enclosure 4 feet by 6 feet, I am provided with washbasin, toilet, tiny closet, a small enclosure opening into the aisle in case my shoes need shining, mirrors, reading light, night light, eyeglasses case, armchair or bed and—greatest treasure of all —privacy. I am separated from fellow travelers by a door as well as the traditional curtain. No matter that disrobing requires the agility of a contortionist; in the skies above, only presidents and potentates rate luxuries like these.

But I find it impossible to sleep while hurtling feet first toward my destination, especially on a train that stops at least once an hour. Never mind. Wolfe, drinking, roistering or thrashing about in his berth, stored up vivid images for *Of Time and the River* on the passage from midnight to dawn over this route: a little "moving-picture theater . . . that one small cell of radiance, warmth and joy" in a dark Carolina town; a black station attendant toiling to pull a heavy truck loaded with baggage, the landscape of Virginia, "dreaming in the moonlight."

Through my window, I observe the cotton mills and lumberyards of Wolfe's era but I also see newer plants that produce plastic roses, nuclear power or nylon pantyhose. And neon billboards proclaiming theme parks, auto speedways and the electronic ministry. Who would have dreamed of such eventualities in the days when a woman's rarest possession was a pair of silk stockings?

As we cross the Potomac, the porter knocks to offer a plastic cup of coffee. It is still the case that most train attendants are black. But white jackets have been replaced by snappy red vests or tunics; the deferential "yes ma'am" has given way to amiable breeziness. My requests meet with an almost unvarying response. I would like a bucket of ice. "No problem!" An extra blanket. "No problem!" A morning paper. "No problem!" More coffee. "Sure. No problem!"

I am surprised, however, that this porter is a female. Lots of women work on trains nowadays, she informs me, explaining cheerily: "This is the 80's, honey."

With my parents' reluctant permission, I left home in the spring of 1944, at age 22. Armed with my clippings about riding a circus elephant and pretending to be a Wac, I envisioned being snapped up by the Washington bureau of, say, the **New York Herald-Tribune.**

But my timid inquiries at offices in the National Press Building met with disdain. How dare I imagine, after two years of writing feature stories for a newspaper in the remote South, that I possessed the skill and know-how to operate at the pinnacle of American journalism?

The few women reporters I met on my rounds treated me more coolly than their male colleagues, seeing absolutely nothing to be gained by sharing their privileged status with younger women. Eventually a man from Birmingham, who worked for the Washington bureau of the Associated Press, helped me get a toe in the door. The AP hired me to sit all day at a desk, earphones at the ready. When a male reporter telephoned a story from a beat somewhere in the capital, I typed the words he dictated.

I shared a house in northeast Washington, a lower middle-class, all-white neighborhood, with three other young women from Alabama. I had barely known them back home, but when I telephoned they urged me to bring my suitcase promptly, board the streetcar, and move in (a sure indication, I later learned, of needing a fourth to share the rent).

Reared in the woods, I never got accustomed to living in a fortress formed by a solid block of houses. Laundry festooned every small, fenced backyard; our clothesline was never empty. We called this two-bedroom, one-bath, red brick row house the "Alabama Embassy."

Four young women, fresh from Alabama, felt perfectly safe here, crime being virtually nonexistent. Frugally, we all used the same house key, leaving it in plain sight on the window sill by the front door. Having no cars, we rode to and from work, day and night, by streetcar.

My housemates were "government girls," a livelihood almost totally off-limits to women throughout the nineteenth century. In the 1920s, a few women infiltrated federal echelons; in the 1930s, President Franklin Roosevelt, at the urging of his wife, Eleanor, appointed the first woman cabinet member, Frances Perkins, and named around one hundred other women to mid-level federal positions.

But World War II brought young women into government en masse. While working in Birmingham for the telephone company,

a pioneer in employing women, Jane Culbreth had spotted an ad seeking women to work for the Federal Bureau of Investigation. In a hurry to fill clerical vacancies, the FBI did not conduct its customary background check until these new employees reached Washington. If this inquiry turned up the slightest question as to a young woman's moral reputation, the FBI promptly shipped her home.

Jane always reported to work at least thirty minutes ahead of time, being in mortal fear of the public humiliation ordained by FBI Director J. Edgar Hoover for anyone who arrived even a couple of minutes late: having one's name and tardiness announced throughout the building by loudspeaker.

When she first got to Washington, Jane worked from midnight to morning at a seemingly endless task: typing ID cards for workers in war plants. Eventually the FBI grew to trust Jane to the extent of dispatching her on foot to a nearby bank in downtown Washington to withdraw cash—on occasion, as much as $100,000—needed to pay informers.

Lillian Keener, employed by the Coast and Geodetic Survey, also worked nights. After the war's end, we learned that Lillian's job had been to draw detailed maps of bombing targets in Japan. Mary Eleanor Bell worked at the Chemical Warfare Division of the War Department under the man who had inspired my "Hildy" phase, Charles MacArthur, coauthor of The Front Page *and husband of the famous actress Helen Hayes.*

On weekdays, two of us left for work as the other two returned. Our washing machine hummed and rattled day and night. A steady stream of young men in uniform found their way to the Alabama Embassy. However, having been reared in the age of chastity, the three of us who married after the war went to the altar, each a virgin.

After I had spent a couple of months in the humble task of typing stories dictated by men, the AP's Washington chief Paul Miller summoned me to his office, a heretofore unprecedented event for one of my lowly status. "PM," as we referred to him, presided over a bureau staffed by eighty-one males and four females, one being the daughter of a powerful newspaper owner in Oklahoma. Due solely to the exigencies of war, PM informed me, he was transferring

Flora Lewis to Europe,* moving various men up the reportorial ladder, and assigning me to the lowest rung on that ladder—covering Alabama, Louisiana, and Mississippi on Capitol Hill.

My desk editors shook their heads in sorrowful disbelief. To see a mere dictation girl promoted to reportorial status was akin to being a witness at Armageddon.

My friend Mary Sterne, another young woman from Alabama, had parlayed her slight experience as a reporter for a newspaper in her hometown of Anniston into a job on the highly respected Baltimore Sun. For the first few months, all went well. Mary liked her male colleagues and they liked her. Her byline even appeared over a few stories.

But one day she telephoned from Baltimore. She urgently needed to talk to me. When she arrived at the Alabama Embassy, my normally jolly friend seemed on the verge of tears.

"What's happened?" I asked.

Growing up in a highly regarded Jewish family, Mary had never encountered anti-Semitism head-on. Like Eli Evans and Harry Golden, who also grew up in small southern towns, she had realized that she was regarded as different. But she had also experienced what Evans and Golden described as "philo-Semitism," the ambivalent feelings of the white southern majority toward the relatively few Jews who lived in their midst: on the one hand, their Christian neighbors regarded them as profoundly religious members of their community; on the other hand, they held their ancestors responsible for the death of Christ.

When Mary had been hired to write for the Sun, the question of her religion had never arisen. Perhaps, to her interviewer, she appeared to be just a typical southern girl.

But when she asked for time off to observe Rosh Hashanah, her editor seemed taken aback.

"Mary," he said, "the Sun doesn't hire Jews."

After much discussion, the Sun's executives realized they had no choice but to keep Mary on its staff. This posed a dilemma for Mary: should she resign in protest? We talked all night.

*Lewis was to become a foreign correspondent for the *New York Times*, based in Paris, and later a columnist on its prestigious Op-Ed page.

Mary decided to keep her job. Eventually the Sun *quietly ended job discrimination against Jews. I like to think that this decision stemmed, in part, from Mary's bitter experience.*

I found the House and Senate press galleries to be overwhelmingly male preserves. As an indication of the way things proceeded in normal times, the Congressional Directory, *listing those entitled to use its press galleries, printed small symbols in front of the names of male correspondents. A * designated those whose wives were entitled to accompany them on special occasions; a + designated those who might be accompanied by "unmarried daughters in society"; a # designated those entitled to bring "other ladies."*

The Directory *listed female reporters without symbols of any kind, its editors evidently unable to conceive of these interlopers as having husbands or other gentlemen, let alone unmarried daughters in society.*

As in the News *city room, a perpetual cloud of smoke hung over the back rooms of the House press gallery. Regulars assigned to the Hill lounged on worn leather sofas, idly turning the pages of the latest edition of the* Washington Times Herald, Daily News, Evening Star, *or* Post.

All day and late into the evening, reporters and an occasional House member hunched over a table, silent except for the slap of cards. Representative Carter Manasco, of Jasper, Alabama, a cigar poking from his lips, and William F. Arbogast, head of the AP House staff, were regulars at this poker game. The ringing of bells alerted players to lay down their cards and rush out, Manasco to the House floor and Arbogast to gaze imperially down from his front row seat in the gallery reserved for the press.

In Congress, the odds against women were even more pronounced. In the House of Representatives, five women sat alongside 430 men: Mary T. Norton of New Jersey, the first woman Democrat elected to Congress, and her Republican colleague, Edith Nourse Rogers of Massachusetts, both of whom had taken office in the mid-1920s; Margaret Chase Smith of Maine and Frances P. Bolton of Ohio, each having succeeded to her husband's unexpired term in 1940; and Clare Boothe Luce of Connecticut, elected in 1942.

In the fall of 1944, three more women entered the House: Helen Gahagan Douglas of California and Emily Taft Douglas of Illinois, both from careers on the stage, and Chase Going Woodhouse of Connecticut, a former economics professor.

Senator Hattie Caraway, who had made a minor dent on history in 1932 by becoming the first woman elected to the U.S. Senate (with crucial help from her Louisiana colleague, Huey Long), sat amidst 95 senators, a short woman in a somber dress, as unassuming as a housemother at a fraternity meeting. When the Senate was in session, Senator Caraway spoke so infrequently—fifteen speeches in thirteen years by one account—that reporters dubbed her "Silent Hattie."

When Senator Caraway retired at the end of 1944, to be succeeded by a 39-year-old former Rhodes scholar and president of the University of Arkansas, J. William Fulbright, I described in my column "Arkansans in Washington" the Senate's gallant, if slightly patronizing, farewell to its sole woman member.

Old-timers of the Senate gallery, peering down at the Seventy-ninth edition of that wing of Congress, will miss a familiar figure.

For 12 years she has been a part of the Senate picture, a little woman in a black dress, sitting quietly in the center of the strong Democratic corps.

Guides pointed her out to tourists—"the only woman senator." Smooth-tongued senators, used to shouting "Mr. President!" stammered on the unaccustomed "Madame President" when she occupied the vice president's chair.

The lady senator herself seldom spoke except in answer to her name on a roll call. It is a name which has been on rolls of Congress since 1913, when her late husband took his seat in the House as a representative from Arkansas. The same name has been intoned since 1920 by the clerk of the Senate, where for 11 years it was answered by Senator Thaddeus Caraway. Since 1931, it has been called for his widow.

The little woman in the black dress was not present late Tuesday as the Seventy-eighth Congress passed into history. Senator Carl

Associated Press, December 23, 1944. Reprinted by permission.

Hatch, Democrat of New Mexico, rose in the final minutes before adjournment.

Of Mrs. Hattie Caraway, first woman to be elected to a full Senate term, he said:

"It occurred to me that possibly senators had overlooked the fact that there is leaving us this afternoon, not to return again, the lady senator, Mrs. Hattie W. Caraway, the senator from Arkansas. To her I wish to pay a brief tribute.

"Mrs. Caraway has been a member of the Senate longer than I have. She has always been most gracious, most kindly and most ladylike. If I may be forgiven for saying so, inasmuch as I believe that her votes throughout the time since I have been here have corresponded almost exactly with mine, I am tempted to say that the senator from Arkansas has been most statesmanlike in the votes she has cast.

"So, without regard to the gentlemen who are leaving the Senate and will not return, I think it would be a very fitting thing for us, who are men, to stand for a moment and give a handclap for the senator from Arkansas."

Time-honored Senate rules forbid clapping in the chamber but the staid Congressional Record noted at this point:

"The Senate applauded, senators rising in their places."

Other than its glamorous setting, I found my congressional beat —Alabama, Mississippi, and Louisiana—almost as routine as covering the PTA: announcements of new postmasters, war contracts, windy speeches to which not even I listened. In the unusual event that one of my members made national news—for example, Mississippi's notorious racist, Senator Theodore G. "The Man" Bilbo, launching one of his tirades—the AP turned the story over to a male reporter.

Dutifully, I made the rounds of offices, passing the time of day with staff members. If I urgently needed to speak directly to a member, I sent a pageboy to summon him off the floor. Representatives and Senators, particularly those from my home state, greeted me in extravagant, albeit patronizing, language, for example:

Representative Frank Boykin of Mobile: "Hello there, honey! Everything's made for love!"

Senator Lister Hill: "My, you lookin' pretty today, Miss Virginia! How's yo' daddy and yo' sweet mother?"

But late one spring afternoon, I was actually admitted to the inner sanctum of the lecherous, divorced Senator Bilbo. Innocent though I was, I knew to stay on my side of his big desk.

Perhaps Washington's extreme humidity reminded Bilbo of an episode from his past. But the story he told sent shivers through me.

As a young man, Bilbo reminisced, he was crazy about a pretty schoolteacher in rural Mississippi. He and she had even talked of marriage.

"Then, one hot day after school," Bilbo told me, "I put my arms around that girl and, when I held her close, I noticed something I had never noticed before: I knew from her body odor that she had nigger blood. I didn't say a word. I ran out of that schoolhouse and never looked back."

After six months or so, I was transferred out of Bilbo territory. Assigned to the delegations from Arkansas and Tennessee, I made friends with Brooks Hays, the fervently liberal representative from Little Rock and, upon occasion, exchanged a few polite words with solemn Wilbur D. Mills, who years later, by consorting with strippers and cavorting in fountains, was to demonstrate a side of his nature never revealed to me. Once or twice, I even questioned, on some topic of purely Arkansas interest, Hattie Caraway's aloof successor, Bill Fulbright.

In the delegation from Tennessee, I was particularly taken by three liberal House members: the gaunt bachelor and former schoolteacher Percy Priest; the handsome Albert Gore (father of the future vice president); and the soon-to-be presidential hopeful Estes Kefauver, later revealed to have been a notorious skirt chaser.

I spent hours leaning over the rail of the Senate press gallery. Without a moment's notice, almost anything could happen: that Republican icon, Ohio's Robert Taft, might embark on one of his dull but momentous speeches, or Michigan's Arthur H. Vandenberg become so impassioned in debate that a long lock of his white hair, virtually glued across his bald scalp, would come loose and flap, embarrassingly, on one shoulder, or Kentucky's Alben Barkley

might suddenly rise, as he did in 1944, to denounce a Roosevelt veto and dramatically offer to resign as Democratic leader.

On the House side, I tried to sit beside Arbogast between poker hands. He would whisper the names of colorful players such as the cherubic Adolph Sabath of Illinois; those contentious New Yorkers Emanuel ("Manny") Celler and Vito Marcantonio, the American Labor Party's sole representative; the tiny commissioner from the Philippines, Carlos P. Romulo; the only two black members of the House, Chicago's dignified William L. Dawson and New York's dapper Adam Clayton Powell, Jr.; the tall jug-eared Lyndon B. Johnson, protégé of his powerful fellow Texan, Speaker Sam Rayburn.

I loved working on the Hill, so much so that it never occurred to me to protest when I learned from a male colleague that the AP paid me approximately one-half what it paid men who performed the same duties.

I saw President Franklin Roosevelt twice. In 1941, before Pearl Harbor, a veteran correspondent invited me to one of FDR's clubby, unstructured press conferences. I needed no security clearance; my friend simply informed the White House press office that he would be bringing a reporter from Alabama.

About twenty men, May Craig of Maine, the only woman regularly assigned to the White House, and I stood around the president's desk in the Oval Office. I have no recollection of questions asked or subjects discussed. But I vividly remember FDR, joking, gesturing with his long, ivory cigarette holder, airily dismissing questions he called "iffy," charming even jaded veterans of the White House press corps.

I don't recall being awestruck at finding myself five feet away from the man who had been president as far back as I could remember. FDR had talked to me so many times over the radio, smiled out at me from so many newsreels, forged such a personal bond with me. I simply felt as if I were in the presence of a very old friend. (FDR was 59.)

Three years later, I watched from the gallery of the House of Representatives as Roosevelt reported to Congress on his historic conference with Stalin and Churchill at Yalta, where Allied leaders agreed on dividing postwar Europe and forming an organization to be known as the United Nations.

FDR looked exhausted. On the only occasion since he had as-sumed the presidency, he spoke to Congress from a chair in the well of the House. I was shocked at the weakness of his once magnificent voice.

But like most who came of age in the Great Depression, I regarded Franklin Roosevelt as our permanent president. It never crossed my mind that I might be observing his last hurrah.

Like virtually every American alive that day, I remember the moment I heard of FDR's death. For some reason, I was still around the AP's dilapidated office on Pennsylvania Avenue in the late afternoon of Thursday, April 12, 1945. Most reporters on the "day side" had left for the nearest bar, poker game, sexual rendezvous, or, in a few cases, home.

Suddenly the man assigned to routine watch at the White House, even though the president was in Warm Springs, Georgia, telephoned to relay Press Secretary Stephen Early's shattering news.

With barely a gasp, the desk editors sent out that rarest of all alarms, a "flash" that would set ten bells ringing on teletype machines all over the world: "FDR Dead"

Then, galvanizing the remnants of their staff, the editors yelled: "Get reaction!"

Within a minute, phones jangled in the offices and living rooms of senators, representatives, cabinet members, Supreme Court justices, and other public figures. We were brutally direct: "This is the Associated Press. President Roosevelt is dead. We're calling to ask for comment."

Practically none of those to whom I gave this startling message had heard the news: a few broke into tears; others (among them, Justice Hugo Black) were rendered—for once in a political lifetime —temporarily speechless.

Thus, using the simple device patented by Alexander Graham Bell in 1876, I helped inform official Washington that the era of Franklin Roosevelt had ended.

On the following Saturday, as Roosevelt's funeral cortege moved slowly out of Union Station, I stood beside the Senate Office Building, assigned to produce what was called a "color story."

No time to type, rewrite, or change a word. Just get to a phone

booth and dictate what came to mind as fast as possible. Almost as soon as they came out of my mouth, my words went over the "A" wire to every AP affiliate. That brief, instant story appeared in newspapers all over the country, reaching more readers than any article over which I was to agonize for months, any book over which I was to labor for years.

Washington, April 14—(AP)—"Here he comes."

They said it quietly, many of them tearfully, a whisper from one to the next all along the lines.

They were the people waiting in a still, hazy Washington morning to tell Franklin Roosevelt goodbye. They stood shoulder to shoulder, four deep and more in places—white and negro, Italian and oriental, congressman and day laborer. The official estimate was that they numbered 300,000 to 400,000.

Only a few months ago, many of them had lined the same sidewalks to watch a man in a heavy navy cape ride bareheaded through the drizzling rain waving his hat and smiling, back to the White House to start his fourth term as United States president.

Two old men, immaculate in black suits, stood near Union Station.

"Well, here he comes," said one slowly. "The president's casket."

"I saw them bring Harding back," said the other. "Seems a long time ago."

Along the tree-shaded street toward the Capitol, the people were quiet. They had brought their children, in carriages, in their arms and seated along the curb.

Only whispers, the solemn muffled beat of approaching drums, a baby's sudden wail, broke the stillness.

"Now here come the horses," a mother explained. "The president's in there under the flag."

As the caisson lumbered into view, a woman began to weep. The crying spread to other women behind the hemp rope. The people had brought their cameras and the approach of the flag-flanked casket was the signal to focus them.

Men removed their hats and placed them on their breasts. Soldiers moved quickly to salute. Civilians seeing them made their own uncertain salutes.

Associated Press, April 14, 1945. Reprinted by permission.

All along the way they were telling the story over again.

"Yes, it sure was quick. A good way to go."

The horses passed and the long, black car came next. The people knew its riders.

"There's Mrs. Roosevelt. And Anna. And Elliott."

They knew the next people, too. "There's Truman. There's [Henry] Wallace."

A child piped up as a car passed with a dog hanging from its window: "Is that Fala?" "No," said his mother, "Fala's a Scottie."

The undertone of drums faded. The people began to walk away, slowly looking back down the long view of Constitution Avenue, watching the procession move toward the monuments of Washington and Lincoln and Jefferson.

Perhaps because they liked my story on Roosevelt's funeral procession, AP editors began, cautiously, to give me wider range. Not to the extent of dispatching me to a major principality like State or Treasury but at least to obscure nooks and crannies of Washington's vast bureaucracy such as, for example, the Federal Communications Commission.

After observing the antics of congressmen and senators, I mentally pegged the dignified, gray-haired, white, male FCC commissioners, presiding in a big, dimly lit hearing room, as seven virtually identical dwarfs. At best, after numbing hours, I would emerge from a hearing with a one-paragraph story about a successful licensee.

Gradually, however, I began to realize that one "dwarf" stood out. Perhaps I first noticed Clifford J. Durr because he spoke in the familiar cadences of a Montgomery aristocrat. Then I perceived that Commissioner Durr sought to represent the interests of that widest possible audience: the American people.

After I caught onto Durr's mission, I began to enjoy my hours in that hearing room. Although I had not realized it at first, something was going on at the FCC: a struggle between special interests and one man who would come to be known as the "peoples' FCC commissioner."

I could always count on Durr to lean over that big dais and insist, in his quiet, mannerly way, that, to receive or renew its li-

cense, a radio station must prove that it offered quality programs, broad coverage, public service time, and, above all, that it stood for freedom of speech.

Durr also persisted in trying to convince his fellow commissioners that 15% of the new FM frequencies be reserved for educational programs broadcast by colleges and universities. Eventually Clifford Durr's mission—to use the nation's airwaves to help educate its people—would evolve into what is known and widely appreciated as public radio and public television.

It often fell my lot to be part of the skeleton staff maintained by the AP on Saturdays. Star reporters never drew the Saturday shift; even gray-haired specialists who passed their weekdays at normally uneventful beats such as Agriculture, Interior, or Labor had Saturdays off.

However, on Saturday, May 19, 1945, the AP received word that there was life in at least one government bureau. Having no senior reporters on duty, the desk editor dispatched me to pick up what both of us assumed would be a routine press release. As I left on this errand, I tried to remember what exactly the Interstate Commerce Commission did.

In my college course on "The South Today," I had become vaguely aware of the term "freight rate differentials." I knew, in general, that freight rates on certain types of finished products moving out of the South were higher than rates paid by competitors in the northeast to move these same products.

I even dimly recalled that, during the late 1930s, southern governors, led by Alabama's Bibb Graves, had conducted a veritable crusade for equalization of freight rates. But this arcane topic never aroused my passion as had the plight of the sharecroppers.

Nonetheless, upon encountering the words "freight rates" when I arrived at the ICC, I had sense enough to realize that this was no humdrum press release. I rushed to a telephone and dictated at least the gist of an announcement that was to create headlines in Sunday papers all over the country. Like my color story on Roosevelt's death, this news moved immediately on the "A" wire.

To interpret this announcement, the AP summoned its regular ICC reporter on the double. But a tyro of the Saturday shift—and

a southerner to boot—had provided clients of the mighty AP with their first awareness that the South had won an historic economic victory.

The AP account, as embellished by my senior colleague, read in part as follows.

Washington, May 19—(AP)—The South and the Western states out in the Rocky Mountains today won their long fight for parity with the East in basic freight rates.

The Interstate Commerce Commission ordered, in effect, that as soon as schedules can be prepared, an article moving by railroad freight shall take the same rate classification regardless of where it starts and stops.

In this way, spokesmen for the South and West contended, their sections of the country would be in a better position to compete with the East in the establishment and development of industry.

At war's end, male correspondents began to trickle back from battlefronts in Europe and the Pacific, confident that the status quo ante bellum would be quickly restored.

*After all, it was only fitting that the House, Senate, Supreme Court, major government posts like State and War, and the White House—all run by men—be covered, as always, by male reporters. Some married women, such as my friend on the United Press, Ann, whose husband was a rising young radio newscaster named David Brinkley, and Liz Carpenter who, with her husband, Les, covered Texans in Washington, stayed on, as did Helen Thomas, who worked for the obscure Washington City News Office.**

The vast majority of "government girls" and many female reporters acquiesced with scarcely a murmur. To fulfill their anointed destinies as wives and mothers—or, failing that, to teach, type, nurse, or check library books in or out—young women who had

Associated Press, April 14, 1945. Reprinted by permission.

*The marriage of Ann and David Brinkley ended in divorce; Liz Carpenter became nationally known as press secretary to First Lady Lady Bird Johnson; Helen Thomas, who joined International News Service, covered eight presidents, becoming by the 1990s the dean of the White House press corps.

handled, even excelled in, jobs once held by men meekly boarded the train and headed home.

The AP made it plain that I need no longer worry about compli-cated subjects like freight rates. Although promoted from the re-gional to the national staff, I would be confined to matters only a woman could understand, for example, what outfits Bess and Margaret Truman planned to wear at Easter.

Women assigned to the White House "distaff side" received an occasional summons to come to the Blue Room, sit in a demure circle, sip tea, and receive from a press secretary (Bess and Mar-garet never appearing) whatever information she deigned to reveal as to the doings of the intensely private First Lady and her shy daughter.

Most of the time Bess and Margaret generated barely enough news to justify a paragraph on the "A" wire. However, on her first anniversary in the White House, Bess, engaging in what was for her a veritable whirlwind of activity, gave me a rare opportunity to write more than a paragraph.

Washington, April 12—(AP)—It looks like 60 fellow Spanish stu-dents will be treated to the first White House sample of Mrs. Bess Truman's famed home cooking.

But they won't get Missouri dishes. When the Spanish pupils sit down to lunch at the White House a week from tomorrow, the menu will feature what their teacher, Ramon Ramos, calls Pan-American food.

White House social secretaries say the dishes will be fixed by the First Lady herself and six or eight helpers from her own Spanish class. The versatile Prof. Ramos will supervise.

The ladies are to gather in the White House kitchen about 9 a.m. in order to have food ready for 60 of Prof. Ramos' other pupils by lunchtime.

Miss Reathel Odum, White House secretary, doesn't know the menu but—she guesses, with a wrinkle of the nose—"It'll be some-thing full of garlic."

Meantime, the distaff side of the White House was busy today

Associated Press, April 12, 1946. Reprinted by permission.

with other guests: Mrs. Truman's 10 friends of the Independence, Mo., Tuesday Bridge Club.

The energetic ladies, interested in everything but bridge, turned up all over town. They spent yesterday morning ooh'ing at Washington's Spring from the windows of two official limousines. In the afternoon they found time to sit in on President Truman's weekly news conference—but they didn't kibitz.

Their schedule for the visit, which will end sometime this weekend, still includes a ride on the presidential yacht and tea at Blair House.

Mrs. Truman was beginning her second year as First Lady with a bang. Her secretaries told a news conference yesterday that she's dated up almost every day through April, with these events ahead:

1. A tea for about 400 members of the White House clerical staff.
2. A picnic lunch on the White House grounds for the Senate Ladies Luncheon Club, with Mrs. Truman and cabinet wives as hostesses.
3. A White House garden party for about 600 wounded veterans who are convalescing in Washington area hospitals.
4. A family reunion here of Trumans and Wallaces, sometime in May.

Young women who came of age during the Second World War, college graduates in particular, sensed that life might offer them options broader than those that had been open to their mothers. But it came as a real surprise, to me at least, that a famous woman who had combined career and marriage should argue strongly against the very path she herself had pursued.

Washington, March 21—(AP)—Marriage? Career?

When you come to this perplexing cross-roads, young woman, take it from Rep. Clare Boothe Luce: "Get married."

These oldtime words of wisdom make a somewhat startling comeback.

Associated Press, March 21, 1946. Reprinted by permission.

1. They came from one who is congresswoman and author as well as wife and:

2. They were heard by a conference of 500 earnest young co-eds, primed to invade every new-fangled career in the books.

The lady Republican told the girls they face untold opportunities in every career. But in marriage the chances are "slowly surely closing."

And why Mrs. Luce? She diagrams it this way:

Papa, who pays, can no longer afford to keep up his unmarried daughter until her knight comes riding, so:

Daughter goes to work, drawing down a sizable pay check and competing with young men. More workers, figures Mrs. Luce, make for lower salaries, so:

The young man can't afford to marry early. He hesitates to ask the young woman to give up her pay check and independence.

Mrs. Luce, who's planning to give up Congress herself, is just getting warmed up to this unhappy state of affairs. She can think of countless angles. For instance:

Our young career woman is more particular about her husband-to-be. He must outshine her career. He may have to be five to 10 years older to interest her.

"And," says Mrs. Luce, "the older men are already married. She won't take one her own age. There she is."

Mrs. Luce foresees less (1) marriages; (2) children; (3) productivity; (4) prosperity. But—if it's any consolation—more and more careers for women.

What now little girl?

"I've given you the facts," says Mrs. Luce, scurrying off to matters marital and congressional, "now do something about it."

Despite her worldly success, I had never admired the frosty, ambitious, carefully coiffed Luce. It must have been pure coincidence therefore that, six months after reporting her speech, I quit a promising career on the Associated Press and married for love, fully expecting to devote all my energies to the sole destiny projected for me by my parents, peers, and society in general.

Before I left Washington, members of the Eightieth Congress— some just released from war service—took their seats in January

1947. I have no recollection of the freshman representative from California, Richard M. Nixon, but I do recall being disappointed that this virtual unknown had displaced one of my favorites, the dark, brooding, and idealistic Jerry M. Voorhis.

However, I clearly remember a thin, charismatic new member from Boston who, in his infrequent visits to the House chamber, always gazed up to check out female reporters in the Press Gallery. Even I, a married woman, could not help gazing back at this handsome young man; many other Capitol Hill women, I have since learned, responded much more intimately to John F. Kennedy's arched eyebrows and teasing glances.

Over in the Senate, Robert M. La Follette, Jr., had been defeated by a dour, heavy-jowled newcomer who—for a reason I have forgotten but related, I am certain, to a news story—took me to lunch one day in a dim basement restaurant on Capitol Hill. That was all there was to it: one lunch. How was I to know that the man with whom I was breaking bread—Joseph R. McCarthy—would emerge from obscurity two years later to head a national witchhunt for supposed Communists infiltrating the federal government?

Year of Transition: 1948

Upon my return from Washington, I found Alabama, having been industrialized and militarized by war, teetering on the brink of further sweeping change—economic, political, and social.

War had drastically altered the state's work force: more women, more blacks, more rural folk leaving the land for jobs in cities and towns.

The issue of civil rights, smoldering since the Constitution of 1901, was about to burst into flame.

Leaders of its economic elite were flirting with a heretofore taboo: open Republicanism.

Alabama, however, remained the most liberal state in the South. At a time when other southern states elected senators with strong Republican leanings, like Harry Byrd and Carter Glass of Virginia, Ellison D. ("Cotton Ed") Smith of South Carolina, and W. Lee ("Pass the biscuits, Pappy") O'Daniel of Texas, or an outspoken racist reactionary like Clyde Hoey of North Carolina, Alabama voters, in the vigorously contested statewide elections of 1944 and 1946, had returned Lister Hill to the Senate, to be joined by another ardent New Dealer, John Sparkman.

(By 1952, political scientists, rating members of the U.S. Senate on legislative ability, integrity, and issues, would rank the team of Hill and Sparkman fourth in the nation in senatorial caliber, outshone only by the two senators from Massachusetts, New York, and Connecticut.)

In 1946, voters in Alabama's northern tier dispatched four outspoken progressives to the U.S. House of Representatives: Bob Jones, Carl Elliott, Kenneth Roberts, and Albert Rains. The state also elected a charismatic new governor whose unexpected victory startled traditional political foes of the right and the left.

James E. ("Big Jim") Folsom, a political tyro, had promised to support expanded programs for teacher pay, old-age pensions, health facilities, and paved roads—thus clearly hinting at heavier taxes on corporate and landed wealth.

When Folsom, a tall (6' 8"), dark, and handsome widower, burst upon the Alabama and national political stage in 1946, his followers merely winked at his widely publicized weaknesses for strong drink and pretty women. But in March 1948, the 39-year-old governor's personal life became a serious issue when a woman charged, in a paternity suit, that he had fathered what was then spoken of as an "illegitimate" child.

Without denying this charge, Folsom tried to ignore the paternity suit. But this scandal threatened to erode his tremendous popularity with the majority of Alabama voters.

Two months later, whether by coincidence or political calculation, Folsom married a young woman who had caught his eye when he had campaigned for governor. His remarriage in May 1948 made the paternity suit less of an issue and put a stop to the public antics of "Kissin' Jim."

Having returned to my pre-war job on the Birmingham News, *I went to Montgomery to interview Jamelle Folsom. I continued to use my maiden name professionally, a practice virtually unheard-of in Alabama in the late 1940s, but I lapsed into popular parlance by referring to Jamelle Folsom as a "girl." At least—having been schooled in polite, mid-century journalism—I did not fix Alabama's 21-year-old First Lady with a cold stare and ask:*

"Tell me how you feel about the paternity suit."

GOV. FOLSOM'S WIFE MAKES HERSELF AT HOME AND LENDS HOMEY TOUCH TO MANSION

Montgomery, Ala., May 22—A pretty, 21-year-old girl lives quietly behind the closed blinds of the square, stone mansion which is Number 702 among the aristocratic homes of South Perry Street.

She has been First Lady of Alabama for 17 strange, exciting days, but the quick flurry which her marriage stirred up has begun to settle.

Wedding presents still drift in to add to the simple, gold-rimmed

Birmingham News, May 23, 1948. Reprinted by permission.

china, chosen because the governor doesn't like flowered plates, and the silverware with carved roses, which the bride has always wanted.

In Jamelle Moore Folsom, Alabama has its first governor's wife in six years.

Yet it is obvious that Number 702 is expecting no formal calls from the neighbors of South Perry Street.

The social world of old Montgomery, in return, does not look for engraved invitations to tea or formal dinner at the governor's mansion.

The big door opens easily, however, to troops of grade school sightseers, to Jim Folsom's political friends and to an interviewer from Birmingham.

Inside is a small, very young girl, with startling brown eyes and a friendly eagerness to please.

Life has moved swiftly for Jamelle since that Saturday afternoon two years ago when Jim Folsom spotted a girl in a white dress among the crowd listening to his speech on the sidewalk of the little Alabama town of Berry.

Today the First Lady is wearing a flowered voile for the hot Montgomery morning and a gardenia from the yard in her dark hair.

She looks like Cecil B. DeMille's idea of a young southern belle, and her accent is that soft blur of words which actresses attempt and always fail to achieve.

Jamelle has been up since 6:30, she says. She had to waken her stepdaughters, 9-year-old Rachel and 5-year-old Melissa, to start the long process of getting ready for school.

The mansion is astir. Mrs. Grace Jones, social secretary, is opening envelopes full of news stories and pictures entitled "Big Jim Weds Little Jamelle."

In the big, old-fashioned kitchen, the Negro dietitian is washing turnip greens. Other maids are busy with ironing boards and a stack of clothes.

Down the long, curving stairs of the hall, a Negro man carries a load of winter coats to storage.

Jamelle is excited because the mansion is to be redecorated and she is to choose the color scheme. Six years of the masculine touch have left smudged baseboards, soiled chairs and sofas and weary lampshades in the high-ceilinged rooms.

Upstairs, one bedroom holds the early wedding presents, most of their cards bearing the names of Folsom's friends in state government and the legislature.

The back bedroom, which stretches across the length of the house, dwarfs the long bed tailored to the governor's six feet, eight inches.

"These are what the school children always like to see," Jamelle gingerly pulls a huge, fuzzy pair of men's slippers from under the bed.

There is an appealing earnestness about Jamelle's plans for coping with a sudden role of wife, mother and First Lady at 21.

She has discouraged parties in favor of family life in the mansion. She says the governor likes to hear her play the piano for Rachel and Melissa in the evenings.

The four Folsoms are together at breakfast and supper and the governor drives over from the capitol for midday dinner.

"The morning's gone and he's back before I get anything done," Jamelle finds helplessly.

Since Mrs. Ruby Ellis, the governor's sister, returned to her home in Cullman, Jamelle is consulted on meals, wonders what colors would look well in the dining room, answers her mail and plays with her new daughters.

She is touched that Rachel and Melissa decided, on their own, to call her "mother"—"because I'm young enough for them to call me Jamelle if they had wanted to, you know."

Jamelle's talk is sprinkled with "the governor likes this" and "the governor wants that," but in the family circle she calls him Jim or Elisha, his middle name.

"Elisha in the Bible was a tall man, too, and I guess that's what makes me call him that."

His wife says she and Jim like to swim, play tennis and particularly to pitch horseshoes. The ring of iron shoes may some day be heard in the mansion's backyard.

"And I can beat him, too," Jamelle boasts. "I'm just a country gal and I've pitched horseshoes all my life."

Mr. and Mrs. E. M. Moore's daughter, Jamelle, was the prettiest girl in the whole 750 population of Berry, where her father owned a general merchandise store.

When he went into war work and moved Jamelle and her mother to Birmingham, even city girls didn't give Berry's prettiest much competition.

At Ensley High School, where she went three years, the band, the ROTC and the Ushers Club all thought Jamelle would make the best-looking sponsor in school.

Before her senior year, though, Mr. Moore bought back his store and the family returned to Berry, where Jamelle got her diploma and a trip to New York as a graduation present.

She thought of going to see John Powers about a model's job— "some folks tried to put it into my head that I could model"—but never got up courage.

"It's good I never did," she thinks now. A month or two after she came home, she met Jim Folsom.

Jamelle is a strange combination of poise and childlike frankness. She talks with the natural simplicity of a little town girl and this is how she tells the story:

"I remember that Saturday real well. I had washed my hair that morning, but mother said, 'You better come down to the bank and hear Jim Folsom talk.'

"I said 'Oh, mother, I'd be bored to death to hear about politics,' but after she and daddy had gone I thought maybe I might miss something.

"I took down my hair, and I remember I wore a plain white dress.

"He really did sort of stutter and stop when he looked over at me, and afterwards he asked me to have a coke.

"I didn't much like cokes, but I really did enjoy that one! Then he asked me to go over to the next town—about 18 miles—and hear him speak that evening.

"I said I'd have to ask my father, so he walked over to the house with me. Mother said she didn't know whether I should go or not, but Daddy said, 'Let her go, if she wants. It won't hurt anything.'

"So I went and afterwards we went to some friends' house for a gathering and then he took me home.

"After that, he would call me up from Birmingham or Mobile or wherever he was speaking and I'd talk to him over the old crank phone on the wall of our living room.

"I knew then that he'd be our next governor. I guess it was sort of woman's intuition."

It must have been intuition, for Jamelle is no student of politics. She plans to stay home and redecorate if the governor goes to the Democratic Convention this summer.

Six months at a Birmingham business college in early 1947 trained Jamelle in shorthand and typing. In June, the Moores sold their store and house and moved to Montgomery.

Jamelle was to be a clerk in the state senate, and her father went to work for the revenue department.

In October of last year, Jamelle began to turn down dates with everyone except the governor, at whose side she became a familiar sight in Montgomery.

Jamelle thinks she can already tell a difference in the feeling of family atmosphere at the mansion.

Her idea is as simple as this: "I want to make it a home for the governor and the girls. That's what the governor wants."

Alabama governors cannot serve two consecutive terms. What do the Folsoms plan to do in 1951?

"I think the governor would like to go back to Cullman," says Jamelle.

They haven't planned a larger family, but Jamelle would like to have children of her own some day.

"I've plenty of time for that though."

This is the story of the girl who is First Lady of Alabama. She is only 21 and this is only the beginning of her story.

Jamelle Folsom was to be Alabama's First Lady from 1948 to 1951 and from 1955 to 1959. Her son, James E. Folsom, Jr., served as governor of Alabama from April 1993 to January 1995.

The Democratic primary of 1948 projected another tall country boy onto the state and national political stage; indeed, Carl Elliott was often mistaken for Jim Folsom.

These two men were alike in other ways: both ardently desired to improve the conditions of life for the plain folk from whom they

had sprung; both ended their careers as political losers; both spent their latter years in virtual poverty.

Folsom, opposed by the politically astute big farmers and "big mules" of business and industry, failed to achieve his major objectives of reapportionment, elimination or reduction of the poll tax, substantial improvement in public education, and increased support for the elderly.

But Elliott, although he lost his congressional seat in 1964 because of his opposition to George Wallace, was to leave a major legacy. With Alabama Senator Lister Hill, he coauthored the National Defense Education Act of 1958, thus pioneering the concept of federal loans to assist Americans in achieving higher education. Hill and Elliott also worked as a team to create the Library Services Act of 1956, which provided federal financial aid for public libraries.

In honor of these achievements and of his stand against George Wallace, Elliott received in 1990 the first John F. Kennedy Profile in Courage Award.

Here is my impression of Elliott on the brink of his political career.

HE TRAVELED AND SPOKE A LOT—
THEY LISTENED AND VOTED A LOT

Jasper, Ala., May 11—The tall fellow with the battered campaign hat wound up his speech and mopped his forehead.

There was a pattering of hand-claps, but applause seemed too formal for a crowd of 15. They stepped up to shake hands with the candidate.

It was Saturday afternoon and he had provided the only diversion around the country store near where Alabama and Mississippi meet.

"Y' know," said a worn farmer, "you're the only political candidate has ever come to this town in my memory."

An onlooker who had wandered up late asked curiously, "Are you Jim Folsom?"

"No," said the candidate, "I'm Carl Elliott. Get it, Carl Elliott."

Birmingham News, May 11, 1948. Reprinted by permission.

For more than three months, Carl Elliott repeated scenes like this 85 times. Some Saturdays he made 10 speeches.

On election day, voters of the Seventh Alabama District chose him Democratic nominee to represent them in Congress by a majority of 8,000 out of about 25,000 votes.

The story of Carl Elliott is another chapter in the favorite legend of American politics. Elliott himself put it pointedly in his campaign slogan, "From Farm Boy to Congress."

Alabamians are familiar with the legend in the backgrounds of Hugo Black, John Sparkman, John Steelman and Jim Folsom.

Thirty-four years ago, Carl Elliott was born in Franklin County—the first of nine children of Mr. and Mrs. G. W. Elliott, who worked a tenant farm about 10 miles from Red Bay.

His family had been tenant farmers in Franklin for more than a century. But in their first son, Carl, was born the mysterious urge to break the mold, to learn and to lead other men.

As a farm boy, he had stood by the country store on Saturday afternoons, spellbound by the political orators. He remembers Tom Heflin and the Bankheads, Will and John.

At Vina High School, Carl, already heading toward his future six-foot, four-inch height, was school janitor.

When he was 16, he was ready to make the trip to Tuscaloosa where the state university would educate a boy in return for lawn-mowing, cooking, table waiting, furnace fixing, and a spell of house painting.

University students elected Carl Elliott, then 19, as president of the student body, as past students had elected another farm boy, John Sparkman, to head them 15 years before.

With a crisp new law degree, Carl, at 22, went to Russellville to set himself up in practice. A year later, he decided Jasper fields looked more promising.

Big, friendly and energetic, Carl got along in Jasper. In 1940, he married pretty, brown-haired Jane Hamilton.

He started to join up—the Masons, Lions, Eastern Star, P.T.A., Walker County Bar Association. He was already a Methodist.

The infantry latched onto Carl during the war and he served 28 months. When he came back, he joined the American Legion.

113

At times, law practice got so absorbing he almost forgot the ambitions of a farm boy around the country store.

His first political try—for judge of the Walker County Court—went down in defeat.

Early this year, Carl decided to go out for the House seat held for the past seven years by Rep. Carter Manasco and before then by Speaker Will Bankhead.

By this time, Carl had the asset of a family—Carl, Jr., 7; Martha, 3; and John, 11 months.

He began moving his long, 195-pound frame around the mud roads of the county. He promised to work for hard-surface roads and $50-a-month old age pensions.

He told cotton and corn farmers and coal miners that Carl Elliott stood for better education, lower taxes, benefits, outlawing Communists and preparedness "as the key to peace."

If a farmer seemed interested, Carl told him: "You're one of my campaign managers. Just see what you can do for me around here."

He called himself a "middle-of-the-roader" and promised to "represent labor and management equally."

He said he was against shipping anything to Russia and for more industry in the Seventh District.

His rambling, old-fashioned house on Birmingham Avenue was campaign headquarters and all his workers were volunteers.

Money came in small dribbles. At one meeting of 100 people, the hat came back with 100 contributions of a dollar each.

The formula of paved roads and pensions, handshakes, speeches and more speeches worked for Carl, as it had for Jim Folsom.

The governor's blessing, however, was claimed by J. H. Kelly, a Haleyville lumberman, who ran a poor third.

On the Monday before election Tuesday, Carl took a 400-mile swing through each of the seven counties in the district.

At every crossroads, he stopped to shake a hand, say a few words, wave his hat.

The next day he was a congressman-to-be.

In 1948, left-wing Democrats, reviving the name of the Progressive Party, nominated Henry Wallace for president and Glen H. Taylor of Idaho, a first-term United States senator, for vice presi-

dent. *Only a rash political figure with little to lose would have signed on as a partner in Henry Wallace's quixotic campaign.*

By openly defying a Birmingham segregation ordinance, Senator Taylor sought national attention. His motive notwithstanding, Taylor displayed considerable courage by challenging Eugene ("Bull") Connor on that volatile police commissioner's home turf.

On the night of May 1, 1948, the Idaho senator insisted upon trying to enter the Alliance Gospel Tabernacle through a door marked "Negro." Two Birmingham police officers hustled Taylor into a police car, charged him with disorderly conduct, and took the senator to Southside Jail.

Taylor was released on bail, but his arrest generated headlines across the nation. Four days later, along with eleven routine cases of drunkenness, disorderly conduct, and carrying concealed weapons, the Taylor case came to trial in Birmingham's police court. Judge Oliver Hall found Taylor guilty, fined him $50 and $3 in court costs, and gave him a suspended jail sentence of 180 days. Attorneys for the senator promptly appealed, citing the 14th amendment's guarantee of equal privilege.

I wrote the front page news story on the Taylor trial; however, my accompanying "color story" gave a better feel for the atmosphere in that dingy, hot, and crowded courtroom. With the civil rights movement yet to be born, Judge Hall appeared eager to find moments of comic relief in this early challenge to Birmingham's seemingly immutable segregation code.

JUDGE ON TICKLISH SPOT
BUT SENATOR COULDN'T PULL RANK

Judge Oliver Hall confided to his crowded courtroom last night that he found trying a United States senator a ticklish job.

"I occupy the lowest position of judicial existence in Alabama. There is none lower," declared the frank judge. "And I have before me a United States senator—a member of the highest legislative body of the country."

When he advised Sen. Taylor that guitar-playing might have more effect on Alabamians, laughter swept through the courtroom for the first time in a tense evening.

Birmingham News, May 5, 1948. Reprinted by permission.

"I won't censure you for laughing," the judge told his audience. "If we can keep our senses of humor, we can avoid a lot of trouble."

Speaking of his respect for a United States senator, the judge referred to Taylor as senator from "the great state of Utah."

He was quickly corrected around the witness stand; Taylor is from Idaho.

The senator, known as one of the upper chamber's snappiest dressers, faced trial in a pinstripe, tan suit, white shirt, matching brown and white suspenders, tie and handkerchief—and a large blue button reading "Wallace, '48."

Crowds began to gather outside the dingy night court almost two hours before the trial was set to begin.

Earlycomers were ushered into the courtroom at 6:45 p.m., and waited until about 8:30 before the Taylor case came up.

When the courtroom filled, police were stationed at city hall steps to stop a crowd of more than 100 curious onlookers.

Photographers, banned from the courtroom by orders of Police Commissioner Eugene Connor, lined the steps to flash the senator as he appeared for trial.

Inside the courtroom, a wide aisle separated Negro and white spectators. The orderly crowd was about evenly divided between the two races.

At times during the trial, the courtroom was so silent that only the voice of an attorney and the whir of two electric fans were heard.

A sprinkling of well-dressed citizens, most of them leading lawyers and their wives, had front-row seats for the hearing. They stood out prominently in the drably dressed crowd.

One of the cases which went on before the senator was that of another Taylor, charged with disorderly conduct.

He was sentenced, although his wife told Judge Hall in a barely audible voice, "All is forgiven as far as I am concerned."

Throughout the senator's trial, the wife watched her husband as he peered through the bars of a cell which adjoins the courtroom. She was so absorbed in her personal tragedy that she seemed almost unaware that a senator, too, was being tried.

Judge Hall and reporters got a chuckle from the answer of a portly Negro woman, charged with conducting a lottery. Asked if she had any request to put to the court, she replied:

"I just wants the lowest fine."

Police Commissioner Eugene Connor appeared in the city hall before the case went to trial but did not come into the courtroom.

"It's just a disorderly conduct case, that's all," he commented to newsmen.

The Taylor case came to an abrupt halt at one point when fluorescent lights above the judge's desk went out.

When another recess was called, for no apparent reason, a reporter asked Judge Hall why he called the rest period.

"Just to relax my nerves," the judge replied.

In April 1949, Circuit Court Judge George Lewis Bailes upheld the police court verdict. The U.S. Supreme Court declined to review the case. Connor continued to clamor for Taylor's return to Alabama to serve his jail term, but Governor Folsom refused to request extradition.

In the fall of 1948, Taylor, having renounced the Progressive Party, was defeated for renomination to the Senate as a Democrat. He vanished from public life, his defiance of Birmingham's segregation laws virtually forgotten.

The States' Rights Party (promptly nicknamed "Dixiecrats") was called into convention July 17, 1948, in Birmingham's Municipal Auditorium as if someone had uttered the magic incantation "Abracadabra!"

Someone had.

It was no accident that Birmingham—home of the redneck racist "Bull" Connor and the aristocratic New Deal foe Frank Dixon—was the setting from which to launch this scheme to hold the presidential election hostage by capturing 127 electoral votes from the "Solid South," stalemating the electoral college, and deciding the outcome on the bargaining table of the House of Representatives.

In Birmingham, the wizards behind the so-called states' rights movement had all the ingredients necessary to bring this political stew to an instant boiling point: a climate of high emotion in the aftermath of the Democratic convention that had nominated Harry Truman, a hospitable city government, a readily available big hall,

*and a crowd happy—on that steamy and otherwise boring Satur-
day—to play the role of delegates.*

*My front-page color story captured the antic, almost hysterical
quality of this gathering. How could anyone take these people seri-
ously? I had no inkling that I was witnessing the birth pangs of
southern presidential Republicanism.*

ORATORS HAVE OWN WAY

AS REVIVAL-LIKE FEVER GRIPS GREAT THRONG:

STING OF PHILADELPHIA SOOTHED;

EVERY LINE, EVERY ACT CHEERED.

All the pent-up fever of a giant, boisterous revival meeting was
loosed in Municipal Auditorium yesterday.

The crowd filled the 6,000-seat hall to its top rafters, jammed the
aisles and swung their legs over the balcony rails.

Outdoors loudspeakers carried the speeches, horns, and rebel
yells to a few hundred in shirt sleeves who munched popsicles as
they listened.

It was a responsive, excited, sometimes hysterical crowd—and
the convention orators made the most of it.

The magic names were Robert E. Lee and Jefferson Davis. They
never failed to bring swelling roars from the audience.

The rat-tat-tat of "Dixie," played by a swing band, raised the
people screaming to their feet.

The phrasemakers talked over and over about "the dagger in the
back of the South." Recognizing its cue, the crowd yelled back with
one vast voice.

The swaying state standards, Confederate banners, gyrating
paraders, all bathed in the unreal lights of newsreel cameras, made
a fantastic scene.

Everybody was a delegate. Anybody who felt the spirit move him
paraded.

It was a crowd to soothe the ruffled feelings of the men who had
been booed and laughed at in Philadelphia. With a single exception,
it violently approved every word the orators said.

The audience came closest to mob hysteria when a lone man
spoke up in some sort of protest, nobody knew quite what.

Birmingham News, July 18, 1948. Reprinted by permission.

"Throw that Communist out," the people screamed. A crowd quickly collected around the objector, who turned out to be Brig. Gen. Herbert C. Holdridge, of Washington, D.C., a retired army officer and self-styled candidate for president.

Surrounded by yelling, angry men, Holdridge gratefully accepted police escort to an auditorium office where he was almost instantly forgotten in the excitement.

The people, their radio memories of Philadelphia still vivid, seemed eager to take part in a convention of their own.

Radio broadcasts in the morning brought the curious, the sympathizers, the excitable streaming into the afternoon meeting.

They craned forward with feverish interest to see for the first time the two men they had just screamed into nomination for the presidency and vice-presidency.

If Gov. Strom Thurmond and Gov. Fielding Wright looked a little less than enthusiastic, it did not dim the crowd's ardor.

Tutored by newsreels and pictures from Philadelphia, men and women grabbed state standards at the strategic moments and snake-danced through the aisles and across the stage.

A 77-year-old woman, who said everybody knew her as the "Wool Hat Woman of Georgia" but her real name was Mrs. Beulah Waller, jigged on the stage and the crowd yelled "Wool Hat Woman!"

The Kentucky standard in the Thurmond parade was carried by a woman from Paducah who has lived in Birmingham the past two years.

The "Others" sign was in the hands of a Birmingham college boy.

An Alabamian held the "North Carolina" standard aloft. "Somebody's got to carry it," he yelled.

The 55 boys from "Ole Miss" University were the convention's noisiest demonstrators. "To hell with Truman, to hell with Truman," they chanted.

A young boy from Charlottesville waved the "Virginia" standard. He said he was self-appointed.

Texas' banner was in the hands of a woman who said her father had been a Philadelphia delegate and she had come to meet him.

The "delegates" cooperated with vehemence. Resolutions were read from the stage. Chairman Walter Sellers moved that they be adopted.

"Is there any discussion?" he asked. There never was.

"All in favor?" asked the chairman. The crowd roared.

"All opposed?" Nobody. The resolution passed.

The people laughed a bit self-consciously—but it was fun to pass resolutions.

Arnold Toynbee, world-renowned historian who was a Rushton lecturer at Birmingham-Southern College recently, came in for his share of opprobrium from one convention speaker.

Lloyd E. Price, a former Florida state senator, told the crowd he didn't like Toynbee's designation of the South as a backward section.

"There isn't a student in a Negro college in the South who doesn't know more about history than Toynbee," Price told the amused crowd, "He is the favorite of the lee-be-ral, leftist, in-te-lec-tual people of this country."

College students, young, tireless and leather-lunged, were the noise-makers of the convention.

Chairman Sellers said delegations were there from the University of Alabama, Auburn, Birmingham-Southern, Howard and "Ole Miss."

A reporter, spot-checking the crowd before the afternoon session opened, asked several balcony sitters what had brought them to the meeting and got these answers:

"I'm a southerner. We've got to do something to save ourselves."

"I listened to that thing from Philadelphia and I didn't like the way they treated our senators."

"I was fixing my car and heard it on the radio so I came on down."

"I'm so interested I haven't left this seat since 9 o'clock this morning."

The name of Harry Truman drew the convention's loudest boos. When Gov. Jim Folsom of Alabama stepped on the stage, the audience divided between cheers and boos.

In the noise and excitement, the southern Democrats entirely forgot one name which once had been a byword—Franklin Delano Roosevelt was never mentioned.

Henry A. Wallace, standard bearer of the Progressive Party, made a brief tour of northern Alabama in September 1948. I went to Decatur to meet Wallace's train, travel with his motorcade, and

assess his reception by the overwhelmingly white farm people of northern Alabama, long known for their undisguised racism.

The onetime farmer from Iowa had no concept of how to get his populist message across to plain white folk of the South. It would be left to another man named Wallace to demonstrate mastery of this political sorcery.

My story appeared on the front page of the Birmingham Age-Herald, *a morning newspaper under the same ownership as the* News.

WALLACE RUNS GAMUT OF BOOS, JEERS AND PENT-UP VIOLENCE

Henry A. Wallace and a 20-car motorcade ran the gamut of North Alabama crowds yesterday, from early morning boos in Decatur to pent-up violence in Gadsden.

In the cool morning, the Progressive Party's candidate for the presidency met nothing more dangerous than jeers, laughter and the heckling of a few Guntersville high school boys.

But as the hot September sun mounted, an egg splattered against the new automobile in which Wallace rode through Albertville, and a huge, angry crowd waited in Gadsden's Broad Street.

Alabama members of the Progressive Party, escorting Wallace, evidently sensed in advance the ugly mood of the Gadsden crowd.

The Wallace car, its back windows shut tightly, pulled up beside the courthouse and a loudspeaker proclaimed that the former vice president would not speak where there was "police intimidation."

As the auto inched through the crowd, men surged forward to its windows for a glimpse of the shirt-sleeved Wallace in its back seat.

"He's scared," they jeered. "Come on out," they dared him.

Gadsden's main street was not segregated, although originally it had been roped off into white and Negro sections.

But the big crowd spilled over these boundaries and both races stood shoulder to shoulder.

The overhanging balcony of the old courthouse, exposed to the afternoon sun, was filled to the creaking point with men in shirt-sleeves and overalls.

Birmingham Age-Herald, September 2, 1948.

Little knots of policemen and highway patrol officers stood like small safety islands through the crowd.

This was the city from which Mayor Herbert Meighan had sent out word Tuesday that Wallace "was not wanted."

Wallace spent Tuesday night in a Pullman pulled off on a lonely Decatur siding.

At 7:15 a.m., only a handful of reporters and photographers were outside the Pullman, but within an hour the motorcade of 20 or more cars had formed.

Driving the cars were members of the Progressive Party in Alabama, but they were filled mostly with newspaper men. About 20 representatives of press services and big newspapers were with Wallace on the Pullman.

In Decatur, where there is no segregation law for outdoor meetings, Wallace spoke in front of a courthouse which came to fame in the 1930s as the scene of the Scottsboro trials.

In conservative blue suit and tie, he looked fresh and almost portly. The gaunt look of Secretary and Vice President Wallace was gone almost entirely.

He spoke glowingly of the Tennessee Valley Authority and of his belief that the nation should have many more TVAs.

He held out to the crowd a promise of lower living costs, more education, cheap fertilizer and world peace—but the people were not tempted.

"Better watch Henry," one yelled as the cars drove away. "He'll plow up your cotton!"

The Wallace trail led through the rich cotton and corn fields of the Tennessee River Valley to prosperous Huntsville.

Like many an Alabama politician before him, Wallace stood in the street before the courthouse and spoke by loudspeaker.

Out of the crowd of almost 1,000 only a few hundred actually saw him. The candidate made no attempt to put himself on a platform as an egg and tomato target.

Again he spoke of better wages for southern workers and twice as much industry in the South.

The Huntsville crowd was the most orderly of the entire trip. J. P. Mooney, Birmingham Progressive Party leader, thanked them for their "fine behavior," adding, "God bless you—and vote right."

At Guntersville the motorcade clogged traffic on the main street. An organized group of high school age boys baited Wallace.

It was here that Wallace showed most obviously his weakness at appealing to a crowd. Interruptions threw him off his speaking stride.

He halted and stumbled through his speech as the boys yelled, "You're a ham," and threatened, "Want an egg?"

He had no comeback for the biting comments of a man in a painter's cap and no ability to turn the crowd from jeers to sympathy.

Even the once-magic name of Franklin D. Roosevelt and praise of the late Sen. John Bankhead, Sen. Lister Hill and Justice Hugo Black fell on hostile ears.

"They aren't your kind," a member of the crowd yelled.

But the hecklers also were unpopular. An overalled farmer commented on their performance: "I never thought I'd see anything like that in Marshall County."

"Why, those boys can't even vote," said his neighbor.

Wallace, who seemed to shrink at the mention of egg-throwing, again thanked the crowd for sparing him.

"Can it be that the Dixiecrats who egged me through North Carolina don't have the same influence in Alabama?" he asked.

A man answered him from the sidewalk. "Hooray for Thurmond and Wright," he called.

The motorcade passed up Albertville where the first egg scrambled itself against a window of Wallace's car.

A few miles further, the cars stopped in a shaded grove beside the home of a tenant farmer. Fried chicken appeared from baskets in the cars and a banjo player began to strum and sing Wallace-Taylor ballads.

Wallace, once an Iowa farmer, strode into the nearby cornfield to look over the crop. Photographers trailed him hungrily.

The tenant, a huge man in blue overalls, hurried out to tell Wallace the Alabama land produced hybrid corn called Tennessee Ten. He did not seem to know that his visitor had been the developer of hybrid corn.

Wallace shook hands with the farmer and bowed to his wife, daughters and granddaughter.

It was here the Progressive Party made its most solid conquest of the Alabama tour.

"I believe I'll vote for him," the farmer told newsmen later. "Didn't know he was coming, but he seemed real nice."

"That's the first time I ever did see a candidate for president. Maybe he'll get elected some day and then I will have shook the hand of a president."

In the November 1948 presidential election, electors pledged to the States' Rights candidates, Strom Thurmond and Fielding Wright—but listed on the ballot as Democrats—carried Alabama by an overwhelming majority. Henry Wallace received less than 1,500 votes in the entire state.

As, without a moment's hesitation, I had relinquished my career at the Associated Press in favor of marriage, so—four years later— I gave up journalism altogether, moved to the small Alabama town of Montevallo, where my husband held an administrative position at a woman's college, and set in to add to our family.

To contribute to our sustenance, I taught English at Alabama College to young women who spent four years in this sheltered environment preparing to become secretaries or schoolteachers. My only qualification for this job was my bachelor's degree in English. Fortunately for me, the new head of the English Department, holding no advanced degree himself, put little or no stock in the traditional paraphernalia of academe.

Born in Cornwall, educated at the universities of Capetown and Liverpool and at the Sorbonne, fluent in Latin, Greek, Chinese, and Russian as well as French, Italian, and Spanish, Robert Payne had taught naval architecture and English literature at Lienta University in Kunming, China. How he had happened to accept an invitation to join the faculty of this small college deep in the heart of Alabama, I do not know. Perhaps he had no other means of support.

Robert's marital status intrigued our little circle of younger faculty and served as a topic of endless speculation among his students. He maintained the fiction of bachelorhood but—we later learned—was at that time in the process of being divorced from the daughter of a former Chinese prime minister.

My spouse Larry and I became familiar with Robert's daily rit-

ual because we lived in adjoining apartments in an old house. If one of us arose to feed the baby at 2 a.m. and when we left for work at 8 a.m., we could hear Robert pecking away on his portable typewriter on the other side of the thin wall that separated our living quarters.

This unvarying routine resulted in an average of two books a year. In the four years that he was our neighbor, Robert presented us each Christmas with an autographed copy of his newest book— a novel about seventeenth-century India, two books about the Communist revolution in China, a biography of General George C. Marshall, all bearing the imprint of major New York publishers.

After his morning nap, Robert would show up for his afternoon class, wearing the blue suit, red tie, and rumpled white shirt that comprised his entire wardrobe, and proceed to astound his listeners by declaiming on whatever entered his mind.

Payne's disdain for traditional academic procedures shocked and horrified the older women who had made up that faculty for decades. But his haphazard approach to the teaching of English suited me fine. Taking my cue from him, I felt no need to burden my students with the nuts and bolts of composing sentences and paragraphs, correcting errors in spelling, or otherwise obeying the rules of grammar.

Instead we sat in a circle—on the grass when possible—and discussed whatever piece of literature struck my fancy. Following my father's example, I encouraged my students to read aloud and to take roles in plays, all of us weeping copiously over Thornton Wilder's "Our Town."

After four years, Robert Payne resumed his peripatetic life. Once Larry and I ran into him—clad in blue suit and red tie—in a bookstore on New York's Fifth Avenue. We reminisced over coffee.

In February 1983, I was shocked to see a frowning photograph of Robert on the obituary page of the New York Times; he had died at 71. The Times marvelled that Payne had written more than 100 books under his own name as well as five pseudonyms. His catholicity was equally remarkable: biographies of, among others, Charlie Chaplin, Greta Garbo, Hitler, Stalin, Lenin, Trotsky, Gandhi, Schweitzer, Chiang Kai-shek, Mao Zedong, Sun Yat-sen, Shakespeare, and Alexander the Great.

Although the widely respected critic Orville Prescott had once declared "no man alive can write more beautiful prose than Robert Payne," none of his books attracted more than brief attention.

Poor Robert. All those long nights beating on your portable. What drove you? Less might have been better.

In the little piece that follows, I may subconsciously have romanticized our little town and quiet lifestyle to justify having abandoned my career on the journalistic fast track.

It's possible that I actually believed what I wrote, at least for the moment.

Or I may have been willing, in order to earn a few badly needed dollars, to adopt the folksy tone required for publication in the Ford Times, *a little magazine aimed at selling Ford automobiles to residents of small towns in mid-America.*

Probably all of the above.

MY FAVORITE TOWN: MONTEVALLO, ALABAMA

Our friends were politely shocked. Leave Washington? Walk out on a good government job and a good newspaper job to live in a little town on a mound in a valley in Alabama? Never shake the hand of the president of the United States at another crowded press reception? Never again glimpse your own profile in the newsreel of another hearing on the Hill? Stop getting those expensively engraved invitations to cocktails and caviar with some lobbyist or maybe tea and cookies with Mamie? Swap cherry blossoms and Senate bean soup and parades down Pennsylvania Avenue for a small college and the town of Montevallo, Alabama, whose population just manages to clear the 2,000 mark if you add in some 700 college girls?

Just a whim, our Washington friends told one another indulgently; one of those rural urges; give them six months. Privately, we did some wondering ourselves as our little car nudged its way through the cloverleaf mazes of Arlington and onto Robert E. Lee Boulevard, headed south.

It is noontime in our Alabama town, two years, one baby and one

Ford Times 45 (February 1953):2–6. Reprinted by permission.

cocker spaniel later. A lot of folks like to nap after their midday dinner and the streets are quiet and empty. That noise is the wheeze of the 12:30 bus from Birmingham, stopped to let a housewife with packages off at her door. You won't find an ulcer case in a town which takes its own good time—one hour and a half—between walking home for noon dinner and walking back to work.

I hear the noon lines still wait in government basement cafeterias, seafood houses on the Potomac and swank French restaurants on Connecticut Avenue.

Talking of food, my neighbor to the west brought over two old-fashioned, brown oven cups the other day, filled with egg custard and just a spoonful of homemade preserves at the bottom. Larry said he hadn't eaten anything like it since he was a boy in Indiana.

True, there's not a French chef in town but we have some fresh peanut butter cookies in the pantry, from the fragrant kitchen of another neighbor, and a jar of honey-in-the-comb from my friend at the post office who keeps bees.

We felt a little sad when the young couple from Washington who passed through town not long ago said they had no idea who lived in the 153 other units in their apartment village out toward the Maryland line. Maybe they were feeling sorry for us too, since town seemed pretty quiet that night. Rocking on the porch, they brought us up to date on the constant ebb and flow of Iowans, Hoosiers and Down Easters who become, for a spell, Washingtonians. It was one a.m., long past our bedtime, when they left and we slept through the Carter fire and the noisiest scrap in many a month between the couple down the street who don't get along.

Ordinarily the mournful, midnight wail of the laundry whistle, which means fire in our town, will wake every man, woman and baby from Shoals Creek to Dry Valley. It's the exact same whistle which proclaims noon and quitting time every day, but on a dark, chill morning it seems an ominous, urgent cry of trouble and doom.

You can feel the stir of the town struggling from sleep, watch bedroom windows emerge from darkness and hear the muttering motors in the cars of the first volunteers. The alarm of fire in our Alabama night is a personal thing, not the voice of a sleek, red machine that can be shut out with the pillow and then forgotten.

Small town noises are fun. Hurdy-gurdy tunes floating over town

on a summer's night are the gypsy call of a carnival camped down by the creek. The drum roll of our high school band on the morning of a big game is more enthusiastic than any full-grown army band escorting a visiting shah to the White House.

In political season, loudspeakers interrupt biscuit-making, school lessons and domino games to herald a Main Street speech in just fifteen minutes, folks. Everybody got a big kick out of the hillbilly band of one candidate and the toy, steam-belching locomotive of another, but it was the guy who landed a helicopter in that vacant lot across from the post office who won the governor's seat.

The zing of a bicycle bell means that the grocery boy is here, his basket heavy with brown paper sacks. A triumphant, extra-loud whoosh on the laundry whistle announces not just an ordinary twelve o'clock, but the magical time of Saturday noon.

There's a certain magic, too, in the strum-strum of a guitar played by a Negro boy to dark store windows and deserted Main Street after the last show in our one movie house (thirty-seven cents apiece and two Westerns every Saturday).

We remember Washington, the exciting glimpse of today's celebrity across a smoky cocktail lounge and the lighted beauty of the city from the windows of an expensive little restaurant on Arlington Ridge Road. We remember long bus queues in the five p.m. twilight and the huddle of a state society in a hotel ballroom, everybody talking of home. We remember Washington, the electric quality of a city acting its drama on a world-wide stage, the thrill of a spectator at the big ringside and the temporary quality of home in an apartment next door to strangers.

In the spring, when the Birmingham paper carries a picture of cherry blossoms around the Tidal Basin, we'll talk again about running back up for a quick visit. But those are the first swimming days of the year in the wide bend of Shoals Creek down by Big Spring. About that time, too, our whole Main Street closes up one afternoon for the annual town picnic. Who would help with the potato salad if I weren't there? Who would broil dozens and dozens of hotdogs just the right shade of crackling brown if Larry were way up yonder in Washington?

Historian

Storming the Barricades

In the early 1960s, I undertook to pursue a doctorate in history, a daunting task under the best of circumstances. I had no choice as to institutions of higher education: I would have to commute sixty miles each way over a two-lane highway to the University of Alabama at Tuscaloosa. Most members of the all-male history faculty regarded me with incredulity: a woman in her mid-forties, with a husband, children, and a full-time job in Birmingham, planning to commute to campus!

My faculty advisor, James F. Doster, at the start of each seminar, never failed to explain my presence to his male students thus:

"Mrs. Hamilton is a journalist."

And, judging by his tone, destined to remain so.

Professor Thomas B. Alexander, widely acknowledged for his studies of Whigs in the pre–Civil War South and the intellectual leader of the Americanists at Tuscaloosa, took it upon himself to assure me solemnly at least once, often twice, each semester:

"Mrs. Hamilton, you cannot possibly do it!"

But Professor John Ramsey, after reading my first seminar paper, offered hope:

"Mrs. Hamilton, it would be a shame if you did not go ahead and finish."

Those few words—the only encouragement I received from the history faculty during my entire Ph.D. program—may well have saved me from giving up altogether. At least one man thought I could "do it."

As a form of academic penance, I was required to spend a semester technically "in residence." For a few nights each week I slept in the graduate women's dormitory, a one-hour drive from my

home. Male students, as evidence of their attitude toward women who sought advanced degrees, called this "lesbian hall."

When I passed my orals, Professor Alexander was, shall we say, man enough to declare: "Well, if I had a hat, I'd eat it."

In 1968, Marjorie Howell Cook and I became the second and third females to be awarded history doctorates at the University of Alabama.

After I retired, I was invited to speak to the Southern Association of Women Historians, meeting in conjunction with the Southern Historical Association at Fort Worth, Texas. In that informal talk, I tried to convey to my younger colleagues some sense of the inhospitable climate that faced women, particularly in the South, who sought after World War II to enter the almost entirely male domain of academe.

I mentioned the work of women historians, born in the late nineteenth or early twentieth centuries, who tackled the big canvas, such as Mary Beard, Esther Forbes, Catherine Drinker Bowen, and Barbara Tuchman. I recounted some of the disparaging remarks about their books from male critics, for example Edmund Wilson's judgment of Bowen's Yankee from Olympus: *"Mrs. Bowen's own mind is too blunt, too limited, and too prosaic for her to be able to deal with the Holmeses."*

I dwelt at some length on the numerous "wife typists," those patient helpmeets during the era of manual typewriters whose only rewards for weary shoulders, aching backs, spreading rumps, broken fingernails, inky smudges, and nervous tension might be an acknowledgment such as: "To my wife upon whose shoulders fell the heavy burden of typing this manuscript," or: "To my wife who served as typist, grammarian, critic, sounding board, and sentry at the study door," or: "To my wife who undertook a great deal of research with me . . . helped shape many of the ideas in this volume and gave the various drafts searching criticism . . . also managed to perform clerical and stenographic chores and, with the help of the children, to create at home those conditions in which hard and sustained work is possible."

Then I recounted some individual experiences—my own and those of other retired women historians.

Excerpts from "CLIO'S DAUGHTERS; WHENCE AND WHITHER?"

In the 1930s, young women interested in teaching careers were conditioned to believe that their ultimate aspiration would be to teach in high school. For decades to come, women would continue to encounter this cultural barrier. As late as the 1970s, when one woman started to fill out her application for admission to the history graduate program at a southern university, a male friend advised her:

"When you get to the part where they ask you to check your goal, be sure to check high school teaching. They don't believe women have any business teaching at the college level."

Prior to World War II, a sprinkling of fully qualified women historians did teach at the college level in the South, the catch being that they could only find jobs on the faculties of women's colleges.

In the late 1930s and early 1940s, the faculty of Alabama College for Women (now the University of Montevallo) was about seventy-five percent female. These women, almost all of them single, held degrees from prestigious eastern or middle western universities.

According to the 1941 catalog of Alabama College, its faculty and administration consisted of 91 females and 24 males, including the president, dean, and business manager. Ten women members of that faculty held Ph.D.s earned during the twenties and thirties at Stanford, Cornell, Chicago (2), Yale, Iowa, Duke, Wisconsin, North Carolina, and Peabody.

When members of Dr. Hallie Farmer's family first came to visit her in Montevallo in 1927, they had been horrified at the sight of this tiny, dusty, remote Alabama town and begged Hallie to come back to the Midwest.

But Farmer (Ph.D., University of Wisconsin) made a virtue of necessity. She spent her entire thirty-year career at Alabama College, becoming without doubt the strongest member of its faculty, radiating energy and vigor in her trademark somber black dresses, her advice heeded even by male deans and presidents.

From the unlikely base of a sheltered college for women, Farmer

Southern Association of Women Historians meeting, Fort Worth, Texas, November 1991.

133

became a statewide leader for reforms; instrumental in placing women on juries, abolishing the poll tax, ending arbitrary reading tests administered to would-be voters by boards of registrars, banning the use of the lash on state prisoners, and establishing at Alabama College a School for Citizenship to instruct women students how laws were passed and to encourage them to take part in this process.

In the late 1950s, after Farmer had led that faculty for more than twenty years, serving under a series of male presidents—most of them her juniors in age—she was finally offered the presidency of Alabama College for Women.

"It's too late," Farmer said. "I don't have the strength for that job now."

Lucille Griffith, although she held an M.A. from Tulane, received this unsolicited advice from the head of the Duke University history department when he rejected her application to enter graduate school in the 1950s.

"Don't do it. It's too hard on a woman's nervous system. They can't take the pressure."

Although the reason was not so graphically spelled out, Griffith was also rejected by Vanderbilt, North Carolina, Texas, and Rochester. When she applied to Brown, she was informed by the historian Barney Keeney, dean of the graduate school, that his university did not usually accept women of her age (Griffith was in her mid-forties).

Normally mild-mannered, Griffith wrote Keeney what she later described as a "sassy" letter, insisting that she had a reputation for finishing what she started. Probably due to her letter ("Oh yes," Keeney told a mutual acquaintance years later, "she's the one who wrote me *that* letter"), Griffith was accepted.

Back then, those who failed their orals at Brown were allowed to try again; about half of her male colleagues, Griffith recalled, availed themselves of this second chance. But Griffith passed her colonial and early American fields on the first try. Her examiners told her that— nervous system notwithstanding—she had been the best-prepared candidate who had presented herself to them in the past eight years.

Ph.D. in hand, Griffith returned in 1957 to her position as assis-

tant professor at Alabama College for Women. Keeney became president of Brown.

Frances Roberts, trying to be the best possible high school teacher, studied for two summers under Frank Owsley at Vanderbilt. When Owsley moved to Tuscaloosa after World War II, Roberts, who had earned an M.A. degree in history at Alabama in 1940, went back to Tuscaloosa to continue her work with him and entered the Ph.D. program. She quickly encountered the then widespread male notion that the Ph.D. was wasted on women: being destined to marry and keep house, they probably would never use their degrees.

Professor [John] Ramsey's highly regarded "Age of Reason" course attracted a large undergraduate and graduate enrollment. Not knowing his students by name, Ramsey graded (in those days, full professors at Tuscaloosa did all their own grading) solely on the basis of written papers.

Roberts, as was her custom, signed her papers simply F. Roberts. During her first two courses under Ramsey, she received A's on all papers and A's as final grades. But eventually Ramsey discovered that F. Roberts was Frances (with an "e"), whereupon her grades in that course dropped to B.

In 1956, Frances Roberts became the first woman to receive a Ph.D. degree in history from the University of Alabama.

Although camaraderie did develop, some women felt obliged to defer to their male peers who flooded campuses after World War II. In the mid-1950s, Winyss Shepard remembers, she voluntarily withdrew her name from the list of candidates for officers in the graduate history club at the University of Pennsylvania.

"I just believed," she told me, "that the main offices belonged to men. I thought women were only supposed to serve as 'secretary.'"

Shepard remembers that, like male professors, male students found it hard to take female colleagues seriously. They, too, were convinced that women would eventually marry and assume household pursuits. Shepard also recalls an undercurrent of rivalry: "What if this woman should get my job?"

Shepard married and took the then traditional path, reasoning: "Someone has to be with the children."

All her life, Shepard, a Fulbright in France on her record and her Ph.D. from Penn on the wall, voluntarily limited herself to part-time teaching.

Female Ph.D.s in history who had the misfortune to marry men in the same discipline found themselves taking a back seat.

At Penn, Shepard had the then unusual experience of being taught by two such women, both classified as associates. Marriage to male historians barred them, by university rules, from permanent faculty status.

Roberts remembers a three-hour argument she had with the president of the Huntsville campus of the University of Alabama over whether a highly qualified woman Ph.D. should be allowed to teach in the history department of which her husband was a member. The President gave the then widely used excuse: "nepotism."

In this case, Roberts eventually prevailed. But for years this woman, Roberts recalled, "had, up to a point, to stay in the background."

The feeling that first-class male scholars could not be recruited by a female department head was widespread in the late 1960s and early 1970s. As chair at Huntsville, Roberts, on the advice of her all-male faculty and perhaps remembering her graduate school experience, signed all recruitment correspondence "F. C. Roberts."

Lucille Griffith finally achieved the headship of her department after having been twice passed over for males, one young enough to have been her son. When she set in to recruit, Griffith felt obliged to ask male candidates if they minded working under a woman. Teaching positions being hard to come by in that era, most males swore that gender mattered not in the least. But one candid male responded:

"Well, I guess it wouldn't matter. After all, I've worked for a lot of second-class men."

Roberts, Griffith, Wiley, Caudle, and I—all of whom served as chairs of our departments—were succeeded by men.

And now for the widespread, ultimate, and perhaps ongoing discriminatory weapon: women's salaries as compared to those of men.

At one point in her student career, Shepard applied to the employment office at Penn.

"This job is supposed to pay $7,000," a man informed her, "but since you are a woman you might get $6,000."

Evelyn Wiley, who recollected no discrimination during her years as a graduate student at Penn (on a fellowship reserved for women) and no problems with her all-male colleagues in the history department at Birmingham-Southern College, did remember that her salary was less than that of comparable males.

"But I didn't make any 'to-do' over it," she recalled. "No lawsuit or anything like that. I just accepted it."

When Athens College became a state institution in the 1970s and salaries a matter of public record, Mildred Caudle learned, for the first time, that she, a Ph.D., was being paid below most men, including some with master's degrees. Infuriated, she confronted the president. His explanation came readily: "These men have families to support."

Roberts had earned her doctorate and taught for eleven years at the Huntsville campus of the University of Alabama when she discovered—in the course of her extra duty of keeping the college's financial records—that a new instructor in engineering had just been offered $10,000 at a time when her salary was $6,500.

Roberts summoned up the courage to complain. She was offered a $300 raise: "the best we could do." In Roberts's case, the excuse that she was married did not apply; no one took into account that she was the major support of an aged aunt. She took her complaint to the president and received partial redress in the form of a presidential raise.

Even after Roberts had been on the payroll of the University of Alabama Extension Division for 20 years, she still suffered from salary discrimination. She and the only other female full professor, whose field was math, eventually received presidential raises when it became painfully apparent, even to male administrators, that two women were the lowest-paid full professors in the entire Extension Division.

Like Wiley, I had "accepted it" when I was told by the business manager at Birmingham-Southern College that, in setting my meager salary, he—like the president of Athens—took into account the

fact that I was married and not the sole support of a household. No laws protected Wiley, Roberts, Caudle and me; we needed our salaries, however skewed, to help feed our families and pay our mortgages.

But by the late 1970s, I had advanced through the ranks at UAB [the University of Alabama at Birmingham] for more than a decade, achieved full professor status, served as department head, published two books and been a member of the faculty longer than all but two others.

Yet when the then dean of my school released, with no names attached, the salaries of twelve full professors, I found myself number nine, barely above three males widely and deservedly reputed to be the school's worst teachers and overall do-nothings.

Perhaps tenure emboldened me; undoubtedly, three decades of being valued below men had inflicted deep scars on my self-esteem. Trembling with rage, I confronted the dean, vita in hand. The following week, my salary was "adjusted": number six. . . .

At the conclusion of that talk, I had only two pieces of advice for my predominantly younger audience, most of whom had never undergone experiences such as those I had described: (1) Find your way into these traditional preserves of male power: department chairs, deanships, and presidencies; and (2) Spread the story of women's role not only in specialty courses and monographs but in survey courses, textbooks, and major works on the big canvas.

If they succeeded in reaching these goals, there would be no further need for a Southern Association of Women Historians; like the American Woman Suffrage Association and the National Women's Party, it would become a dinosaur of the past.

"You sounded a mite 'techy' in that speech," a friend reported. "Not your usual good-humored self."

True.

I never forgave those graduate school powers at the University of Alabama who treated me like a no-class citizen. I grieved for all those "wife typists" when I read those well-meaning but condescending acknowledgments. I had been angered when I learned, through my interviews, the numerous ways in which capable women

like Hallie Farmer, Frances Roberts, Lucille Griffith, and Mildred Caudle had been demeaned.

Why had my sense of grievance not surfaced earlier? When I had discovered, for example, that male reporters on the Associated Press earned so much more than I? When I found myself restricted to covering Clare Luce's opinions on marriage, Bess Truman's Easter outfit, and other minutiae on the "women's beat"?

Because, for one reason, I had been so young. Because, for another reason, I had emerged from college at a time when women's expectations were so narrow. I had been thrilled by the opportunity to be a journalist in the nation's capital, no matter how unequally assigned or paid. To tell the truth, I had enjoyed being a kind of pet in an almost all-male realm.

Twenty years later, however, my horizons had broadened. I had rejected the seductive pleasure of being one of the few women admitted to a field hitherto restricted to men. In matters of opportunity and pay, I had learned to demand not privilege but equality.

Midway through the twentieth century, Birmingham was the only city of its size in the United States without a degree-granting public institution of higher learning.

Its only four-year institutions were my alma mater, Methodist-affiliated Birmingham-Southern College and its rival, Baptist-affiliated Howard College—both restricted to white students—and Miles College, a small privately funded college that served the few hundred blacks who could afford its tuition.

I had spent ten years handling public relations and teaching an occasional journalism course at Birmingham-Southern—a twelve-month job with two weeks' vacation a year. Like the history professors at Tuscaloosa, my faculty colleagues—almost all of them beneficiaries of the "old boy" system—looked askance at my notion of invading their privileged circle.

Frustrated, I quit Birmingham-Southern in 1965 to oversee the small library and teach history at the extension center of the University of Alabama. For once, my timing was perfect: the take-off of a twenty-five year educational explosion that was to create a major urban university.

Unlike the traditional institutions of Tuscaloosa and Birming-

ham-Southern, *this new school had no secluded campus and no entrenched faculty. I remember my euphoria at finding myself in an urban setting where change and experimentation were encouraged and nothing set in concrete except streets and sidewalks.*

Birmingham-Southern, Howard (later Samford University), and Miles were middle-class enclaves. But the young men and women who flocked to this new instant university—whites and blacks alike —sought to rise out of a background of generations of poverty.

Twenty years after I joined that faculty, **UAB Magazine** *invited me to recall the institution's pioneering era.*

<div align="center">

GETTING THERE:

UAB AND THE HOPE OF THE WORKING CLASS

</div>

When Virginia Hamilton teaches the history of the South, she asks her students about their family histories. They are the grandchildren and great-grandchildren of coal miners and chicken farmers, sharecroppers who never owned any land, and cotton mill workers, she has learned. Birmingham has changed over the last 40 years, but students come to UAB for the same reason they studied at the Birmingham Extension Center in 1936, to better the condition of their lives.

"UAB students, in many cases, are the first generation in their families to get a college degree, and it's a big thing for them and their families. It's a big thing for the state," says Hamilton. "Because black slaves in Alabama were forbidden to read and write—and they were a large portion of the population—free, public education in primary and secondary schools didn't really begin here until after the Civil War. Well-to-do-whites, in the meantime, had managed to educate their children privately, while the poor whites for the most part just did without."

Although the Reconstructionists finally passed a free, public education system into law, it was a system poorly financed through the state's regressive tax base, she adds. Much of the history of UAB, and its current status nationally, can only be understood in this light.

"Historically, Alabama has taxed the poorer elements of the population. Sales tax, still a primary source of funding for education in this state, places most of the burden on those who are least able to pay.
UAB Magazine 6 (Fall 1986).

"We've been dominated by interests that have protected large landowners and corporations from the appropriate taxation that would have financed state services such as education. As a result, higher education in Alabama received little attention until after the Second World War, when the South's economy became dependent on business and industry rather than on agriculture."

At UAB, a fledgling university in 1966, playing educational catch-up with the rest of the nation has been a headache at times, an advantage at others. Virginia Hamilton came to the extension center in 1965. "If students needed a course in the Age of Jackson, for example, I would study up—it wasn't my specialty—and teach the course. I don't recommend that for teachers or students, but with a two-person history faculty, that's the best we could do at the time.

"Specialty courses such as Afro-American history were not offered until the mid-1970s. In fact the university wasn't integrated for the first few years of its existence. Because we came late, after George Wallace's stand in the schoolhouse door in 1963, we didn't have many problems with integration. However, I remember inviting Lewis White [an African-American] to talk to one of my classes during the late 1960s. It was quite a daring thing. At the time he was a local disc jockey and a vocal spokesman for black interests. Today he is [Birmingham] Mayor [Richard] Arrington's public relations assistant.

"We serve the most heavily populated area of the state; most of our students have working-class backgrounds. Tuscaloosa, on the other hand, serves mainly middle-class students, while Auburn serves mainly small-town people from very established financial situations.

"We've come out of poverty. But our students come from a tradition of upward mobility; each generation tries to better itself over the last.

"Only in the 1980s, however, has the undergraduate portion of UAB begun seriously to consider itself a research institution. In the history department today you cannot gain tenure until you've published a book with a valid university or scholarly press. It's my conviction that research complements teaching. It keeps you from reading the same old tattered notes to students every year.

"As we've matured we've taken on the normal coloration of a research university. Our students, however, are no less career-oriented

141

today than they were in the years of the extension center. Education runs in cycles. But the central idea of Thomas Jefferson and this country was that the best-equipped citizens, in order to govern, would be educated citizens. Providing that education was a public responsibility. At UAB, we've always believed that."

NINE

Researching Hugo Black

At the dawn of the 1960s, I chose as the topic of my master's thesis a then almost forgotten nineteenth century female journalist whose determination and grit made my own efforts to break new ground seem paltry. In a sensational series titled "The History of the Standard Oil Company," which ran for eighteen installments in McClure's Magazine *between 1902 and 1904, Ida Minerva Tarbell had—as I put it—"the spunk to describe the legendary [John D.] Rockefeller as cold, ruthless, and unethical."*

Rockefeller, Tarbell charged, had built an international monopoly of the oil industry upon special favors from railroads, mastery of the pipeline system, and sharp marketing practices that helped force small independent refineries out of business. Her articles raised a storm of public indignation that led, in 1911, to the Supreme Court decision that Standard Oil of New Jersey was a monopoly in restraint of trade, based on unfair practices.

Ida, as I called her in my own mind, had appealed to me as a journalist, a crusader, and a strong female role model. At fourteen, she had prayed on her knees that God would keep her from marriage.

"I must be free," Ida wrote in her memoirs, "and to be free I must be a spinster."

I wanted to expand my thesis into a doctoral dissertation, but when I formally proposed doing so, I learned that someone had preempted this topic. I had to content myself with writing an article on Ida Tarbell for American Heritage.*

Next I proposed writing a dissertation on the Scottsboro cases. Professor Doster responded, frowning: "No, no, no, Mrs. Hamilton. That is a dirty subject. I will not let you work on it."

*Virginia Van der Veer Hamilton, "The Gentlewoman and the Robber Baron," *American Heritage* 21 (April 1970):78–86. Reprinted by permission.

143

(No such prudery protected Dan Carter who, some years later, chose the Scottsboro cases as the topic of a dissertation that evolved into his book, Scottsboro: A Tragedy of the American South.*)*

Dr. Doster, a specialist on late nineteenth-century railroad rates, offered as a counter suggestion that I do a dissertation on the Shelby Iron Works, a topic guaranteed to consign me to academic obscurity. I vividly remember his taking me to an attic in the Gorgas Library and showing me dozens of dusty boxes containing the records of this nineteenth-century Alabama enterprise.

I then proposed a study of the Senate career of Hugo Black. More frowns. But since Professor Doster was, at that very moment, directing a dissertation on the undistinguished—indeed embarrassing—Senate career of J. Thomas Heflin, he could find no excuse for rejecting my suggestion.

Justice Black himself proved surprisingly cooperative, offering me unrestricted access to his Senate papers, then housed in a basement room in the Supreme Court building. To my dismay, I found that these papers, covering a Senate career of ten years, filled only one four-drawer file cabinet. As he later did with his Court papers, Black had obviously ordered someone to destroy most of his Senate papers.

Nonetheless, he received me cordially, even inviting my husband and me to his home to play a few games of tennis and to share the spartan luncheon fare upon which he insisted. My spouse—uncertain how hard to hit the ball toward a Supreme Court justice in his eighties—found himself paired with Elizabeth Black, a neophyte player. Justice Black and I, as he had doubtless planned, easily won the match.

When part of my dissertation concerning Black's involvement with the Ku Klux Klan appeared in American Heritage, *its editors asked me to write a brief side story to accompany that article. That piece illustrated two facets of a remarkable man: at eighty-two, Justice Black retained not only his fierce devotion to tennis but also his intense intellectual curiosity about the subject of human history.*

Excerpt from MR. JUSTICE BLACK:
A POSTERIORI

Last year [Black] underwent two operations to remove cataracts

American Heritage 19 (April 1968):62–63. Reprinted by permission.

so that he can go on reading and working. When I visited him one afternoon recently, he was reading proofs of an article he had written for the *Encyclopedia Britannica* on the links between Western civilization and that of ancient Greece. Because of the operations, he was wearing thick lenses, and his desk was surrounded by a bank of bright lights focused on a stack of papers typed in outsized letters.

We talked for a while about the intricacies of Alabama politics and then about his pet idea during the Depression of a thirty-hour work week to spread the jobs around. When I brought up the Klan episode, he said again that he still cannot understand what the fuss was about, since all the information had been published before his appointment. Black said he was surprised to hear that [James] Esdale was alive, and he seemed genuinely interested in my account of the former [Ku Klux Klan] Grand Dragon's present occupation as a bail bondsman whose clients include many Negroes and civil rights workers.

We had talked almost an hour when the door opened without the formality of a knock. It was Elizabeth, the second Mrs. Black (his first wife, Josephine, died in 1951), fiftyish, attractive, once his secretary and now clearly skillful and devoted in her role as wife. She had come to drive him to some Washington ceremony, but said tactfully that she was early and would wait outside.

The interview was over anyway. The Justice emerged from the circle of lights and walked slowly to the door. His doctors, he remarked candidly, had told him a year before that if he ever stopped playing tennis, even for a few days, he could never start again. But now, he said, they are encouraging him to renew his exercises, and he spoke of hitting the tennis ball around some more soon.

I could still sense the determination and intensity of will that had brought this man from an isolated southern county seat to the nation's highest court. If his step was no longer spry, his mind had lost none of its vitality. I thought, as we shook hands, that if Hugo Black willed it, he would play many another set of tennis.

I drove to Montgomery one humid summer day to interview the Justice's uninhibited sister-in-law, Virginia Durr. President Harry Truman had deemed her husband, Clifford, too controversial to win Senate confirmation for a second seven-year term on the FCC. Eventually the Durrs returned to their hometown, but by the mid-

1960s, their championship of the civil and legal rights of blacks had made them virtual outcasts from the white society in which both had been reared. Lacking any clients but the very poor, Clifford Durr closed his law practice.

As I drove past their shabby two-story house near downtown Montgomery, I saw a gray-haired white man mowing the lawn in the noon heat. To spare Durr any embarrassment he might feel at being caught in a task customarily performed in Montgomery by a black "yardman," I drove around a few minutes until he disappeared inside the house.

I ate lunch with the Durrs, Clifford having changed out of his sweat-stained work clothes. Apparently they could not afford a cook. Virginia had prepared the typical Montgomery midday meal of vegetables and fried chicken.

Some young people straggled in and joined us at the table. Absorbed in castigating Hugo Black for not having encouraged her sister, Josephine, to express her talent for writing, Virginia did not introduce us.

Driving back to Birmingham, I theorized that the Durrs, to make ends meet, might have been reduced to taking in boarders. I later realized that they housed and fed so many young civil rights demonstrators that Virginia may not even have known the names of the strangers at her table.

In the 1960s, when I set in to study his Senate career, Justice Hugo Black was widely regarded in his home state as a pariah. The fact that a native of Alabama had helped in 1954 to bring about the unanimous Supreme Court decision in the Brown v. Board of Education *school desegregation case had outraged the majority of white Alabamians. In 1962 Black further enraged his former friends and neighbors—and ignited a national firestorm—by writing the Court opinion banishing voluntary prayer from the public schools.

Upon learning that I was writing a dissertation on Black's Senate career, people who knew me casually merely raised their eyebrows and rolled their eyes. But white males in Birmingham, from top to bottom of the social spectrum, gave Black and his son, Hugo Black, Jr., much rougher treatment. Some who recognized the jus-

tice on Twentieth Street did not hesitate to call out to a member of
the nation's highest court:

"You are a traitor to the South."

Outwardly unruffled, Black would reply:

"Glad to have your views."

Hugo, Jr., following in his father's footsteps as a legal champion
of union members and the poor, endured even ruder salutations,
such as:

"How many niggers did you eat with last night?"

Trying to laugh it off, the justice's son would reply:

"Last night was slow—just seven."

In his memoir, My Father, Hugo, Jr., described some of the in-
sults inflicted upon him, his wife Graham, and their young children
by fellow Alabamians: country clubs blackballed them; anonymous
callers threatened to burn crosses on their lawn and blurted out
over the telephone:

"Hugo Black is a nigger lover."

Lest he stir up more trouble for his son, Justice Black stopped
visiting Birmingham. Eventually the younger Black gave up his
dream of becoming, as had his father, a United States Senator from
Alabama and moved to Miami, a city where his name proved not a
liability but an asset.

By the late 1960s, with Black himself persuading the Court to
uphold certain convictions of civil rights demonstrators, Birming-
ham began to soften toward the justice. Led by some who had
clerked for him during his long court career, the Birmingham and
Alabama bar associations honored him at discreet dinners not
open to the public.

Nonetheless, it was with considerable trepidation that I accepted
an invitation to talk about my biography of Black at the weekly
luncheon of that most jealously guarded citadel of the white estab-
lishment—the Rotary Club of Birmingham. The person who invited
me, General Ed Friend, Jr., had recently been admitted as its first
Jewish member.

As the news account that appeared the following day in the Bir-
mingham Post Herald attests, I managed, with a touch of humor,
to pull it off.

HUGO BLACK JOINS THE ROTARY CLUB

Hugo Black, a "jiner" by nature who became a Klansman but never a Rotarian during his Birmingham days, finally made it to the exclusive, conservative-oriented club Wednesday.

The late Supreme Court justice's acceptance by the Birmingham Rotarians was met with such hearty, approving laughter and applause that he probably wouldn't have regretted the long wait at all.

The Ashland native, whose roots in populism led him to controversial interpretations of the U.S. Constitution, "made it" to the local Rotary Club, the authoress of a book about his Alabama years said, because of the fact that she was invited to speak to the club about Black in the first place.

Dr. Virginia Van der Veer Hamilton, University of Alabama associate professor of history who wrote the book, "Hugo Black, The Alabama Years," indicated that the invitation to speak about Black at the Rotary Club meeting wouldn't have been expected even a few years ago—before the current wave of acknowledgement of the late justice as a constitutional conservative by many members of the establishment.

When Dr. Hamilton half-kiddingly told her audience that Black, who had not been invited to join the club when he was living in Birmingham in 1913, had finally made it, the Rotarians burst out in hearty laughter and gave the authoress prolonged applause.

The late justice no doubt would have enjoyed it.

The male reporter who covered this talk by an "authoress" failed to mention one point. Now that Hugo Black had finally "made it" to their exclusive organization—I ad-libbed, looking out over my all-male audience—perhaps the Rotary Club would soon open its membership to professional persons who, like their speaker that day, happened to be females. The Rotarians, ever the gentlemen, received this preposterous notion politely but without applause.

Fifteen years after that talk, the Rotary Club of Birmingham, prodded by its national organization, presented at its weekly luncheon its first three women members.

Birmingham Post Herald, August 3, 1972.

148

The predominantly white citizenry of Ashland (pop. 2,000), a village deep in the mountains of east Alabama, considered Clay County's famous native a Judas. How else explain the fact that Hugo, whom many older citizens remembered vividly, had helped lead the way toward desegregating their schools and—worse yet, by their standards—outlawing school prayer?

When I first drove to Clay County seeking interviews with those who had known Black in his youth, I had been shocked—indeed, a bit frightened—to be greeted by a sign announcing: The Ku Klux Klan Welcomes You to Ashland.

Asking around the square for those who would talk to me about Black, I got only three takers: Black's first cousin, one of his boyhood companions, and Morland Flegel, a dry cleaner who had recently moved to Ashland from the Midwest. My inquiries met with almost palpable hostility. The modest home in which Black had been reared was standing at that time, but the overwhelming majority in this community vigorously opposed preserving it as an historic site.

But after Black's death in 1972, Ashland unbent toward his memory—to some degree. The glow of the national bicentennial helped. As the climax of a symposium I organized at UAB to commemorate the Justice's career, I planned, with the help of the dry cleaner, a celebration in Ashland. But I never envisioned that this bucolic occasion would attract a couple of worldly sophisticates.

Whoever is calling me long distance, I remember thinking that day in 1976, must be pulling my leg. He had announced matter-of-factly: "This is Max Lerner."

The Max Lerner, editor of the Nation, *who had been among the first to greet Hugo Black in 1937 when the newly appointed Justice arrived from England to confront the national furor over his one-time membership in the Ku Klux Klan? The Max Lerner, whose books and columns I had read in my college days? Still alive?*

Very much so.

(I later learned that Lerner, born in 1902, was a frisky 74-year-old at the time he first telephoned me. When I called him in New York a few days later, his secretary gave me a number where I could reach him in California. Lerner, it turned out, was making one of

his periodic rejuvenation visits to the fabulous pad owned by Hugh Hefner, publisher of Playboy and—shall we say?—"staffed" by Bunnies.)

Max (he insisted that I call him Max) and Otto Preminger, the famed movie producer-director of such classics as Laura and The Man with the Golden Arm, planned to collaborate on a film about Black. They wondered if they could attend my symposium.

Well, of course!

Short, bushy-haired Max and tall, bald Otto created a social sensation at my symposium: two European-born, internationally known sophisticates charming a bunch of locals in the American hinterlands.

But not one another. They bickered, almost to the point of physical violence, over plans for their film as I drove them to Ashland, Max in the backseat scribbling notes for the impromptu talk he had agreed to give when Chief Justice Warren Burger canceled at the last minute.

I had arranged for some backwoods singers to present a program of Sacred Harp, a musical form based on four notes and—as one country fellow put it—"meant to be enjoyed by the singers but not necessarily by the audience." What did Otto the Viennese, attuned to the strains of Strauss and Mozart, think as he endured this discordant wailing? How did this bon vivant, accustomed to Wiener schnitzel, sauerkraut, pilsner beer, fine wines, luscious chocolates, and the legendary Sacher tortes, face up to the spread laid out by the best cooks in Ashland: fried chicken, fried okra, fried tomatoes, corn pudding, sweet potato casserole, cornbread, deep dish apple pie and iced tea?

Max, born in the small town of Minsk in Russia, seemed less of an outsider. Gamely he tramped into a cornfield—site of a proposed library in honor of Black—and gave a brief, graceful tribute.

Otto and Max never got together on a film about Black. The people of Ashland never raised enough money—or enthusiasm—to build the library. The house where Black lived as a boy crumbled to dust.

It was 1995 before Ashland publicly absolved its only famous citizen: the courtroom in the Clay County Courthouse, where he had first practiced law, was dedicated in memory of Hugo Black.

Selma: A Project Left Undone

When I completed my book on Justice Black, I decided to begin research on an Alabama event that seemed to me to be as significant for the twentieth century as the Boston Tea Party for the eighteenth century or John Brown's Raid for the nineteenth century. That event was the series of demonstrations at Selma in the spring of 1965, culminating in "Bloody Sunday"—March 7—on Pettus Bridge, followed by the march of thousands of blacks and their supporters over a fifty-mile stretch of U.S. 80 from Selma to Montgomery.

The drama of those demonstrations and that march, set against a backdrop of the old plantation South, transfixed the nation and led directly to passage of the momentous Voting Rights Act of 1965.

I went to Atlanta in November 1973 to interview Hosea Williams, who had been one of Dr. Martin Luther King, Jr.'s chief lieutenants in 1965. Even from the rough notes I made on this interview, one can sense the thrill and the terror of the historic confrontation at Pettus Bridge between demonstrators and Alabama state troopers.

HOSEA WILLIAMS RECALLS "BLOODY SUNDAY": AN INTERVIEW

I have been to talk with Hosea Williams. His office is just off Auburn Avenue down in the black ghetto—in the education building of a large black Baptist church. It is filled with confusion—people hurrying around doing nothing—stacks of the *People's Crusades,* his newspaper—his wife, daughter, son. At first he seems disinterested, distracted by the here and now of Atlanta politics, taping a TV interview, breaking our first appointment without a word of regret. I start to leave but somehow, fortunately, stay on until a young black

Interview, November 9, 1973, Papers of Virginia V. Hamilton, Birmingham Public Library Archives.

woman says off-handedly—"Oh I didn't know you were waiting to see Rev. Williams," and leads me in.

He is answering a stack of phone calls—his wastebasket is filled with crumpled pieces of messages—and he seems bothered by the intrusion, anxious to get the white interviewer dispensed with and gone. I ask him if Selma finished a stage in the movement—after which it moved North, to the cities, went uptown and political—as some have claimed? But I realize that he is still pursuing the old tactics, the personal ministry, threatening to boycott and to take to the streets. Yes, he says, he is still using the tactics of Selma. His phone rings constantly. Hundreds of folks, hungry, fired from their jobs, waiting to go back to school, call Hosea. While others may have moved on—Andy [Andrew] Young to Congress, John Lewis to the Voters Education Project—he, Hosea, is still in the street movement and still believes in its effectiveness. . . .

He plans to mobilize Atlanta's blacks—and poor whites—in an economic coalition against the power structure "downtown" which has always tried to keep them divided. He believes he can even get the whites behind him; they are learning, he says, that it's not enough "just to be white," that a white stomach gets hungry just like a black one.

I try to lead him back in time to Selma and suddenly he does return. He remembers it all like it was yesterday, he says, and indeed does. For almost an hour, he talks about those days . . . he recalls it all—the sense of love, of togetherness between white and black, of blacks rising above fear, of the federal government—"my government for the first time—moving to take care of me, by federalizing one day those guys who were beating on us the day before."

He says James Bevel was the project leader of SCLC [Southern Christian Leadership Conference] in Selma and his [Hosea's] role was to lead the songs, to preach the people into the fever to march, to go to jail, time and again, as a symbol of the movement in jail, leaving Bevel free to do his organizing. He remembers that there was a meeting between King, his lieutenants and the SNCC [Student Non-Violent Coordinating Committee] people in Atlanta before the Sunday march in which King asked for a vote on marching on Sunday and Williams was the only one voting for it. King wanted to wait—

because he was preaching in Atlanta that Sunday, and he wanted to lead the march himself.

So Hosea went back to Selma with permission from King to lead 50 people to the bridge, and was preaching Saturday night at Brown's Chapel and realized again that the people wanted to march and would have to get the chance. Someone called King and said "Hosea is preachin' the people into marching" and King sent a jet with Andy Young in it to see if Hosea was disobeying orders and to tell Hosea to quit. But when Young got to Selma, he realized that the march could not be stopped and told King.

So Hosea and Lewis, for SNCC, led the march, with Lewis reading a press statement—and seeming to be the spokesman. When they got across the bridge, the officer said: "Turn around and lead the niggers back to the church."

But Williams answered—because no one else did—"We ain't going back this time."

So the officer said, "I'll give you one minute," but in 15 seconds he ordered his men to attack.

About four of them headed straight for Hosea, who put his head between his arms and rolled around to escape the billy clubs. (He demonstrates the old civil rights defense technique.) When they tire of beating on him, they go on forward 15 feet or so to where the rest of the Guard is clubbing the first marchers. Hosea is left in the middle ground. He gets up and starts to run but sees a white mob in front of him and realizes they would surely kill him and that his only safety is back within the line of troopers who have now encircled the marchers. He looks for a hole and dives in.

He is exhilarated at the memory of it: he laughs at his plight. He remembers the tear gas and the ravine down which the troopers hoped to drive the marchers; and the horses' hooves beating on the pavement, but somehow the horses avoid stepping on the marchers. He remembers how the troopers threw down their billy clubs in their zeal and began to stomp the marchers. He wonders that no one was killed that day, and he concludes that it *had* to take place, it was the climax of the Selma episode, it brought about and gave birth to the actual march.

He speaks of [Selma Public Safety Director] Wilson Baker and

how well he and Baker communicated at first—how Baker would call him to his car and joke and talk it all over. He remembers Baker once asking him to his office to discuss things and how they got into a big argument—Baker wanting to persuade Hosea to call off the demonstrations on the premise that voters would be quietly registered when the heat was off—and Hosea trying to persuade Baker to let them continue—and the two of them finally falling out—and breaking their trust and friendship.

"You really trusted him?" I ask.

"Yes, I really did," says Hosea—"and he trusted me, but after that, we couldn't talk anymore."

"I guess you'd each come as far as you could come," I say. He agrees.

He remembers that Baker once arrested him for leading a night march and put him in his car, while the crowd stood around outside. He had been trying to warm up that crowd to march by preaching and realized that they weren't responding, so he had stopped and said, with tears on his cheeks, "I'm going to march if *no one* goes with me." And the whole church followed him out. So the crowd told Baker, "If you arrest him, you're going to have to arrest us all." So Baker realized the prudent thing to do was to let Hosea go—on the promise that he would lead the people back into the church. And he did.

Hosea is caught up now in the memories of it all. Did the coming of the whites really make a difference? Yes, it made all the difference. It was a remarkable time—the only time, he says, when blacks and whites really communicated, really worked together. He remembers the lieutenant governor of Massachusetts living in a black household and eating "cold wheat" for breakfast. He demonstrates how you had to tiptoe between the sleeping bodies of whites and blacks on the floor together at the house where he, Hosea, slept. We comment on the rarity of such occurrences as that in race relations.

What about Selma's blacks? They learned not to be afraid, to put fear out of their hearts, Hosea says. They learned this from SNCC and SCLC; it was something they could not do without outside help. Now, he comments, they have a majority on the Selma city council; and Alabama has four black sheriffs . . . the only such in the country.

We agree about Selma being the perfect place for such a confrontation. He remembers how King decided, at a meeting in the Gaston Motel [in Birmingham] to go to the Black Belt for the franchise . . . and how he picked Selma because of reports that [Dallas County Sheriff Jim] Clark wouldn't allow a meeting of more than three or four blacks at a time. He was planning to come January 1—Emancipation Day—and Clark sent back word that blacks had always celebrated Emancipation Day in Selma and King was welcome to come speak to them. So King replied that [Ralph] Abernathy would speak on Emancipation Day and he, King, would speak on January 2.

Hosea says Clark was the meanest man he's ever met—that you were as safe in Baker's part of Selma as in Dr. King's church but that, when you went to the courthouse, you were in Clark's territory and that was something different.

Not all whites are like Clark. He remembers being picked up for speeding by two state troopers sometime after Selma.

"Why look who's here," the troopers marvelled. "Old Hosea we used to beat on in Selma!"

"And you know," Hosea recalled, "they just wanted to talk. They didn't even give me a ticket. They just wanted to talk, that's all. I think when you meet people on an individual basis, they can get along. Those troopers knew they had done some bad things in Selma."

Hosea walked me to the stairway, still reminiscing. "I love to drive from Montgomery to Selma," he said. "The weeds have grown up along that road but I still try to pick out where we stopped to rest or where we camped at night."

When I interviewed Nicholas Katzenbach in 1974, the onetime U.S. attorney general so frequently at the center of the civil rights maelstrom had evolved into the vice president and general counsel of IBM, occupying a cold office inside an orderly corporate park thirty miles from New York City and safely out of the limelight.

Tall, hulking, baldish Katzenbach enjoyed reminiscing about his former battles; to my surprise, certain recollections caused him to laugh until tears came into his eyes. For example, this is how Katzenbach remembered the White House meeting in 1965 when President Lyndon Johnson tried to cajole, flatter, and bully a fellow

Southern politician, Alabama Governor George C. Wallace, into complying with federal civil rights directives.

NICHOLAS KATZENBACH RECALLS A MEETING
BETWEEN LBJ AND GEORGE WALLACE:
NOTES FROM AN INTERVIEW

(Those present, in addition to the president and the governor, were Katzenbach, his assistant Burke Marshall, and Wallace's sidekick, Seymour Trammell.)

[Katzenbach] said LBJ asked him to jot down five or six things he should discuss with Wallace, such as what are you going to do about schools, about literacy tests, about voting.

LBJ started by introducing GW to Rufus Edmiston, the secret service agent who had saved LBJ's life, because Edmiston was an Alabamian:

"I want you to meet your governor," LBJ said, flattering Wallace.

First thing LBJ said was "What do you think about education— you're for equal education aren't you George?"

"Why yes Mr. President," Wallace replied.

LBJ pressed the point some more, then said, "Why don't we go out there and tell the TV cameras that you and I have agreed to desegregate all the schools in Alabama?"

"Why I can't do that, Mr. President," Wallace demurred. "I don't have the power—" and he went on about local school boards, etc.

But LBJ would have none of it! "Now George, don't tell me that. I *know* who's got the power down in Alabama."

So he kind of boxed Wallace into a corner like that . . . kept pressing him and pressing him hard, harder than I ever expected him to do. Saying that the only way to stop demonstrations and marches "like those out there" (indicating pickets outside White House) was to desegregate and to grant the franchise.

This went on for a long time and it was one Southern politician fencing with another. Only Wallace—who's a smart guy, understand—was just outclassed, simply outclassed, that's all.

Every once in a while, LBJ would change the subject, saying, for example, "George, what do you think about Vietnam?" flattering

Interview, March 19, 1974, Papers of Virginia V. Hamilton, Birmingham Public Library Archives.

him and throwing him off the main subject. At the end he asked Wallace if he'd like to go out with him and say that they agreed on everything. But Wallace said: "Now, Mr. President, I can't do that."

LBJ had him so handled that Wallace couldn't go out in front of the TV cameras with him—he didn't dare. So nothing happened as a result of this conference.

It was one of the funniest things I ever saw, Katzenbach said, chuckling at the recollection of this meeting of two classic Southern politicians and how LBJ had proved himself the master.

Although I did considerable research and also interviewed Andrew Young, John Lewis, Clarence Mitchell, Leroy Collins, and others who figured prominently in the Selma confrontation, I never wrote that book. Instead, I agreed to another project, one with a pressing time frame. When I finished the bicentennial history of Alabama, I embarked on a biography of Senator Lister Hill. Gradually I lost touch with my Selma material.

No one has yet captured, to my satisfaction at least, the drama of Selma, 1965. This moment in American history awaits its historian.

Author on back stoop of the "Alabama Embassy."

"Government girls," Washington, D.C., 1943. (*Left to right*)
Lillian Keener, Jane Culbreth, Mary Eleanor Bell.

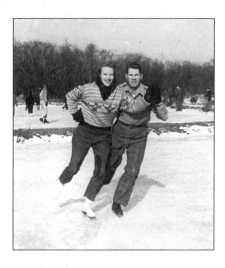

Learning a Yankee sport with Larry, my husband-to-be, 1944.

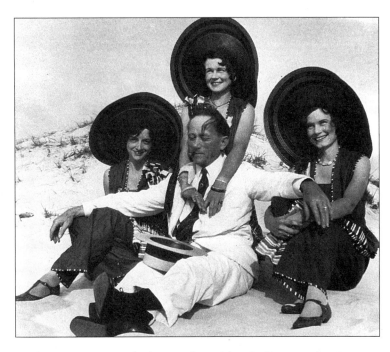

Mississippi Senator Theodore G. Bilbo and friends. (Courtesy of McCain Library Archives, University of Southern Mississippi.)

Senator Hattie Caraway of Arkansas, first woman elected to the U.S. Senate, with her colleague, Senator Joseph T. Robinson. (Courtesy of Arkansas History Commission and Central Arkansas Library System.)

Clifford Durr (*left*) and friends, including Supreme Court Justice Hugo L. Black (*second from right*) on the day of Durr's confirmation as Federal Communications Commissioner, 1941. (Courtesy of the Alabama Department of Archives and History.)

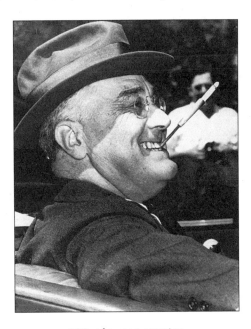

FDR at his most engaging.

Idaho Senator Glen Taylor and son on the Capitol steps. (Courtesy of U.S. Senate Historical Office.)

First Lady Bess Truman recites her lesson in Spanish class, 1946. (Courtesy of Harry S. Truman Library.)

Some of the senators I admired—and some that I did not admire. (*Top*, Albert Gore of Tennessee; *bottom*, Estes Kefauver of Tennessee and Richard Nixon of California. Courtesy of the U.S. Senate Historical Office.)

John F. Kennedy, assisted by his mother, Rose, campaigns for a seat in the U.S. House of Representatives, 1946. (Courtesy of John F. Kennedy Library.)

Lowell S. "Larry" Hamilton, author's spouse.

Alabama's First Lady, 21-year-old Jamelle Folsom, plays old-fashioned tunes like "The Three Little Fishes," 1948. (Copyright *The Birmingham News*. All rights reserved. Reprinted by permission.)

Birmingham Police Commissioner Eugene ("Bull") Connor first attracted public attention in the 1930s as a radio baseball announcer. (Courtesy of Department of Archives and Manuscripts, Birmingham Public Library.)

Faculty picnic, Alabama College, Montevallo, 1950. (*Left to right, standing*) Marcia Sears, Guy Sparks, Amy Sparks, author, two unidentified women; (*left to right, seated*) Ralph Sears, Putnam Porter, Nancy Leonard, Robert Payne, unidentified man.

Alabama College faculty in more formal moment. (*Left to right*) Lucille Griffith, author, Nancy Leonard, Robert Payne, unidentified woman.

Henry Wallace at a rally of his Progressive Party in
Montgomery with unidentified supporter and
Virginia Durr, 1948. (Courtesy of the Alabama
Department of Archives and History.)

Richard Arrington takes the oath as mayor of Birmingham, 1980. Looking on (*left to
right*), former mayors George Seibels and David Vann and the new mayor's wife,
Rachel Arrington. (Copyright *The Birmingham News*. All rights reserved.
Reprinted by permission.)

Professor John Ramsey. (Courtesy of Special Collections, Hoole Library, University of Alabama.)

Frances Roberts in her days as a teacher at Huntsville High School, 1944.
(Courtesy of Dr. Frances Roberts.)

Professor Hallie Farmer. (Courtesy of the University of Montevallo.)

Presenting a copy of Alabama's bicentennial history to
Governor George Wallace, 1977.

So you're retiring—"Congratulations!"

All in a life's work.

Finding Richard Arrington's Roots

To mark the bicentennial of the American Revolution, in 1976 the American Association for State and Local History, with financial support from the National Endowment for the Humanities, planned to publish a series of state histories. Those invited to contribute faced this task: Sum up the history of your state in (1) less than 200 pages, (2) a style attractive to the general public, and (3) one year.

For most academics, one year is barely start-up time; many scholarly books (including my biography of Lister Hill) are ten years in the writing. However, the AP had taught me to turn out information in split seconds, a minute being considered a generous amount of time to report any occurrence. As a journalist, I had been trained to write in plain, easily understandable language.

Thus, when I accepted this invitation, only one problem remained: other than the decades of the 1920s and 1930s, when Hugo Black served as U.S. senator, I knew virtually nothing about Alabama history.

I decided to divide this book-length essay into three major chapters: the first dealing with the Alabama majority—plain whites; the second describing the next largest group in the state's population—blacks; the third concentrated on a much smaller but highly influential group—the white elite.

Poking around the basement of the Alabama Department of Archives and History in Montgomery, I discovered a sizable number of narratives of ex-slaves, collected in the 1930s by white interviewers for the Federal Writers Project of the Works Progress Administration. No scholar had ever seen these interviews. Indeed,

only one member of the archives staff even knew that they were hidden away in a dusty file cabinet.

Purely by chance, I had happened upon a valuable cache of historical material that no antebellum specialist had uncovered. The more than one hundred items I found almost doubled the Alabama collection of ex-slave interviews housed in the Rare Book Room of the Library of Congress.

I reported my discovery to George P. Rawick, the first scholar to consider these narratives to be valid historical evidence. In editing a sixteen-volume set of ex-slave narratives, Rawick believed that he had included all work done by interviewers for this project. Crediting me with the find, he published the forgotten Alabama narratives in an extra volume.

Why had these materials been left behind although other Alabama narratives had been forwarded to the Library of Congress? When a similar find came to light in Mississippi, Rawick concluded that those narratives had been deliberately withheld because whites realized that they depicted slavery in a "bad light."

However, Rawick did not suspect that the "lost" Alabama narratives had been held back for any ulterior motive. Some, he speculated, were rough field notes, considered too sketchy to send in; others may have reached the Federal Writers Project's state headquarters after the main body of narratives had been dispatched to Washington.

Quoting from the narratives was risky business for an academic at that time. Other than Rawick, the majority of historians disdained or neglected this source. Eventually, however, the narratives would come to be used extensively by distinguished specialists on the complex topic of slavery, notably Lawrence Levine, Herbert Gutman, and John Blassingame.

I relied heavily on my find to help picture life under slavery from the black point of view, using excerpts from the narratives not only in the bicentennial history but also in the textbooks I wrote for fourth- and ninth-grade students of Alabama history. In all three books, I included the vivid recollections of an ex-slave in Sumter County named Oliver Bell.

Whenever possible, I persuaded "living artifacts" to visit my classroom, thereby giving my students a brief look at such histori-

cal figures as James E. ("Big Jim") Folsom, Carl Elliott, and H. L. Mitchell, who had spearheaded the Sharecroppers Union. In his first term as mayor of Birmingham, Dr. Richard Arrington accepted my invitation to talk to a class in southern history about his early life as a sharecropper's son.

Knowing that Mayor Arrington had been born in Sumter County, I had checked the ex-slaves narratives. But no one by the name of Arrington had been interviewed.

In a candid and poignant account of his childhood, Dr. Arrington spoke of his regret that he knew so little about how his slave ancestors had lived. Then he mentioned his mother's family name: Bell.

"Was there an Oliver Bell in your family?" I asked after the class.

"Oliver Bell was my great-great-granddaddy," replied the mayor. "But how did you know that name?"

That same day I sent Mayor Arrington a photocopy of the narrative collected from Oliver Bell by Alabama's noted Federal Writers Project interviewer, Ruby Pickens Tartt. He telephoned me the following morning.

"I took that story home and read it to my daddy," the mayor told me, "and he said: 'Those are our folks!'"

Reading Oliver Bell's narrative alongside a transcript of the talk that Richard Arrington gave to my class, one is struck by how little life changed for the descendants of slaves in the almost one hundred years between the end of the Civil War and the beginning of the civil rights revolution. To illustrate this point, I have taken the liberty of arranging excerpts from these two sources in topical fashion.

RICHARD ARRINGTON AND HIS GREAT-GREAT GRANDFATHER:
TWO ORAL HISTORIES

On their family

Bell: I was born [about 1860] on the DeGraffenreid place, nine miles west of Livingston. My mother was Luella DeGraffenreid and my pappy Edmund DeGraffenreid. Then they change their name to Bell.

Arrington: I was born in Sumter County, Alabama, on October

Alabama Department of Archives and History, Montgomery, Alabama (Bell), and Speech, Birmingham, Alabama, 1980 (Arrington).

19, 1934, and lived there—outside the town of Livingston—until I was four or five years old. . . . My mother comes from the Bell family.

Bell: I has about sixteen children, all born in the same place, and most of them livin' here yet. My children by my first wife is [he gives their names] . . . then my second wife and me . . . is got the rest of the children [he names them] . . . and that's many as I can recollect right now.

Arrington: My father had nineteen brothers and sisters. Of course, all but one lived to an advanced age—quite a few are still alive today. When my father's mother died, his father married again and they had five more children.

On the land where they lived

Bell: When old Marsa Amos Travis come out here from California, he taken a likin' to me, and he got behind me . . . and wanted me to move down this side the big house to take care this swamp and look after the hands.

Arrington: Most of the blacks . . . thought the Bells owned all that land. We never actually owned any of the land. . . . When my great-great-grandfather on my mother's side was growing up . . . there was a family that owned this land who were very fond of him. And they turned all the land over to him to live on.

On their houses

Bell: Us lived in the third house from the big house in the [slave] quarter . . . [after the war] I wanted a big house with four rooms and two brick chimneys, and I had to talk five years [to Amos Travis] to get it.

Arrington: The inside walls of our house were papered with old Sears and Roebuck catalogs. The windows were just board windows—open windows.

On the work of family members

Bell: My grandpa . . . was a shoemaker . . . and made stock plows and put a sweep on to sweep cotton and a plow what had a wooden wall board. . . . My mammy was a plow hand and she'd go to work and put me under the shade of a big old post-oak tree, and there I sat all day, and that tree was my nurse. It's still standin' there yet, and I won't let nobody cut it down.

Arrington: My father was a blacksmith . . . [and] a carpenter. . . .
He built quite a few homes down in Sumter County. . . . He did all
the shoeing of horses in addition to farming.

On working in childhood
Bell: [My grandpa] learned me how to pull fodder and chop corn
and cotton when I warn't so high. . . . When I was a boy it was my
job to set out shade trees. One day the Ku Klux come riding by and
they leader was Mr. [Steve] Renfroe, he wore long hair, and he call
my pappy out and ask him a heap of questions, and while he setting
there his horse pulled up nigh all my trees.
Arrington: I recall at a very young age working in the field. I . . .
[had] a sack for picking cotton. And I'd . . . go to the spring . . .
about eight or ten city blocks from where we lived. . . . The horses
drank from one side and we got water from the other side. And
bring buckets of water to the field for my parents and aunt and some
uncles. . . . Another early memory . . . is taking the horse down to
water and the difficulties I had trying to get back up on him after
getting down! There was no saddle.

On schooling
Bell: Didn't nobody help us learn nothin' much but my children
went to Booker T.'s [Washington] school [Tuskegee Institute]. They say
he's a mighty smart man, and my children thinks they is too. . . . I
wish I could read and write.
Arrington: My father . . . went through the third grade in a coun-
try school. For blacks, I guess that was representative of the worst
available education. As he tells it, all the grades were in one room. . . .
On my mother's side . . . my great-great-grandmother was an educa-
tor, and in fact most of the Bell family taught. They didn't finish
college but most of them went off to school. One uncle went to
Tuskegee . . . and another one went to [Alabama] A&M for a year or
so. They came back and taught.

On white people
Bell: Us belonged to Mr. Tresvan DeGraffenreid and Miss Rebecca
and they was all good to us. . . . Us had enough to eat . . . and had
our rations weighed out. . . . What I seed of slavery was a bad idea,
I reckon, but everybody thought their marsa was the best, didn't

know no better. A man was growed before he knowed the whole world didn't belong to his old marsa.

Arrington: My father was a sharecropper; he worked for . . . Leland Nixon . . . a man my mother and father are still very close to and fond of. In fact, they hardly go home to Livingston to visit without going back to see Mr. Nixon.

On sharecropping

Bell: After surrender . . . Dr. Graffenreid . . . measure the corn out to all of them what was share hands. He'd take a bushel and give them a bushel. When he most through, he'd throw a ear of corn to this one, and give himself a ear, then he break a ear in two and he take part and give them part. That was close measurin', I tell you.

Arrington: As is usually the case with sharecropping, you work year in and year out; you never get out of debt. No matter how good the crop is you still owe the man.

On seeking a better life

Bell: There's a cave down by the burial ground what the slaves dug when they run away. . . . You . . . push the dirt out and . . . make a great big room up so the water won't get you and where nobody can't see you. I's seen them with a shoat on their back taking it to the cave, and I's found leather there where they fix their shoes.

Arrington: One day in 1938 and 1939, my father decided he wanted to seek a better life for his family—to seek his fortune in the steel mills. So he . . . borrowed the bus fare. He . . . got a job in the Fairfield area working at the wire mill. . . . He came back in his brother's car and moved our whole family to Birmingham.

Writing for the "General Reader"

In November 1977, I was asked to take part in a panel discussion of the bicentennial state history project at the New Orleans meeting of the Southern Historical Association. In this quintessential academic setting, I talked about the need for professional historians to communicate with the "general reader."

WRITING STATE HISTORY: FOR WHOM?

Some thirty historians, of whom I am one, recently undertook, at considerable peril to our professional reputations, a journey to the back country known as state history. In so doing, we risked being stigmatized by our peers as parochial, banal, and irrelevant, and relegated to the company of genealogists, antiquarians, authors of local cookbooks, and united daughters of lost causes.

If we dared confess at scholarly gatherings that we were writing short, interpretive state histories, our colleagues, deeming this merely a temporary aberration, passed over the subject in charitable silence and inquired as to the progress of our *real* research.

We set forth our findings not in the abstruse verbiage of erudition, but in plain language aimed at that simple creature, the general reader, who is forever being patronized by academics in references such as these: "[This] book should have been directed to the casual reader . . . very interesting and well-written, it makes light, enjoyable reading"; or "While the book may prove instructive to lay readers of state and regional history, it is too narrow in analysis and content to have any significant value for scholars and specialists"; or

Paper delivered at the Southern Historical Association meeting, New Orleans, November 12, 1977; published in *The Register of the Kentucky Historical Association* 76 (July 1978):192–96. Reprinted by permission.

"That amorphous group of people known as general readers may enjoy—if not benefit from—reading this book."

General, casual, and lay readers are fortunate in that they are unlikely to come across such inferences as to their frivolous nature and limited intellect. But the professional historian who assays a popular history cannot escape the consequences. The arrival of a fresh issue of a scholarly journal, wherein one's effort may well be characterized, in plain view of one's peers, as journalistic, cursory, derivative, tertiary, or, most damning of all, impressionistic, is enough to terrify the staunchest maverick.

We further annoyed some colleagues by publishing our findings without the usual supportive paraphernalia of numerous footnotes and extensive bibliographical essays, a deliberate omission which does not seem to have concerned the general reader. Indeed, some Alabama citizens, apparently perturbed by their first encounter with the mysterious symbols for footnotes concealed in the back of a volume, asked its author suspiciously, "What are those little numbers in your book?"

Furthermore, these state histories appeared under the rubric of the bicentennial, in company with sundry other souvenirs such as star-spangled beer mugs, sugar packets embossed with Independence Hall, beach towels emblazoned with stars and stripes, red-white-and-blue sacks for drug prescriptions, and ice buckets in the shape of the Liberty Bell. Other historians, witnessing this all-American effusion of sentiment and commercialism, deemed it prudent to keep a safe distance from the bicentennial. . . .

As you are quite aware, we traditionally relegate state history to the bottom rail of our departmental offerings and consider it the lowest form of drudgery in our curriculum, to be avoided for the sake of one's professional reputation. Yet ironically, at a time when there are many empty seats in courses on the Middle Ages, the Enlightenment, or England under the Tudors, the state history classroom remains comfortably filled and the drudge who teaches it is able to report a sizable number of credit hours to help overcome the deficit incurred by his or her more esoteric colleagues. To a large extent, these dependable patrons for state history courses comprise one of our rare captive audiences, being required by the state bu-

reaucracy to complete this study as part of their preparation for becoming public school teachers.

They can scarcely fail to notice the low esteem in which we hold state history and those who teach it. Taking a cue from us that this is an irrelevant but unavoidable nuisance, to be dispensed with as perfunctorily as possible, our protégés are scarcely inspired to approach their own teaching of state history with commitment, enthusiasm, and imagination. More likely they will require hapless ninth graders to accomplish feats of memorization such as the dates of governors' terms or, a bitter experience often recalled by my own students, the names of all 67 counties in Alabama.

Ninth graders, being fully capable of recognizing irrelevance when they encounter it, proceed to erase this information from their brains as quickly as possible but are likely to retain one lasting impression: if this be history, let us have no more of it. Do you recall Jefferson Davis's warning: do not grind the seed corn? Moving on to high school and college, these students will find it easy to avoid history. A plethora of social studies—pre-law, criminal justice, sociology, anthropology, archaeology, psychology, political science, urban studies, to name some of them—has eroded history's once unchallenged preeminence as a necessary component of every citizen's education. . . .

There is one loophole by which the writing of state history may be construed as reputable. This is to relate it in some way to a national or regional context, such as presidential politics, a manifestation of the frontier, or the overall picture of slavery. If state history can be related to trends such as these, it is relevant; if it has no national or regional connotations, it is parochial. One must be a professional historian to grasp the subtlety of this reasoning. Those unable to present their research in national or regional context make regretful and humble acknowledgment of this shortcoming, producing what one historian has termed "a sizable literature of apology in scholarly prefaces and state historical journals."

Are we any more foresighted in our attitude toward what appears to be a sizable adult audience for state and local history? Inspired by the bicentennial and *Roots,* local historical societies are thriving. There are numerous grass roots efforts to preserve historic sites, es-

tablish folk museums or retain old craftmaking skills. Interest in genealogy is exploding. Professional historians may regard state history as narrow and provincial but . . . state history plays in Peoria, and in Montgomery, Savannah, Baton Rouge, Frankfort, and Durham. Recently one of my archaeological colleagues was quoted in the local press as saying that archaeologists consider amateurs invaluable; the more amateurs, the better chance of finding and saving important archaeological sites. I was struck by this comment because historians seem to adopt the opposite attitude. As with the bicentennial, the greater the distance between us and amateur historians, the more comfortable we feel.

Are there any stirrings of life in our old, cobwebbed attic of state history? I sense a faint pulse: certainly this series of interpretive, readable state histories in which we have participated is a promising sign of life. The reviews of volumes published thus far—even the reviews in scholarly journals by professional historians—have been largely favorable. . . .

Still too many of us hold onto and perpetuate the traditional attitude toward state history, passing on this snobbery not only to future public schoolteachers but to the best and brightest young scholars of our profession whom we warn to avoid anachronisms at all cost and devote their professional careers instead to the study of topics such as Whigs, cotton factors, or American railroads.

One bold lay historian, speaking before a recent meeting of Alabama's college-level teachers of history, sharply chided me and my colleagues for ignoring or demeaning state history, for holding lay historians and genealogists in contempt, and for writing in a language which only other historians could understand. By so doing, she warned us we were killing off the budding interest in history which springs from a curiosity about one's own family and community. "My goal," she told the professionals, "is to offer the gift of history *to every literate person.*"

Should *our* goal be narrower than this? Are we writing primarily for one another? Are we forgetting one of our own most famous lessons when, if asked to communicate what we know to general readers, we reply, "Let them read scholarly journals!"

Fifteen years after I made that talk, I was still trying to get history across to the general reader by almost any possible device, even copying the format of a popular television quiz show. The following guest column, written for the Birmingham News *editorial page—my father's longtime forum—attempts to contradict the popular misconception that Alabama has always stubbornly and consistently opposed the federal government.*

THOSE NATIONAL CONTESTANTS
MIGHT BE STUMPED BY ALABAMA

To illustrate a point, picture this little scenario:

TV Quizmaster: "Welcome to the national finals of Serious Pursuit. Our first category is civil rights. I'll name an event, and you tell me where it took place and something about it. Ready? The stand in the schoolhouse door."

First Contestant: "Gov. George Wallace protesting the use of federal troops to integrate the University of Alabama."

Quizmaster: "Correct! Next question: Bloody Sunday."

Second Contestant: "Alabama troopers using clubs and tear gas on voting rights demonstrators in Selma, Alabama."

Quizmaster: "Right! Third question: the city where police dogs and firehoses were used to disperse black people demonstrating for equal treatment in downtown stores."

Third contestant: "Birmingham, Alabama."

Quizmaster: "Absolutely right. Each of you has won $3,000. Let's go to another category: the federal government. I'll name a program that contributed to the growth of federal power, and you tell me the name of the major sponsor of that measure in Congress and what state that person represented. Each wrong answer will cost you $1,000. Ready? The act that established federal grants-in-aid to pave rural roads and later to construct interstate highways."

First Contestant: "Lyndon Johnson of Texas?"

Quizmaster: "Sorry. The correct answer is Sen. John H. Bankhead of Alabama. Next, what senator first proposed a bill to give the federal government the power to enforce a shorter work week?"

Second Contestant: "Daniel Patrick Moynihan of New York?"

Birmingham News, August 15, 1990. Reprinted by permission.

Quizmaster: "That is not correct. The answer is Hugo Black of Alabama. Next, the Senate sponsor of the Small Business Administration that assists people in setting up their own businesses."

Third Contestant: "Gary Hart of Colorado?"

Quizmaster: "Sorry. The correct answer is Sen. John Sparkman of Alabama. Next, name two members of Congress from the same state who sponsored the National Defense Education Act that established federal loans for college students."

First Contestant: "Must have been Hubert Humphrey and Walter Mondale of Minnesota!"

Quizmaster: "Sorry, that is not correct. The answer is Rep. Carl Elliott and Sen. Lister Hill of Alabama. Next, the Farm Security Administration that helped many tenants become landowners."

Second Contestant: "George McGovern of South Dakota?"

Quizmaster: "Sorry, the correct answer is Sen. John H. Bankhead Jr., of Alabama. Next, who was the chief Senate sponsor of federal housing programs for the poor and elderly and of the Federal Housing Administration to help average Americans become homeowners by guaranteeing home mortgages?"

Third Contestant: "Eugene McCarthy of Minnesota?"

Quizmaster: "Sorry. The correct answer is Sen. John Sparkman of Alabama. Next, what senator led the drive to build the National Institutes of Health into a huge medical research effort to seek the causes and cures of diseases?"

First Contestant: "I know this one: Teddy . . . er, Edward Kennedy of Massachusetts."

Quizmaster: "No, that is not correct. The answer is Sen. Lister Hill of Alabama. Next question: It's well known that Sen. George Norris of Nebraska envisioned the Tennessee Valley Authority that put the federal government in the business of generating cheaper electric power and thereby brought industries and prosperity to an entire river valley. The question is: Who was the co-sponsor of that bill in the House?"

Second Contestant: "Geraldine Ferraro?"

Quizmaster: "No, the correct answer is Lister Hill of Alabama. Now for our final question: Who sponsored the bill containing the first provision for a federal income tax to pay for all these programs?"

Third Contestant: "Sen. Huey Long of Louisiana!"

Quizmaster: "Sorry, the answer is Rep. Oscar Underwood of Alabama. You've lost all your money so the game is over. You knew every answer in the civil rights category but you struck out in the federal government category. Better luck next time."

Contestants: "This show is rigged!"

No, average Americans, that imaginary contest was not rigged. The state in which dramatic protests against federal authority took place is the same state whose senators and representatives proposed legislative acts that greatly enlarge federal power.

The state where civil rights for blacks were so strongly opposed is the same state whose congressional representatives sponsored numerous programs that enhanced the quality of life for Americans of every racial background.

Furthermore, our little fantasy did not include all the contributions of Alabama members of Congress to a more powerful federal presence. To cite other examples:

Sen. John Tyler Morgan has been called "the father of the Panama Canal" because, long before Teddy Roosevelt entered the picture, he advocated an isthmian canal built with federal might and money.

Underwood led the House to pass the Federal Reserve system to regulate banks and the nation's credit supply.

John Bankhead, Jr., became the congressional champion of raising the price of cotton and other major crops by means of federal controls and loans.

Elliott and Hill sponsored the act to provide federal matching funds to improve libraries and library services.

Hill's 1938 Senate victory and that of Claude Pepper in Florida, signaling that average southerners favored federal work standards, led to passage of the act establishing the minimum wage and the maximum work week and prohibiting child labor.

Hill sponsored the act creating a federal program to bring telephone service to rural Americans and the Hill-Burton Act to construct hospitals in small towns.

Although they faced numerous opponents, these men enjoyed the loyal backing of the majority of Alabama voters. Hill served in Congress 45 years; Sparkman, 42 years; Bankhead, 33 years; Underwood, 31 years. Morgan served in the Senate 30 years; Bankhead Jr., 15 years; Black, 10 years. Morgan and both Bankheads died in of-

fice. Black resigned to become a Supreme Court justice. Underwood, Hill and Sparkman retired undefeated.

In the face of this state's long and imposing record of activism in the federal sector, it's ironic that Alabama is known, nationally and worldwide, almost solely in terms of stubborn opposition to "the feds."

What accounts for Alabama's seeming "love/hate" relationship with the federal government?

There is no glib, quiz show response to this question. The answer would be lengthy and involved, a modern-day morality play comprising these elements:

Humanity's ceaseless quest for a better life. Powerful defenders of the status quo. Racism nurtured by poverty and fomented for personal gain.

Some Personal Notes

I no longer possess the will to attempt scholarly work. Nor do I find any satisfaction in straight reporting of the type I wrote as a journalist. However I do enjoy trying to make a simple point in relatively few words.

I use the personal essay as a painless form of reminiscence ("Dusting the Books," "Before the Freeway: There was U.S. 11," "Of Time and the Train," "Looking for Clark Cable," "Leaving Home at Christmas"). I attempt light social commentary ("Mrs. Husband's Name," "Congratulations: You're Retiring!").

By far my most successful effort in the field of the personal essay came about as the result of my impulsive purchase, at age 70, of a red sports car. After I described this event in the "Hers" column of the *New York Times Magazine,* I received a slew of mail from fellow septuagenarians—and some even older letter writers—who owned or coveted red sports cars.

So I enjoy trying to write essays, if I do not allow myself to delve too deeply into personal matters. Essays are just long enough, just short enough, just impersonal enough, just gratifying enough, to feed my writing habit.

Leaving Home for Christmas

I still remember the artful phrase that first enticed us to leave home for Christmas, a habit we have kept up for 25 years. Earlier that year, my father had died suddenly. Bereft of this central figure, how were we—my mother especially—to endure our usual rituals? In the want-ad section of the *Saturday Review,* a wellspring of intriguing possibilities in those days, I found our refuge: "Tiki, Your Tropic Island Home."

Thus beguiled, we caught the last ferry of the day to Sanibel late one December afternoon. No bridge yet connected Sanibel to Florida's west coast; condominiums, trendy shops and throngs of rich Easterners had yet to despoil this little crescent of land. Anxiously scanning a hand-drawn map by our dashboard's dim light, we followed a narrow road to two tiny frame cottages within sight and sound of the Gulf of Mexico. The phrase-maker had not misled us. Based upon his modest rental fee, we expected, indeed sought, mere seashells of houses, not in any way reminiscent of home.

Our only present, we told our young son and daughter, was to be the trip itself. (However, on Christmas Day, my daughter gave her grandmother a gift she would always keep: a small cardboard box filled with perfect shells chosen from the abundance that washed ashore on each incoming tide.) In lieu of a tree, the children hung conchs, whelks, angel wings and sand dollars on a limb of weathered driftwood they brought up from the beach.

Friends and relatives received not the latest gadget to open a wine bottle or another cleverly designed cover for the bridge table, but cards noting that we had made contributions in their names to the international relief agency CARE. This new turn of events left them

New York Times, Travel Section, December 13, 1987. Copyright © 1987 by The New York Times Company. Reprinted by permission.

obviously discomfited; in their thank-you notes I sensed puzzlement or polite disapproval.

But we did not abandon every tradition that first holiday season away from home. On Christmas Eve, the children and I went to a seaside carol service, candles flickering in the breeze, stars brilliant overhead, outside a little chapel on neighboring Captiva Island. On Dec. 25, bowing to my mother's sense of propriety, our small family, joined by an iconoclastic, 70-year-old friend, Dottie, donned city clothes to have Christmas dinner at Captiva's South Seas Plantation, then a low, wooden structure surrounded by a few simple cottages.

After Christmas at Tiki, leaving home each December did not seem so heretical. Always constrained by finances, we usually chose sunny islands that could be reached by car, such as Marathon, Islamorada and Key West in the Florida Keys, Hilton Head and Jekyll on the Atlantic, and Longboat Key and Sanibel on the Gulf. Instinctively, we sought the promised safety of numbers. Cheerful, irreverent Dottie came along on a number of trips. Other years, we invited an unmarried aunt, a widowed sister-in-law, a young cousin from Indiana who had never seen the Atlantic Ocean, or a dour spinster who had grown up next door to my mother in New Orleans. Later we were joined each Christmas by our son's girlfriend of the moment, each hoping to achieve permanent conquest of that elusive swain.

In departing from familiar surroundings, we put ourselves more at risk for the unexpected. A spell of gray weather seemed gloomier, a minor mishap scarier than at home. In Key West, my daughter got a fish bone caught in her throat; terrified, we rushed her to a local doctor who calmly prescribed a diet of mashed potatoes. On the beach at Sanibel, a stray pit bull nipped me on the ankle. We made a citizen's arrest of the animal, impounded him at a veterinary clinic on the mainland and nervously telephoned every day to see if he had exhibited any symptoms of rabies.

After all these years at the beach, I no longer consider turkey the only appropriate Christmas cuisine. Instead, I remember my son, on a balcony over the Atlantic, grilling quail for Christmas breakfast; how we taught some new acquaintances from Canada to make seafood gumbo; our own discovery of the luscious she-crab soup of the Carolina lowlands; and how we prepared West Indies salad, her fa-

190

vorite holiday dish, to celebrate our daughter's arrival from California one Christmas Eve. Even my husband's famous mince pie, warm and reeking of brandy, does not seem as irresistible when the temperature stands at 80 degrees.

When I recount these culinary apostasies to stay-at-homes, I try to cushion the shock by recalling our annual custom during my mother's lifetime: a traditional Christmas dinner at some expensive seaside dining room where tinsel, ornaments and other artificial displays paled by comparison with the blinding reflection of sun on water and sand.

Or I describe the eggnog party we had one holiday season for other assorted Christmas refugees at our apartment complex—until then total strangers to us and to one another—using my grandmother's classically simple recipe: one dozen eggs, one quart of cream, one cup of sugar, one pint of whisky.

If skeptical relatives ask how we observe particular moments of the holiday season, I tell about attending a Christmas Eve midnight mass with the fishermen of Brunswick, Ga., and their families in a church built to resemble a boat. Or another Christmas Eve when we floated in a glass-bottomed boat on the clear waters of Key Largo's John Pennekamp State Park, peering down at coral reefs and at a nine-foot bronze statue, "Christ of the Deep." Or a slow, quiet Christmas morning drive through Sanibel's Ding Darling Wildlife Refuge to commune with other odd birds, like roseate spoonbills, snowy egrets and blue herons, along with a few fellow specimens of migratory Homo sapiens, far from their traditional December habitats.

As we pack to leave home each year, I look forward to another reprieve from decorating, shopping, entertaining, cooking—burdens that fall primarily upon women in our society. If a member of our family will not be with us—for one particular Christmas or ever again—we will find this absence easier to bear because the setting of our holiday season is also never the same.

In my childhood, I never doubted that each Christmas would be just like the one before, my family as immutable as our rituals. Now at the start of each year, I set out with fresh enthusiasm to choose a new beach for the Christmas ahead.

Mrs. Husband's Name

Before I married for the first and only time, shortly after the end of World War II, I ordered a supply of calling cards ample enough—I now realize—to last a lifetime. I did not anticipate paying many formal calls. In fact, none at all. Because my mother and her married friends possessed these little engraved cards, I simply assumed that they were indigenous to the state of matrimony.

My mother, after selecting a gift for a bride, a baby, or a graduate, always rustled in her purse until she found one of her calling cards to be enclosed with the package. With her fountain pen, she sometimes added "Mr. &" in front of her engraved name; if she knew the family well, she drew a faint line through her married name and wrote at the top of the card "Ted and Dorothy." In girlhood, I observed this little ritual numerous times.

My calling cards bore my new name: Mrs., followed by my husband's first, middle and last names. Friends and relatives would continue to use my first name, but, as the cards made clear, my original surname, with its three separate words, odd capitalization, and obvious Dutch extraction, had vanished from my life save for the middle initial "V" embroidered on my new towels and engraved on my flat silver. On my wedding day, I surrendered not only my virginity but also this considerable element of my identity.

I had liked my surname despite the fact that it was complex and hard to spell; salesclerks and schoolteachers always got it wrong. My grandmother insisted that this name had noble origins; to back up her claim, she prominently displayed on her living room wall the Van der Veer coat of arms, bearing its red cap fringed with ermine.

As a news reporter before my marriage, I had prized my alliterative byline. But I gave up my original name without a murmur; it never occurred to me to do otherwise. I recall being relieved that

Personal essay, 1990.

192

my new name, Mrs. Lowell Stuart Hamilton, sounded dignified, harmonious, and even, to Scottish ears, lordly. But to tell the truth, had the object of my affections been Elmer Gantry, I would unquestioningly have accepted that name as my fate.

I immediately began to refer to myself as Mrs. Hamilton when ordering items or arranging household details over the telephone, in part because, according to the phone directory, I no longer had a name, address, or telephone number of my own. Even the mailbox bore my husband's name.

When I returned to work (somewhat aberrant behavior for married women of middle-class status in those days), I never questioned the fact that the announcement of my new position was couched in wifely terminology. When I received a Ford Foundation grant in the 1950s, the heading in my local newspaper identified the recipient as Mrs. (Husband's Initials) Hamilton. When I enrolled in graduate school at the University of Alabama in quest of a Ph.D. degree, members of the all-male faculty of the History Department made frequent and emphatic use of "Mrs." to express their disdain for a female with such aspirations.

In the wake of the 1960s, however, whiffs of change penetrated even my conformist world. I had been agreeably surprised to see that my doctoral diploma had been issued in my maiden name, augmented by Hamilton. I ordered this name printed on new stationery to replace the old envelopes and letterheads bearing Mrs. (Husband's Name).

Further emboldened, I sought credit cards in this name. Prior to this time, all my credit cards had been exact duplicates of those issued to my husband. Department store officials put up stiff resistance to this heretical notion. Reluctantly, they offered cards identifying me as Mrs. (Husband's Name). But eventually I and other contentious females prevailed.

Shortly thereafter, I used one of my new credit cards to register for a professional meeting at a hotel in New Orleans. My uncle, a highly conventional member of that city's legal establishment, attempted unsuccessfully to reach his visiting niece by telephone. He had given the switchboard operator my married name.

"Doll," he told me indignantly when we finally got together. "They swore you were not registered at that hotel!"

I considered myself avant garde but this must have seemed like

tame stuff to my younger female colleagues. From the very start, some had refused to take their spouses' names. When I invited several such couples to dinner, I didn't really mind having to commit so many names to memory, but I did elevate my eyebrows slightly when I received wedding invitations couched in language of their own choosing, sometimes hand-decorated, and, on occasion, identifying both sets of parents by first names.

Remember the Cheshire Cat in *Alice's Adventures in Wonderland* that faded away so gradually, its grin the last feature to disappear? In somewhat this same manner, my married name has dematerialized. Nowadays I am actually surprised to see it on a piece of mail. Usually a letter such as this comes from a college classmate or some other female friend of long-standing who still uses those little return address stickers with Mrs. (Husband's Name). Recently I received an invitation on which eight women thus identified themselves. Although they surely considered this quite proper, I found it incongruous that all those masculine names should be associated with a bridal shower.

Yet, like the Cheshire Cat, my married name has not totally vanished from use. Perhaps it is understandable that women of my generation, born in the ancien regime of the 1920s and schooled in little proprieties by their mothers, should harbor a certain dichotomy in this regard. When I receive a wedding invitation phrased with oldtime formality ("Mr. and Mrs. Husband's Full Name Request the Honour etc.") and after I run my finger over the engraving, I nod approvingly. Before I set forth to choose a gift for this bride, I will go to my desk drawer—as I have done unerringly over the past four decades—and take a little engraved piece of cardboard, faintly yellow at the edges, from a dwindling stack.

So You're Retiring? Congratulations!

What this country once needed, according to an old saw, was a good, five-cent cigar. One thing this country needs today is the appropriate sentiment with which to salute those retiring from the workplace.

We possess an almost endless assortment of banalities with which to greet newborns and engaged couples or comfort the sick and the freshly bereaved. But we haven't the foggiest notion what to say to our fellow Americans now retiring in record numbers. I discovered this gap in our language recently when I received a number of cards and letters marking my own retirement.

Not knowing what to say to someone who is retiring, most well-wishers fell back upon that vague and indeterminate term: "Congratulations!" When I received my first congratulations upon retiring, I thought perhaps there had been some mistake. My friend had sent me the wrong form letter, the one intended for new college graduates or first-time parents. But to my surprise this turned out to be de riguer; most of those who composed their own sentiments offered me cheery congratulations.

Perhaps, without knowing it, my acquaintances and former students had gotten this idea from greeting cards. Most of the printed cards I received bore on their outside covers a flower or two under a coquettish heading such as "On Your Retirement" or "You're Retiring." But when I turned to the inside, the cards, too, congratulated me.

In case I might have overlooked some little-known connotation of the term *congratulations,* I checked with my dictionary. Just as I had thought, this plural is used to acknowledge "the achievement or good fortune of another."

Personal Essay, 1987.

Did those who wrote me letters or composed the greeting cards actually equate retirement with "achievement" and "good fortune"? Congratulations: you have escaped the great American preoccupation with work? Congratulations: you can now draw Medicare and Social Security! Congratulations: you have lived so long!

Or have we decided that the simplest way to deal with most changes in the human condition is to put a good face on them. (So your divorce is final? Congratulations! Your new baby has arrived and now you have *four* boys! Congratulations! Or *four* girls! Congratulations! Your company has transferred you to Antarctica? Congratulations!)

Having offered their congratulations upon my retirement, most who composed their own sentiments and, indeed, even the professional versifiers seemed vague about what to say next. I was exhorted to enjoy my memories and look back upon all I had done. Having set me to this dreary task, friends and greeting cards had little further to suggest. One printed card hoped that the years ahead would be "especially nice"; others described retirement more optimistically ("wonderful") and vaguely predicted that it would bring me "every happiness" and "rich rewards."

However I infinitely preferred these professionally composed clichés to the slightly ominous tone of my personal mail. Several correspondents pointedly hoped that my health would not deteriorate. And one well-meaning friend confessed that she found it difficult to think of me as being of retirement age "because you always seem so alive."

Back to the drawing board, all you bards of the greeting card industry! Think again, all you well-wishers!

As Old as You Drive

For me, 1991 is a climacteric. The reasons are so portentous that I prefer to express them in roman numerals. The L reunion of my college graduating class, my XLV wedding anniversary and—most alarming of all—my LXX birthday. Let's contemplate these in order of occurrence:

Early in 1991—just in case we had suppressed our awareness that 50 years have flashed by since 1941—my alma mater formally notified my class that our special celebration would soon take place. From the college's standpoint, this might well seem like a celebration. After all, we are close to making that big final bequest.

The alumni office sent two separate computer printouts of our names, which were followed by letters of the alphabet denoting sex, fraternity or sorority, academic major, marital status and other miscellany. Some of my classmates were listed as L, meaning lost—in the sense, I assume, of contact with the college. Maybe these people get L on purpose; in that way, they don't receive appeals for money and announcements of mind-boggling reunions.

Practically every male, I noted, had an R after his name, as did we relatively few career females, most of whom had occupied ourselves over the past half-century by teaching. Apparently, those who list their occupations as "homemaker" never retire.

The most disquieting letter on the computer printout was D. Surely I don't have to explain. The D's appeared on a separate sheet. Rather a tasteful way of handling it, I thought.

My next big event will be that forty-fifth wedding anniversary, one of those quaint connubial observances undoubtedly destined for the sociological dustbin. When you stop to think about it, my

New York Times Magazine, March 10, 1991. Copyright © 1991 by The New York Times Company. Reprinted by permission.

spouse and I have existed in a state of wedlock since before most human beings on this planet were born.

During our courtship, I remember, we used to clutch-dance to a song whose lyrics went like this: "And the days dwindle down/To a precious few." Forty-five years ago, I never took those words literally. Nowadays, if I chance to hear the mournful strains of "September Song" while driving to the grocery store, I almost total the car in my haste to switch stations.

Finally, this fall looms that decade-buster birthday. I can't decide which sounds more ominous: seventy or septuagenarian.

Naturally, I've tried to come up with some coping mechanism. A long, expensive trip is out of the question. My spouse has narrowly survived several traumatic visits to the cardiac intensive care unit, so neither of us wants to stray more than a short distance from our cardiologist.

I considered buying a pair of white designer pants and a matching jacket to wear to the class reunion but quickly came to my senses. I'll never manage to shed fifteen pounds that fast. As for a face lift, I've become accustomed to seeing those blotches, lines and scars in the mirror—the service stripes of a survivor.

I had all this in the back of my mind when my spouse and I went our separate ways the other day. We do this on purpose so as to gather more chitchat to enliven the cocktail hour. He needed a new pair of slacks. I started for the library. Instead, some inner compass steered me into a car dealership.

"My name is Gary," the salesman said politely. "Looking for anything in particular?" Not many years ago car salesmen referred to my spouse as "the boss" and to me as "the little woman."

"A sports car," I heard myself replying.

I'll say this for Gary; he never batted an eye.

"Five-speed?" he inquired.

Caution flag! I've driven many a standard-shift car, but that fifth speed is something else.

"Automatic," I told Gary.

"Sun roof?" he asked.

Caution flag! Members of the class of 1941 spent a lot of summer days broiling under the midday sun; many are now paying the piper. The major change in my facial structure over the past half-century

resulted from plastic surgery a few years back to remove a basal-cell carcinoma.

"No sun roof," I replied.

"Any special color?"

Caution to the wind!

"Red."

Gary wheeled a car out of the lineup, fire-engine red with black stripes and a back seat just big enough for my purse and a sack full of prescription-drug refills. We went for a little spin. I seemed to sit taller in this sleek, low-slung number. Not a bad idea, given the number of cars I observe apparently being steered by invisible drivers—most of them females who have shrunk in stature—peering at the road from between the spokes of their steering wheels.

"Is the engine any different from the one I have now?" I asked.

"You bet," Gary said enthusiastically. "Press down on that accelerator." Zoom!

"Well," I said insouciantly, as if I bought cars all the time without my spouse's advice, consent or knowledge, "what's the bottom line?"

As it happened, Gary had a Special Deal until 4 p.m. that very day: factory invoice plus $49. I've gradually grown accustomed to the fact that many a new car costs more than the first house we bought, so when Gary presented the figure I didn't even gasp. Instead I said, "Could I give you a deposit until tomorrow? Like $100?"

Sorry, Gary explained ever so politely, the Special Deal required a check for the full amount before 4 p.m. "I assume," he said, "you plan to pay cash?"

Actually, we *have* paid cash for cars in recent years. The trick is to unearth one of those nest eggs that frugal people like us— scarred by the Great Depression—have so painstakingly squirreled away, take a deep breath and swap it for a new car, free of interest rates and clear of debt.

"Just write a check for the full amount and we'll hold it until you make the arrangements with your bank tomorrow," Gary said.

Write that size check on our household account? What if I got killed in a traffic accident before I could get home and convey this information to my spouse? The A A A credit rating we've so carefully nurtured for 45 years could be blasted to smithereens.

I made several nervous calls to my home phone, but all I could raise was my own voice on the answering machine. It was 3:50 p.m.

"Oh, well," I told Gary, "let's do it!"

One more piece of business remained. Did I, Gary asked poker-faced, want to purchase the extended warranty to add an additional six years or 60,000 miles to the present warranty of three years or 50,000 miles?

Seeing me hesitate, Gary prompted solemnly:

"It depends on how long you plan to keep this car."

"Oh," I burst out, "I plan to drive it till I'm ready to enter the retirement home, and when I get there, I'm going to park it right smack in the middle of all those pale blue, four-door Buicks and Oldsmobiles."

Gary permitted himself a faint smile.

"I love it!" he said.

I arrived home by late afternoon. My spouse proudly displayed the new brown slacks he had bought.

"Let's have a drink," I suggested.

Actually, he took my news with surprising calm. After 45 years, neither of us screams or yells over a little matter like one purchasing a new car unbeknownst to the other.

"I'm glad you got it," my spouse said at the end of his second drink.

He accompanied me the next day to legitimize the check and to drive my old car back home.

Somewhat gingerly at first, I maneuvered that little red machine onto the freeway. I sat tall in the seat. I pressed the accelerator almost to the floor. I laughed out loud. Driving a sports car wouldn't turn back the clock, but, as we were careful to put it in 1941, what the h—! And after all, I won't turn LXX until September.

Index

201